The Beatles

IN PICTURES

AMMONITE
PRESS

First published 2013 by
Ammonite Press
an imprint of AE Publications Ltd,
166 High Street, Lewes, East Sussex, BN7 1XU

Text © AE Publications Ltd, 2013
Images © Mirrorpix, 2013
Copyright © in the work AE Publications Ltd, 2013

ISBN 978-1-90770-890-9

British Cataloguing in Publication Data. A
catalogue record of this book is available from
the British Library.

Editor: George Lewis
Series Editor: Richard Wiles
Designer: Robin Shields
Picture research: Mirrorpix
Colour reproduction by GMC Reprographics
Printed and China

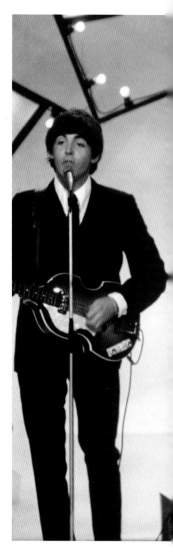

The Fab Four
Page 2: The boys pose for a group portrait.
10th February, 1963

George without mike
Page 5: At a live TV concert, the producers took advantage of the fact that only John and Paul sang lead vocals in the set to cut down on the number of microphones: Harrison joined McCartney on a Lennon-led number.
c.1964

Tie-breaker
Page 7: A CBS photo call for *The Ed Sullivan Show*. Note Harrison without the shirt and neckwear that were until then parts of the standard Beatles rig: a taste of sartorial things to come or just a way of soothing a sore throat?
8th February, 1964

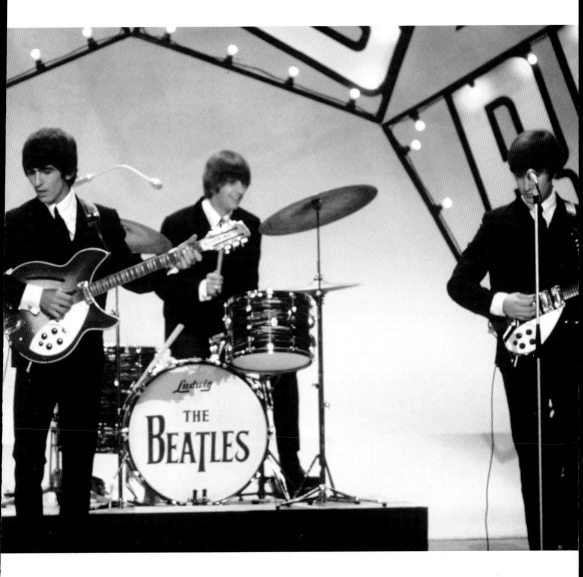

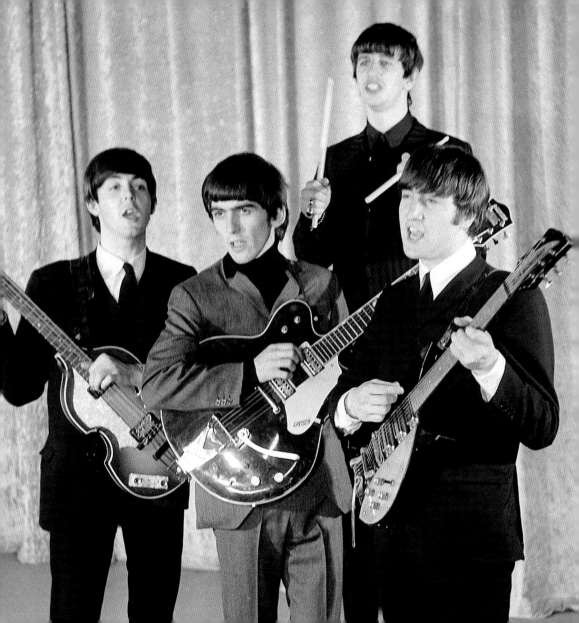

Introduction

The Beatles – John Lennon, Paul McCartney, George Harrison and Ringo Starr – came together in 1960 and broke up in 1970. When they started, few people believed that pop music was anything more than a nine days' wonder, and it was thought that its shooting stars would soon fizzle out and land in the mundane blue-collar jobs they'd hoped to avoid.

But more than half a century later the form is still alive and well and, for some, hugely profitable. Many luminaries of the early period are performing long after they qualified for old age pensions and several of them – including The Rolling Stones and The Who – have lasted long enough to make The Beatles' 10 years together seem almost ephemeral.

Yet in that fairly short time The Beatles stamped a deep impression on the Sixties, reflecting and often creating the zeitgeist. Of course they were to some extent derivative: it's not hard to identify their musical roots in the recordings of Chuck Berry, Little Richard, Fats Domino, Elvis Presley, The Everly Brothers and Buddy Holly. But the Liverpool quartet were no mere imitators: they took the raw material of American rock 'n' roll and synthesised it into something unique and quintessentially British. More than that,

they always resisted the classic temptation to just keep doing what they'd always done and hence ossify. They assimilated some of the outstanding qualities of contemporary rivals such as Smokey Robinson and Bob Dylan, all the while adding new original touches of their own.

And their music has endured, exerting a strong and unmistakeable influence on each succeeding generation. It is starting to look as if The Beatles, like Shakespeare, were not of an age but for all time.

Success made the group members rich beyond the dreams of avarice, but money came between them and their split was acrimonious, with Lennon and McCartney ending up deeply mistrustful of each other's intentions.

Thereafter the four pursued solo careers, with varying degrees of success. For a while they tried to put The Beatles behind them, playing only new material. But they were no more able than anyone else to move beyond the group's shadow. Gradually they reached accommodation with their own past, and in performance started to mix old material with new.

Today it's hard to think of a band that does not owe something to the work of The Beatles; what's not so easy is to identify one that is quite as good.

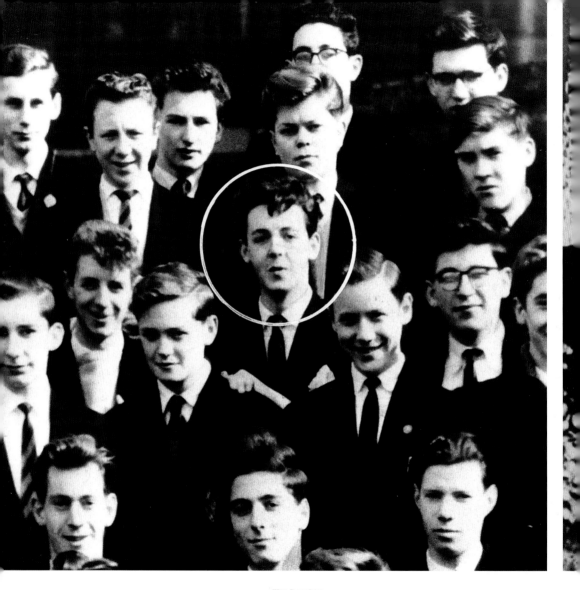

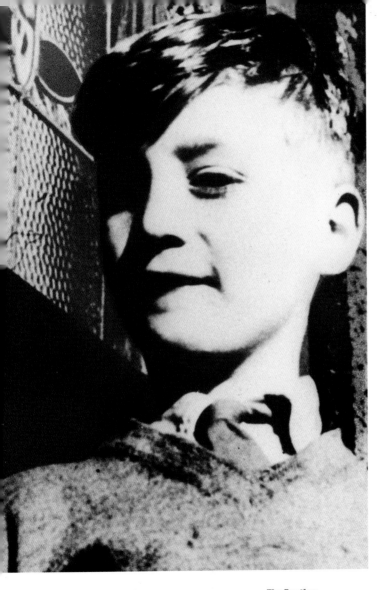

'I used to get mad at my school...'
Far left: McCartney,
J.P. in a photograph at
Liverpool Institute, which
he attended from 1953
to 1960 and where he
became friendly with an
aspiring musician in the
year below him,
Harrison, G.
1950s

'Little child, little child'
The young John Lennon
looks bright and cheeky
and perhaps constrained
by the straight collar and
tie: the child is father of
the man.
c.1950

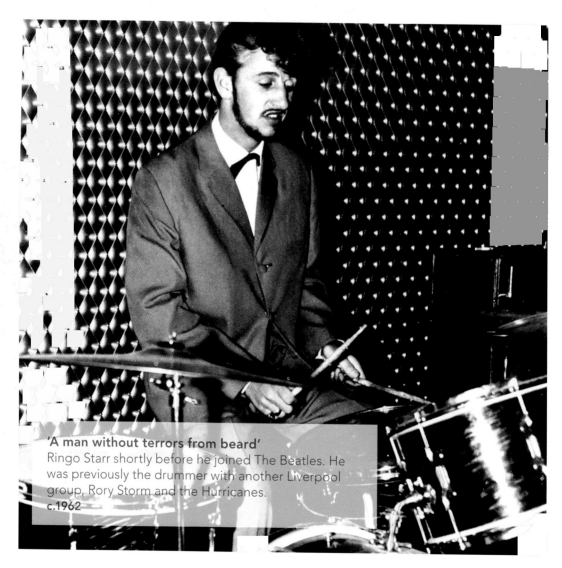

'A man without terrors from beard'
Ringo Starr shortly before he joined The Beatles. He was previously the drummer with another Liverpool group, Rory Storm and the Hurricanes.
c.1962

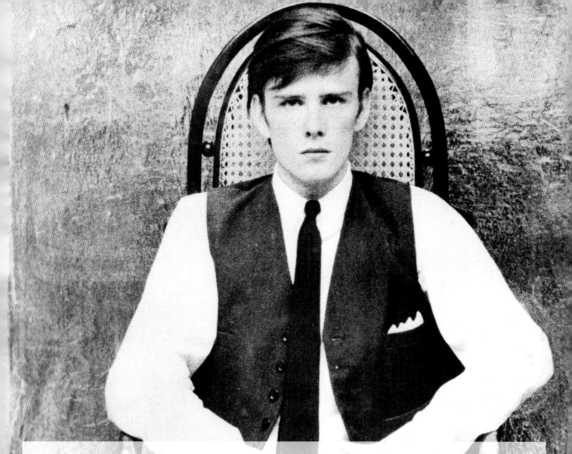

The Fifth Beatle (1)

Stuart Sutcliffe was a modernist painter and occasional bass guitarist who briefly joined John Lennon, Paul McCartney and George Harrison in a group named The Silver Beatles.

pre-1962

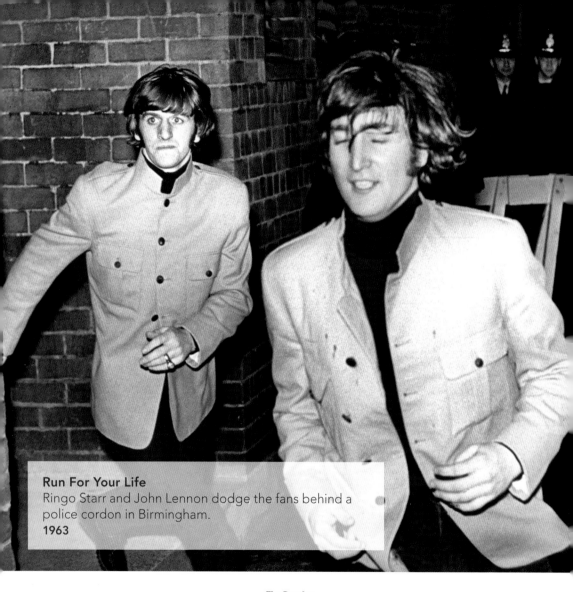

Run For Your Life
Ringo Starr and John Lennon dodge the fans behind a police cordon in Birmingham.
1963

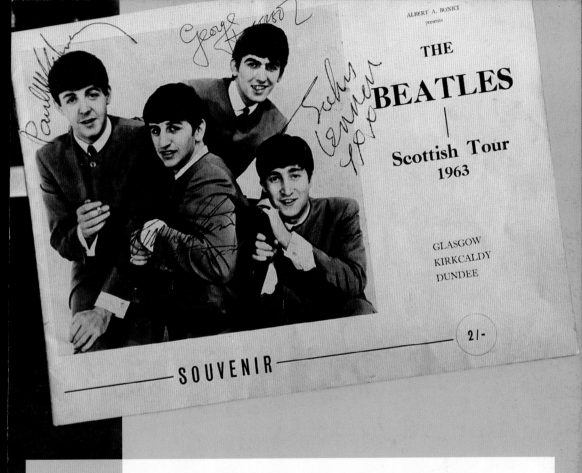

Braving Scotland
Signed souvenir programme from The Beatles' gigs at Glasgow, Kirkcaldy and Dundee on the year's tour of Scotland. Note the cover price of 2/- (two shillings; 10p).
1963

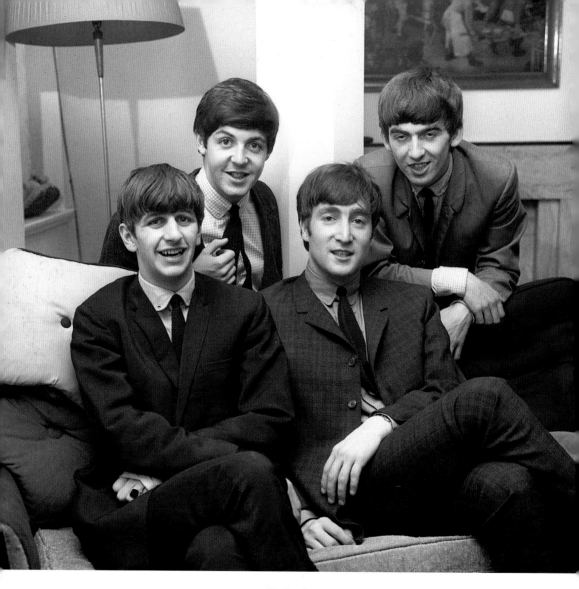

The Beatles

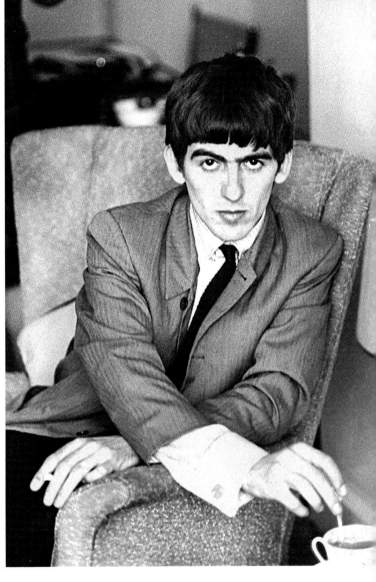

'Can I bring my friends to tea?'
Left: The Beatles at the home of *Daily Mirror* writer and showbiz biographer Donald Zec during an interview for a feature on the band.
Right: George smoulders while stirring his tea.
1963

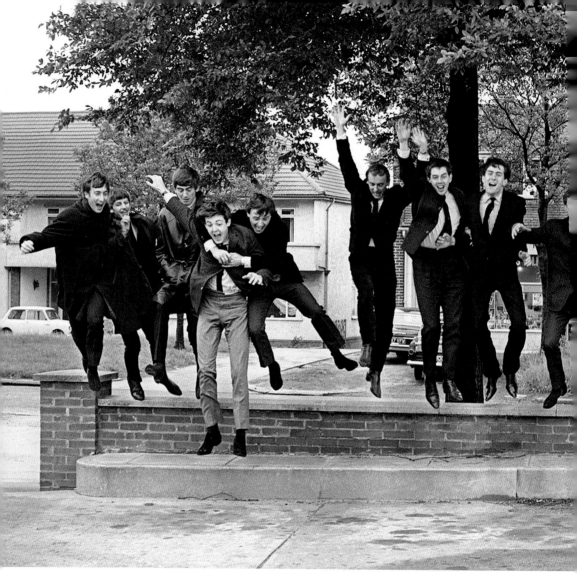

The Beatles
16

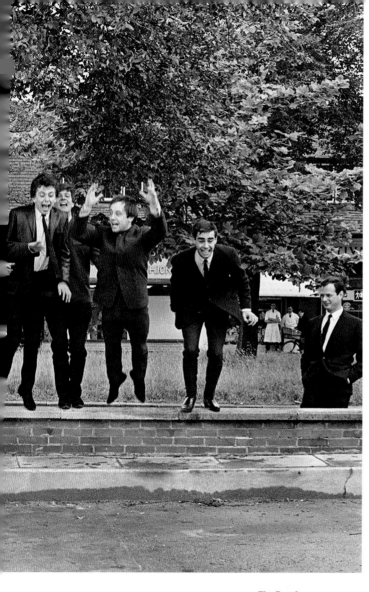

Off the wall
Three leading pop groups
in their native Liverpool.
(L–R) The Beatles; Gerry
and The Pacemakers (with
Gerry Marsden holding
on to Paul McCartney);
Billy J. Kramer and The
Dakotas (Kramer partially
concealed, fourth R).
Watching approvingly, far
right, is the manager of all
of them, Brian Epstein.
18th June, 1963

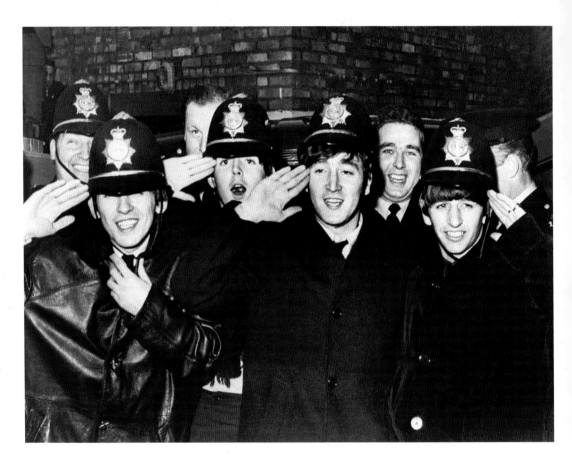

'And so I quit the police department and got myself a steady job'
Impersonating police officers may be an offence, but you have more chance of getting away with it when you're a famous foursome and your current single – *From Me To You* – is No. 1 in the Top 20.
10th June, 1963

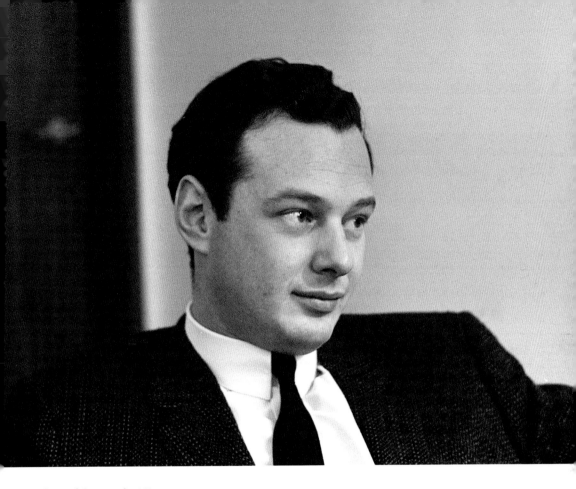

The Fifth Beatle (2)
Brian Epstein was The Beatles' manager from 24th January, 1962 until his death from an overdose of barbiturates on 27th August, 1968. His influence on the group is hard to overestimate: as McCartney said, 'If anyone was the fifth Beatle, it was Brian.'
2nd October, 1963

Six of the best
The lucky winners of the *Scottish Daily Record* 'Meet The Beatles' competition: (L–R) Jean Rankin, June Begg, Teresa Haggart, Christine Mytlewska, Pat Reilly and Sybil McKinnie.
7th October, 1963

The Beatles
21

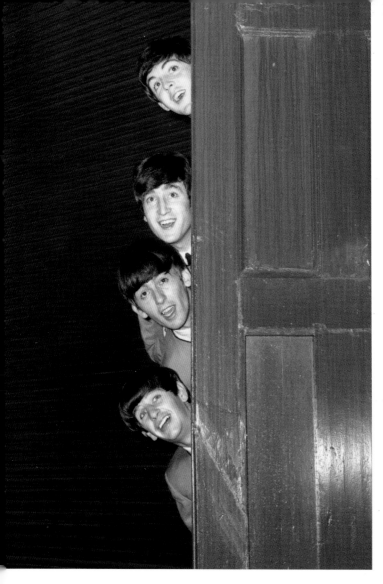

Television set

It's probably fair to say that almost every Briton born in the Fifties who had access to a TV was sat in front of it when The Beatles topped the bill on ITV's *Sunday Night at the London Palladium*. The group's short set culminated in their current No. 1, *She Loves You*, and a rousing rendition of *Twist and Shout*. Here the quartet pose for a pre-show photocall.

13th October, 1963

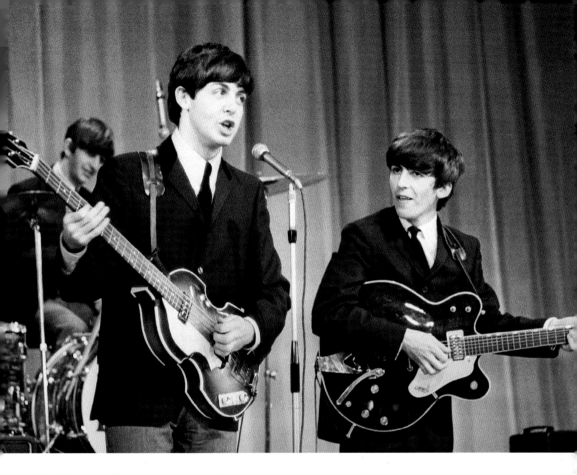

Ready to rock
The Beatles on stage at the London Palladium on one of
those nights when everyone remembers where they were.
13th October, 1963

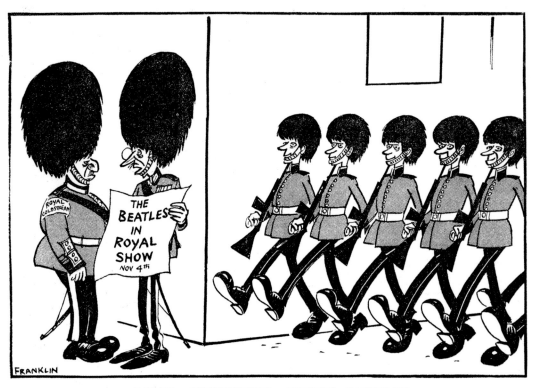

"GAD, SMITHERS, WHAT NEXT?"

Drawing attention
News that The Beatles would appear at the 1963 Royal Command Performance inspired this cartoon by the *Daily Mirror*'s Stanley Franklin.
18th October, 1963

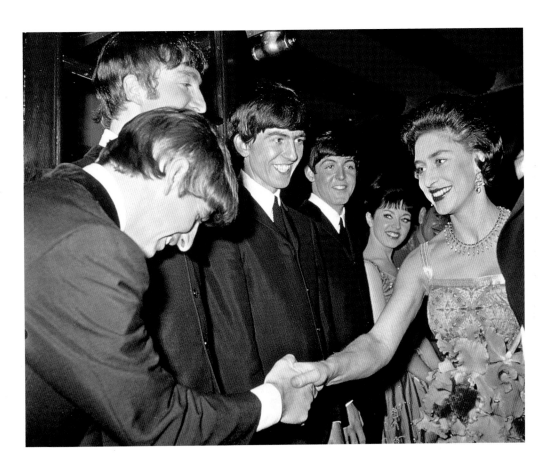

By appointment to…
The Beatles are presented to HRH Princess Margaret at the Royal Command
Performance. The star-studded line-up also included Marlene Dietrich and Tommy
Steele, but there is only one act that most people remember.
4th November, 1963

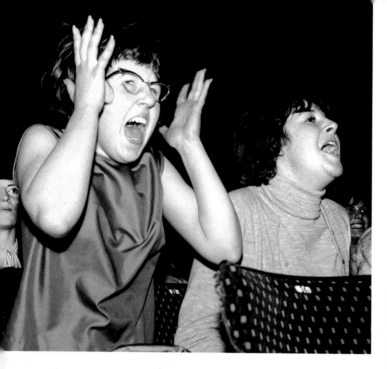
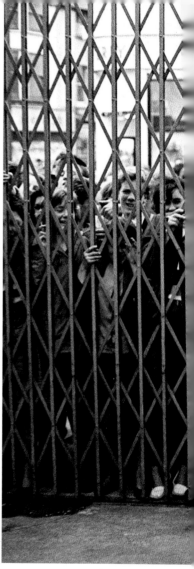

Beatlemania

Fans (particularly girls) would scream so loudly in the group's presence that it was sometimes impossible to hear what they were playing. The photograph shows the teens of Exeter, Devon following a national trend that would shortly sweep the world.
November 1963

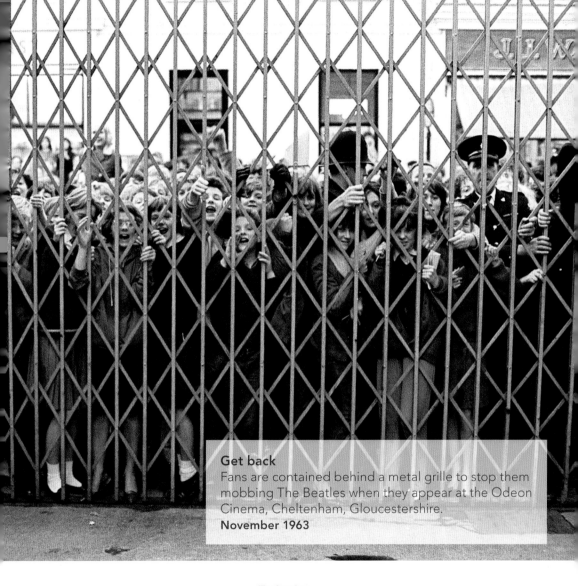

Get back
Fans are contained behind a metal grille to stop them mobbing The Beatles when they appear at the Odeon Cinema, Cheltenham, Gloucestershire.
November 1963

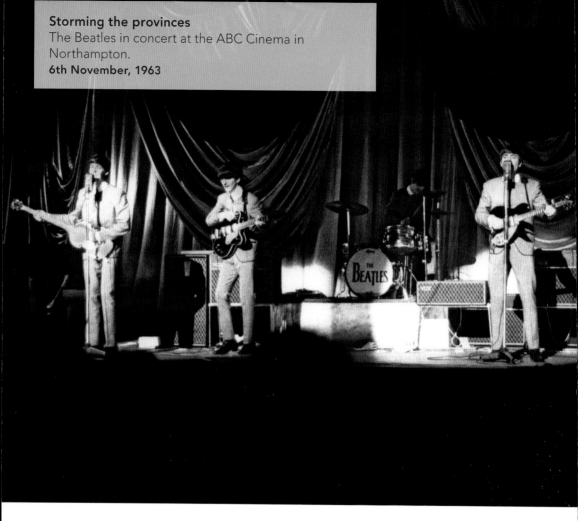

Storming the provinces
The Beatles in concert at the ABC Cinema in Northampton.
6th November, 1963

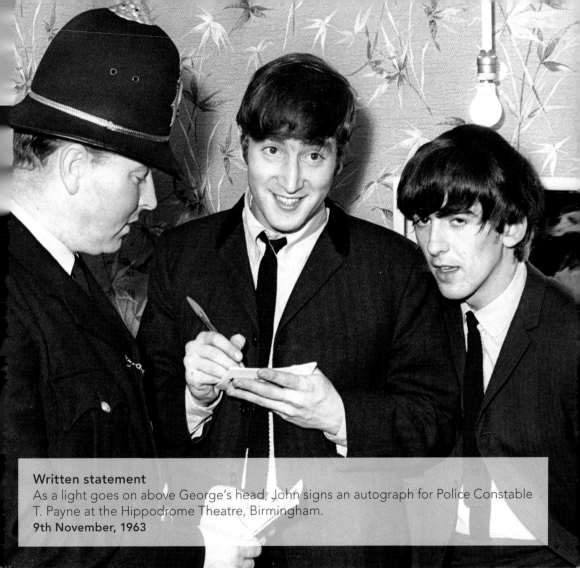

Written statement
As a light goes on above George's head, John signs an autograph for Police Constable
T. Payne at the Hippodrome Theatre, Birmingham.
9th November, 1963

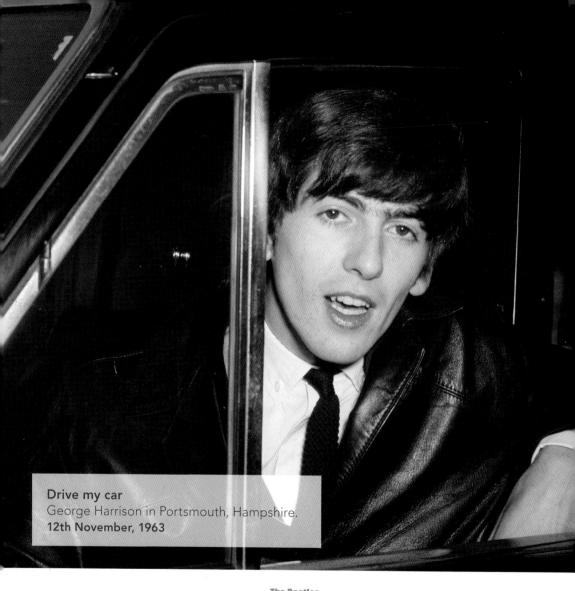

Drive my car
George Harrison in Portsmouth, Hampshire.
12th November, 1963

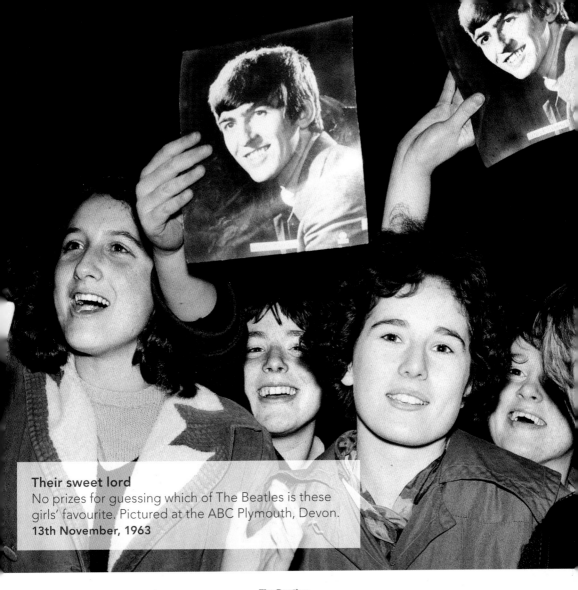

Their sweet lord
No prizes for guessing which of The Beatles is these
girls' favourite. Pictured at the ABC Plymouth, Devon.
13th November, 1963

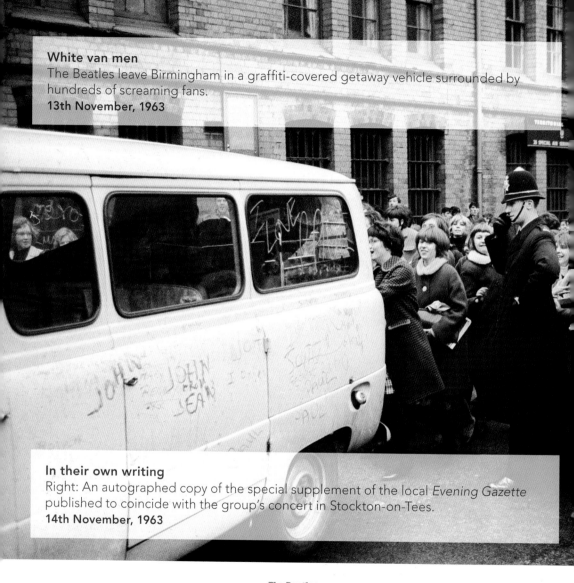

White van men
The Beatles leave Birmingham in a graffiti-covered getaway vehicle surrounded by hundreds of screaming fans.
13th November, 1963

In their own writing
Right: An autographed copy of the special supplement of the local *Evening Gazette* published to coincide with the group's concert in Stockton-on-Tees.
14th November, 1963

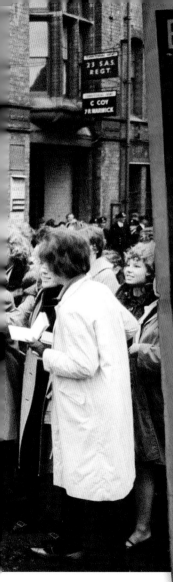

BEATIES

RINGO, GEORGE, PAUL AND JOHN

The biggest names in the business and here they are!

★

MORE FACTS & PHOTOS OF THE 'FAB 4' ARE INSIDE . . . PLUS A HOST OF INTERNATIONAL, NATIONAL AND LOCAL POP PERSONALITIES!

RINGO

GEORGE

PAUL

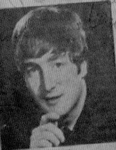

JOHN

THE BIGGEST, BRIGHTEST REVIEW OF THE BOUNCING WORLD OF 'POP' . . . AND ALL FOR 4d

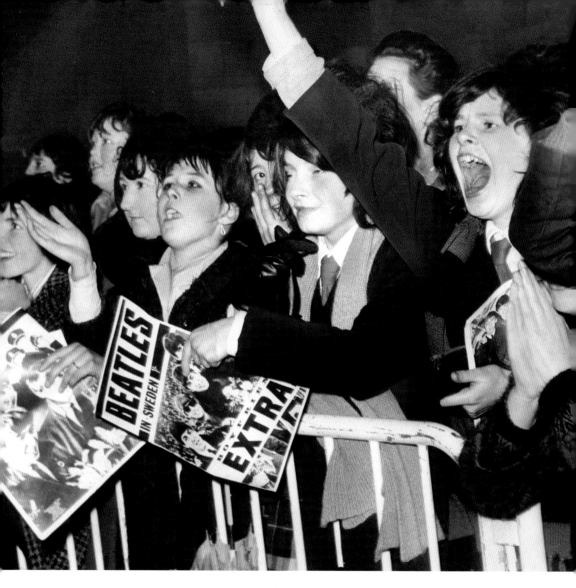

The Beatles

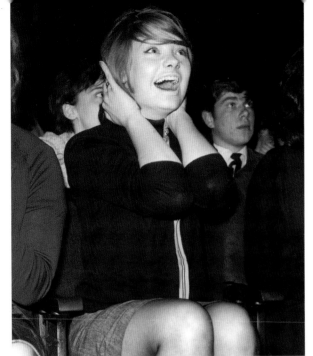

Waiting
Facing page: Another screaming welcome for The Beatles when they visited the Midlands again, this time for two shows at the Gaumont Theatre in Wolverhampton.
19th November, 1963

Watching
Left: A Beatles fan in ecstasy at the Manchester Apollo.
20th November, 1963

Queuing
Left: With duffel coats and food supplies in a bag, these Beatles fans queue for tickets in Newcastle Upon Tyne.
21st November, 1963

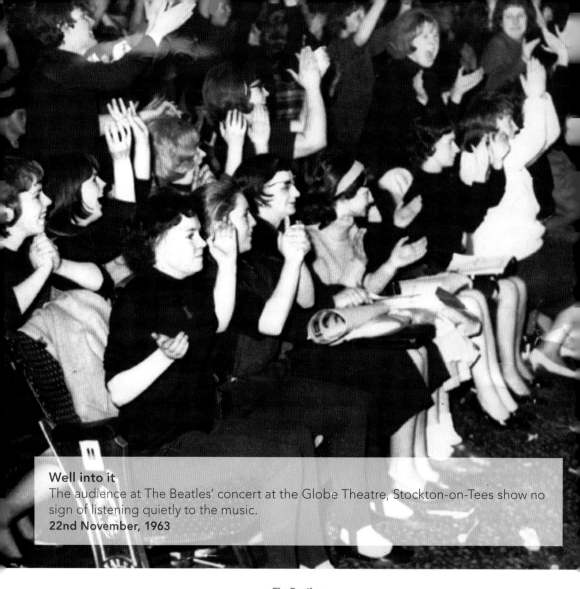

Well into it
The audience at The Beatles' concert at the Globe Theatre, Stockton-on-Tees show no sign of listening quietly to the music.
22nd November, 1963

… Went out front and had a smoke…
… all except Paul, who prefers a beer as The Beatles relax a bit before a performance in Huddersfield, Yorkshire.
29th November, 1963

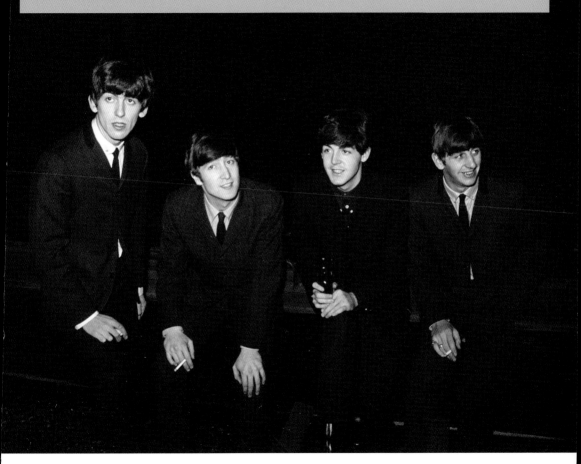

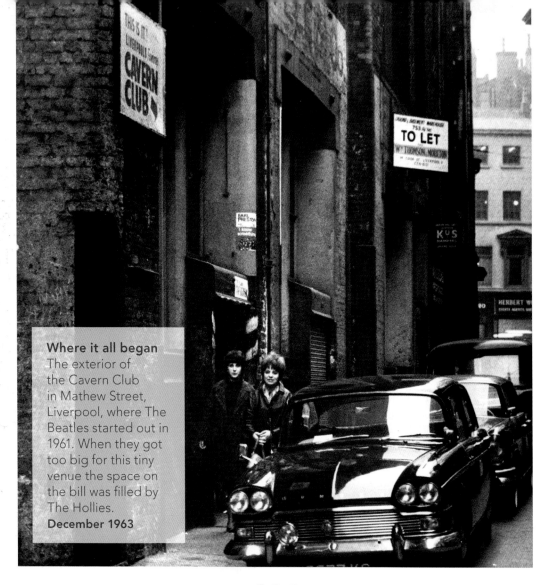

Where it all began
The exterior of the Cavern Club in Mathew Street, Liverpool, where The Beatles started out in 1961. When they got too big for this tiny venue the space on the bill was filled by The Hollies.
December 1963

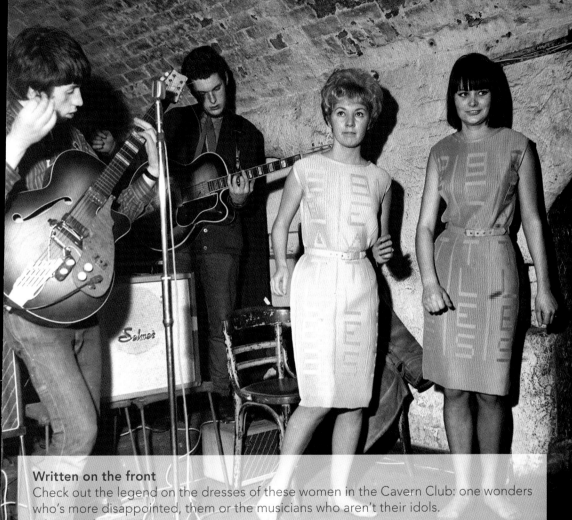

Written on the front
Check out the legend on the dresses of these women in the Cavern Club: one wonders who's more disappointed, them or the musicians who aren't their idols.
6th December, 1963

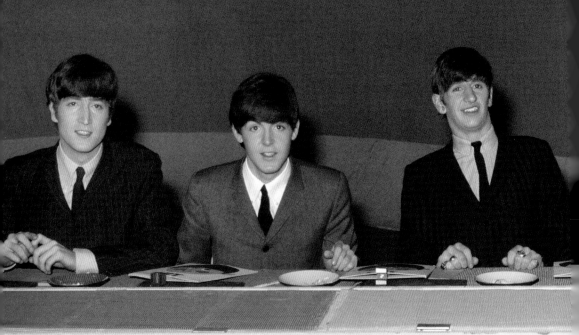

PAUL McCARTNEY

RINGO STARR

A Hit or A Miss?
The Beatles on the BBC TV show *Juke Box Jury*, hosted by David Jacobs. Among the acts whose singles they voted hits were Elvis Presley, The Swinging Blue Jeans and Billy Fury; among those they disliked were old-style crooners Paul Anka and Bobby Vinton.
7th December, 1963

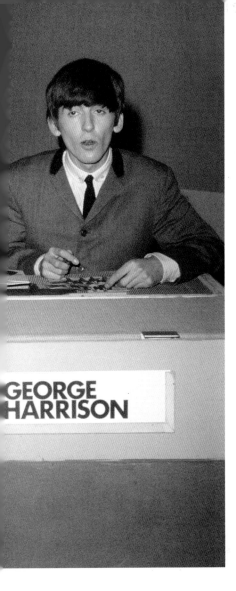

GEORGE
HARRISON

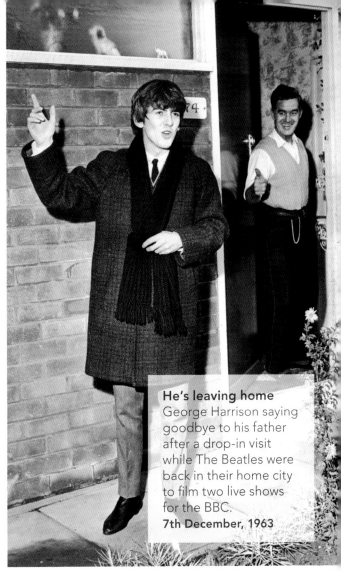

He's leaving home
George Harrison saying
goodbye to his father
after a drop-in visit
while The Beatles were
back in their home city
to film two live shows
for the BBC.
7th December, 1963

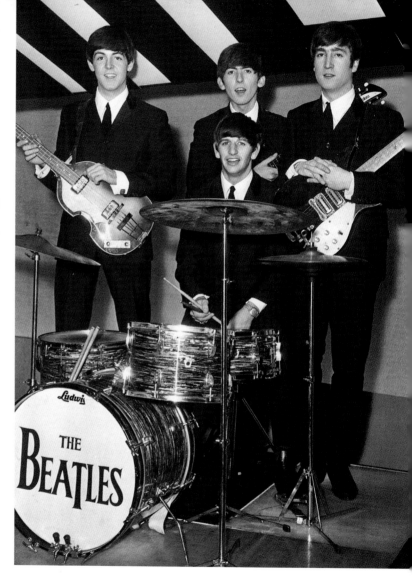

Caught before the act
The Beatles stand still for a publicity photograph during rehearsals for a performance on Associated Television (ATV; part of the ITV network) at the station's studios in Aston, Birmingham.
15th December, 1963

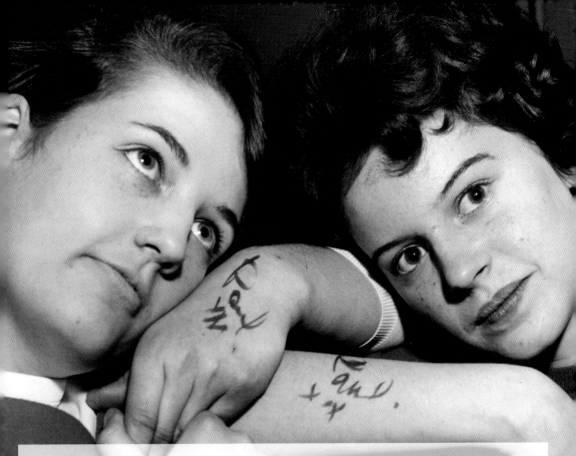

'We'll never wash it off'
When Cheryl Fellows (L) and Carol Young (R) won a *Birmingham Evening Mail* competition – first prize, meeting The Beatles – they got even more than they wished for when Paul McCartney autographed their hands and arms.
15th December, 1963

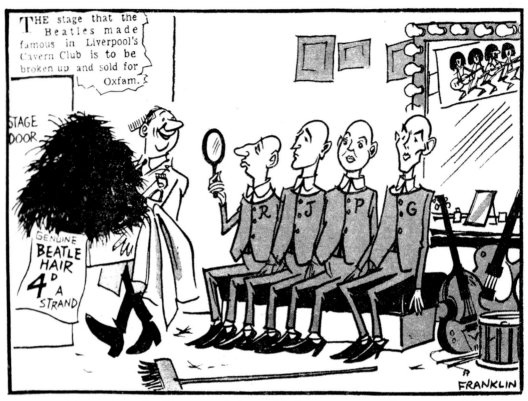

THE stage that the Beatles made famous in Liverpool's Cavern Club is to be broken up and sold for Oxfam.

"Thanks, fellows, it's all for a good cause."

Fourpence a strand
This was the *Daily Mirror* cartoonist's take on the
announcement that the stage at Liverpool's Cavern Club was
to be broken up and sold, with the profits going to Oxfam.
31st December, 1963

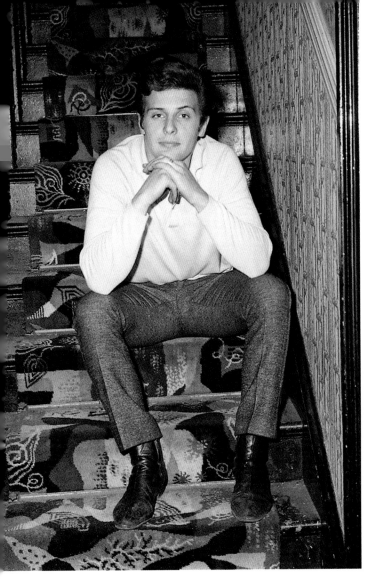

The Fifth Beatle (3)

Pete Best was The Beatles' original drummer, playing with them on their first series of dates in Hamburg, Germany, and remaining with them until he was replaced by Ringo Starr on 16th August, 1962.
1964

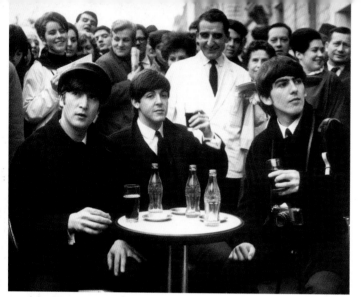

Trois Coca-Colas, s'il vous plaît

John, Paul and George enjoy a glass of the world's most famous fizzy non-alcoholic drink at a street café in Paris while they await the arrival of Ringo, whose flight had been delayed by fog at Liverpool Airport.
14th January, 1964

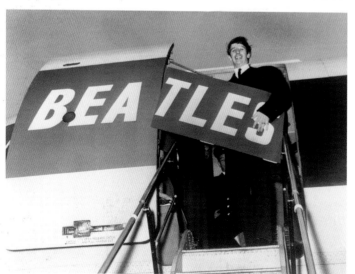

Four-letter joke

When Ringo Starr landed at Orly Airport the following day he emerged from the plane with a placard identifying the one thing better than British European Airways (BEA).
15th January, 1964

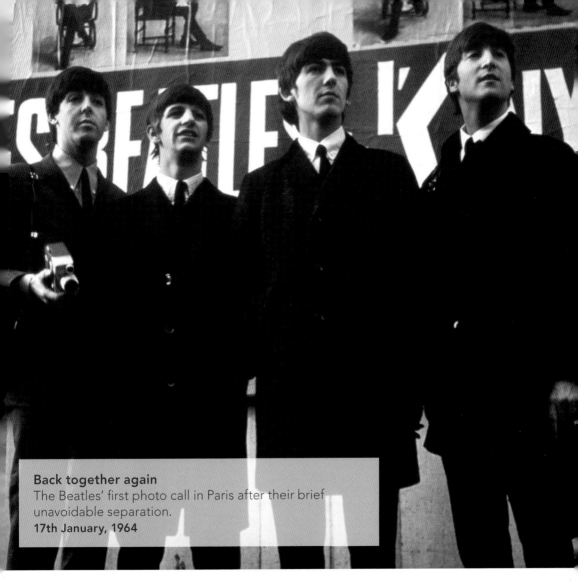

Back together again
The Beatles' first photo call in Paris after their brief
unavoidable separation.
17th January, 1964

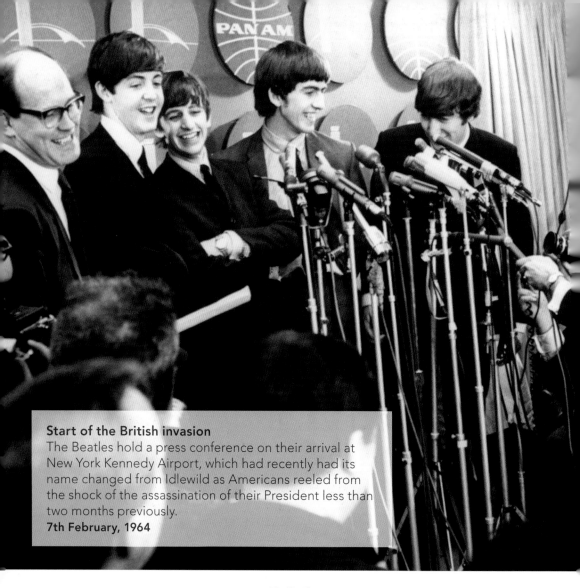

Start of the British invasion
The Beatles hold a press conference on their arrival at
New York Kennedy Airport, which had recently had its
name changed from Idlewild as Americans reeled from
the shock of the assassination of their President less than
two months previously.
7th February, 1964

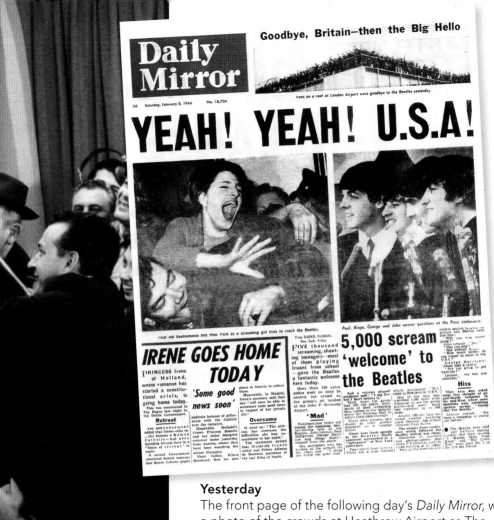

Daily Mirror

3d. Saturday, February 8, 1964 No. 18,704

Goodbye, Britain—then the Big Hello

Fans on a roof at London Airport wave goodbye to the Beatles yesterday.

YEAH! YEAH! U.S.A!

That old Beatlemania hits New York as a screaming girl tries to reach the Beatles.

Paul, Ringo, George and John answer questions at the Press conference.

IRENE GOES HOME TODAY

PRINCESS Irene of Holland, whose romance has started a constitutional crisis, is going home today.

This was announced in The Hague last night by the Dutch Government.

Retreat

The announcement added that Irene—who recently became a Roman Catholic—had been spending several days in the "house of retreat" in Spain.

A second Government statement denied rumours that Queen Juliana might

'Some good news soon'

plane to Austria to collect them.

Meanwhile, in Madrid, Irene's secretary said that she "will soon be able to announce some good news in respect of her private life."

Overcome

It went on: "The princess has overcome the difficulties she had encountered in her spirit."

The statement denied that 24-year-old Irene's suitor was Prince Alfonso of Bourbon, grandson of the last King of Spain.

abdicate because of differences with the Cabinet over the romance.

Meanwhile Holland's Crown Princess Beatrix and her sister Margriet returned home yesterday from Austria, where they have been watching the winter Olympics.

Their father, Prince Bernhard, flew his own

From BARRIE HARDING New York, Friday

FIVE thousand screaming, chanting teenagers—most of them playing truant from school —gave the Beatles a fantastic welcome here today.

More than 100 extra police were on duty to control the crowd as the group's jet landed at the John F. Kennedy Airport.

'Mad'

Pandemonium broke out among the stamping, leather-waving fans as the Beatles—John Lennon, Paul McCartney, George Harrison and Ringo Starr—stepped from the plane.

One policeman who has worked at the airport for ten years said: "I think the crowd has gone mad.

5,000 scream 'welcome' to the Beatles

And a veteran airport employee said: "I say it—but I don't believe it."

Then, when the group had left the plane, thousands of their screaming fans rushed to the balcony above the Customs Hall to watch them pass through.

There were screams and shouts as their guitars appeared on a luggage trolley.

There were fresh squeals as the Beatles finally appeared, surrounded by a "bodyguard" of New York policemen.

Fans waved huge posters. There was a huge banner

which proclaimed: "We come to Beatlesville, U.S.A."

One of the fans had travelled 1,500 miles from Arkansas to see the group. Many more had travelled up to 300 miles.

Airport officials said the crowd rivalled anything since General MacArthur returned from Korea.

The airport Press conference, which followed the Beatles' arrival was chaotic. Hundreds of reporters and photographers, plus seven TV cameras, had the room bursting at the seams.

Part of the question-and-

answer session to some reporters and Beatles went like this :—

John Lennon : "No !"
"Can you sing ?"
"No, without money."
"How much money ?"
"We expect to mean in the U.S.A ?"

George Harrison : "About half a crown."
"Are you going to get haircuts ?"

Lennon : "we had one yesterday."

Hits

They were also asked what they thought of an anti-Beatle campaign in the mid-West, where some motorists were exhibiting stickers saying : "Stamp Out The Beatles."

Lennon replied : "We have a campaign to stamp out Detroit."

● The Beatles were today just before leaving London that their records "I Wanna Hold Your Hand" and "She Loves You" were just No. 1 in the US Hit Parade.

Yesterday
The front page of the following day's *Daily Mirror*, with a photo of the crowds at Heathrow Airport as The Beatles left London.
8th February, 1964

Stand By Me
In rehearsal for *The Ed Sullivan Show*, The Beatles' longtime personal assistant Neil Aspinall (C) stands in for George Harrison, who was saving his voice for the live performance.
9th February 1964

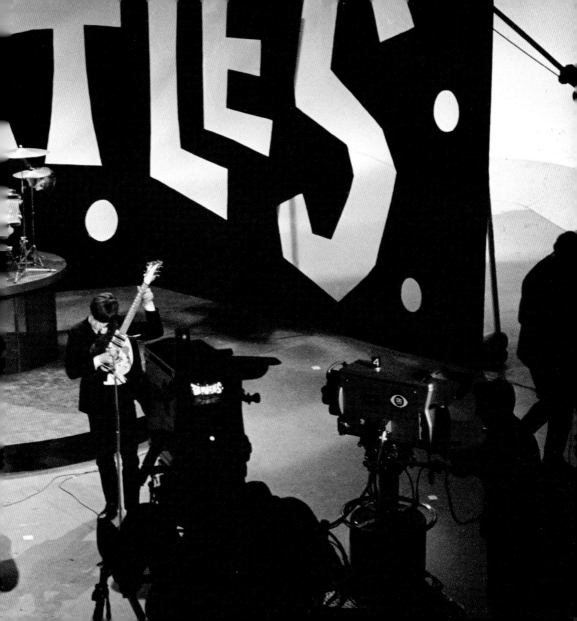

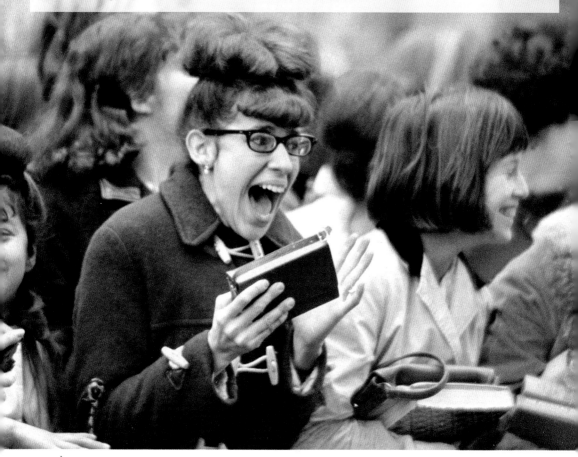

Loud American
George's throat infection has evidently not been passed to this fan on the streets of New York awaiting a glimpse of The Beatles.
9th February, 1964

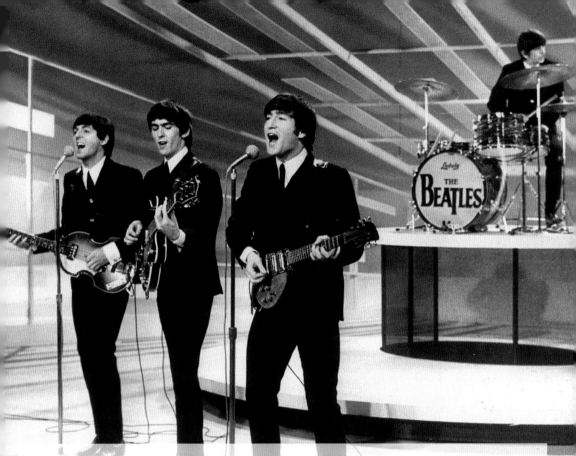

Going out across the nation
The first of The Beatles' three consecutive live Sunday performances on *The Ed Sullivan Show* attracted 73 million viewers. The high point of each show was their current US No. 1, *I Want To Hold Your Hand*.
9th February, 1964

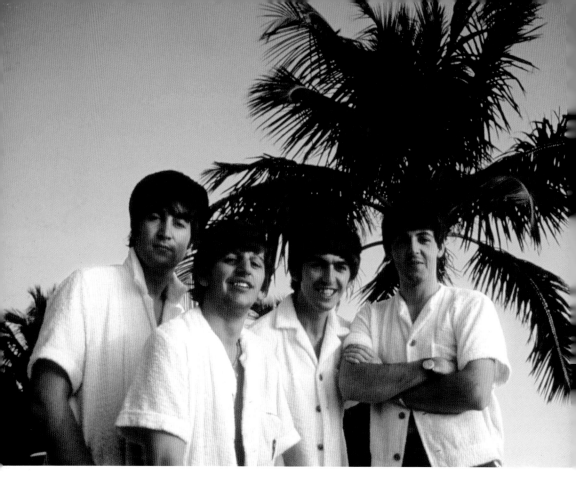

Valentine's Day
The Beatles chill out at the Deauville Hotel, Miami
Beach, Florida.
14th February, 1964

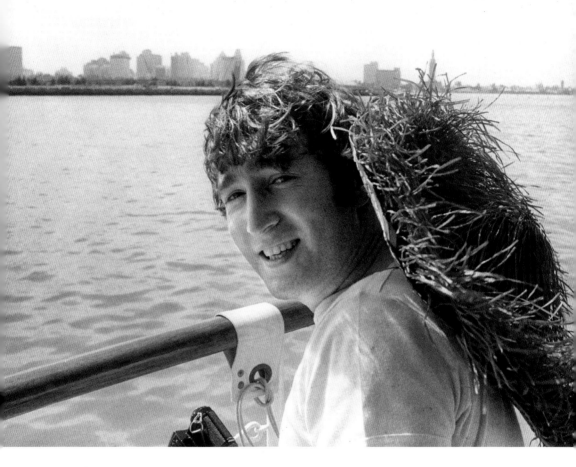

Boat and Boater
John Lennon wearing a natty and no doubt itchy grass
and straw bonnet in Miami, Florida.
17th February, 1964

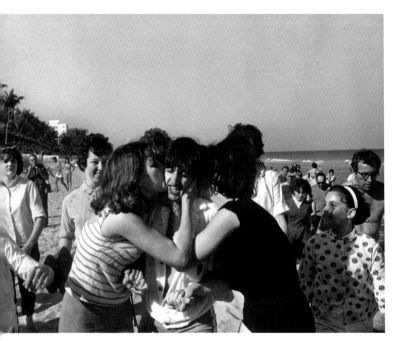

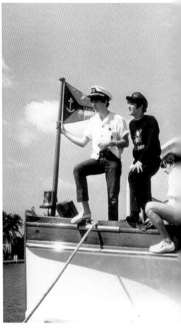

The cheek of it
Ringo is grabbed by two
high school girls on the
beach in Miami, Florida.
18th February, 1964

Day trippers
The Beatles on the deck
of the yacht on which
they made a five-hour trip
around Miami, Florida.
18th February, 1964

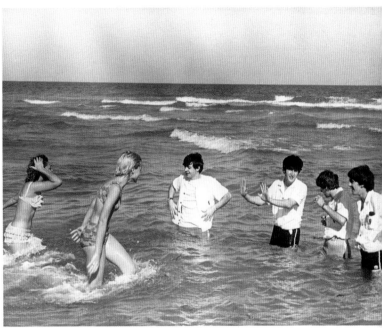

Sea creatures
The Beatles pretend they don't know how to react to these high school girls in the sea off Miami, Florida.
18th February, 1964

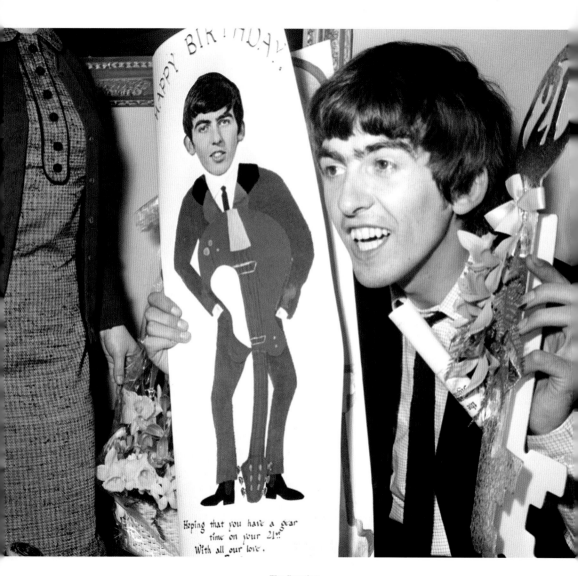

HAPPY BIRTHDAY

Hoping that you have a gear
time on your 21st.
With all our love.

You say it's your birthday...
Left: George Harrison
holding the key of the door
on his 21st.
25 February, 1964

Model image
John Lennon shows off
an effigy that he made
of himself. Some people
found it a bit disturbing,
but it doesn't seem to
faze its creator:
art is meant to shock.
c.1964

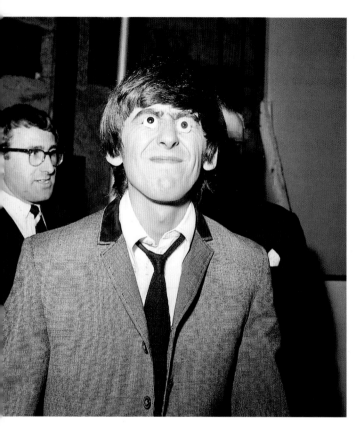

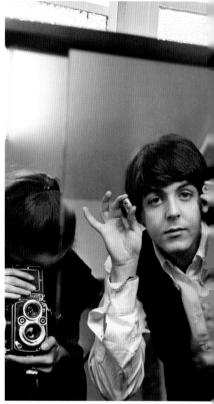

Socket to them
George Harrison with glass eyes while The Beatles'
details were being taken for Madame Tussaud's
during the filming of *A Hard Day's Night* at
Twickenham Film Studios.
12th March, 1964

Eyedentity check
Paul McCartney holds up his
waxwork's eyes so that they
can be compared with the
real things.
12th March, 1964

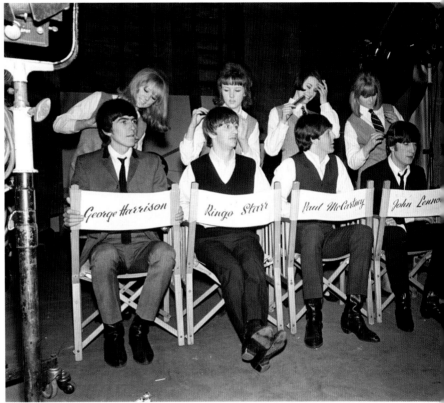

Comb Together

As The Beatles pose for photographs during filming of *A Hard Day's Night* at Madame Tussaud's in London, stylists make sure that none of them has a hair out of place.

12th March, 1964

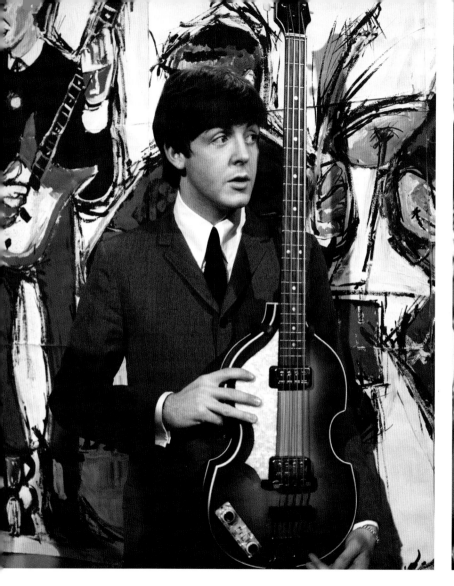

The Beatles

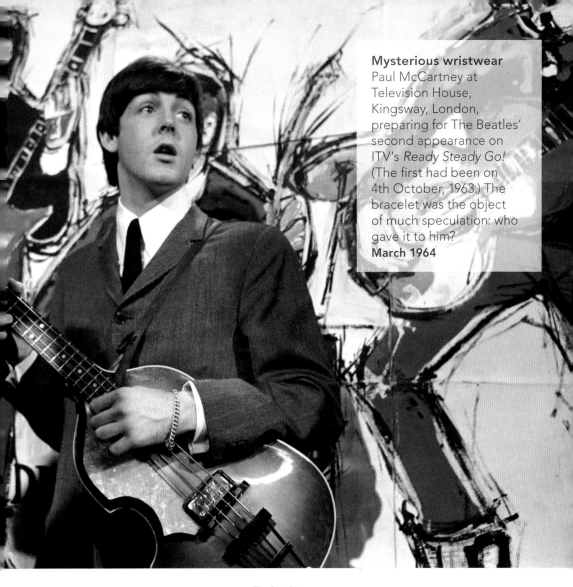

Mysterious wristwear
Paul McCartney at
Television House,
Kingsway, London,
preparing for The Beatles'
second appearance on
ITV's *Ready Steady Go!*
(The first had been on
4th October, 1963.) The
bracelet was the object
of much speculation: who
gave it to him?
March 1964

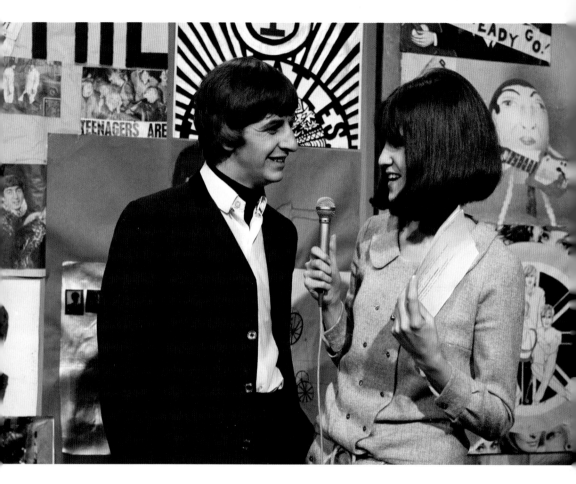

Queen of the Mods
Ringo Starr interviewed on *Ready Steady Go!* by hostess Cathy McGowan, the fan-turned-compère who, in the view of many, made it cool to be uncool.
20th March, 1964

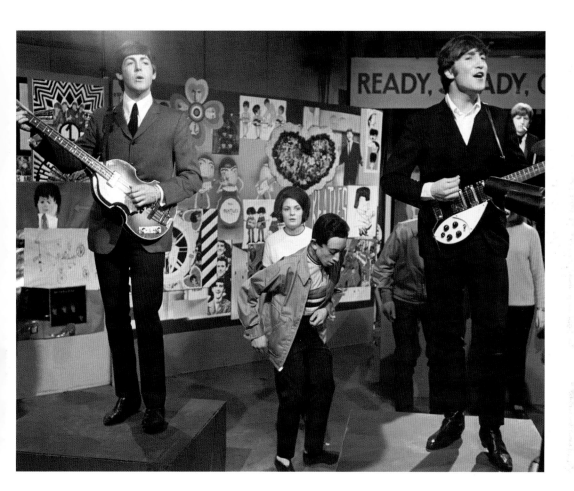

Unplugged

On *Ready Steady Go!* The Beatles performed *It Won't Be Long*, *You Can't Do That* and their No. 1 *Can't Buy Me Love*. Note the absence of wiring: that's because they mimed.
20th March, 1964

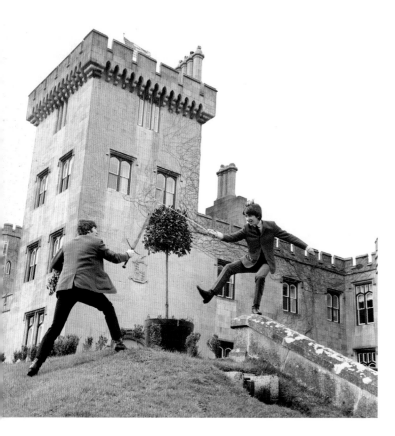
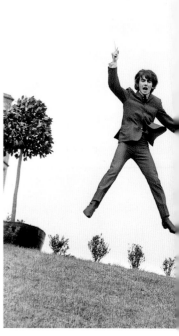

Two musketeers
John Lennon and George Harrison fool around in the
grounds of Dromoland Castle in Ireland, where they
went for an Easter holiday.
27th March, 1964

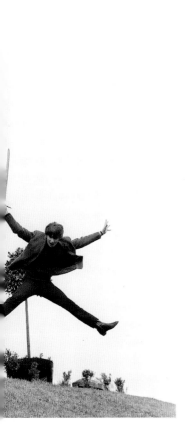

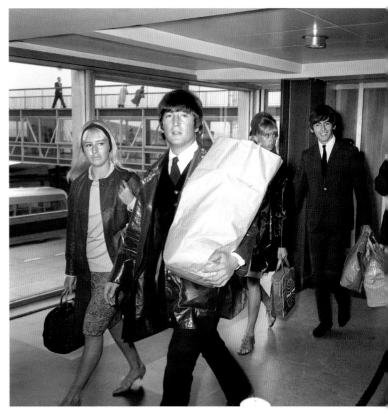

Back to reality

John Lennon and his wife Cynthia head George Harrison
and his girlfriend Patti Boyd through London Heathrow
Airport on their return from Dublin.
May 1964

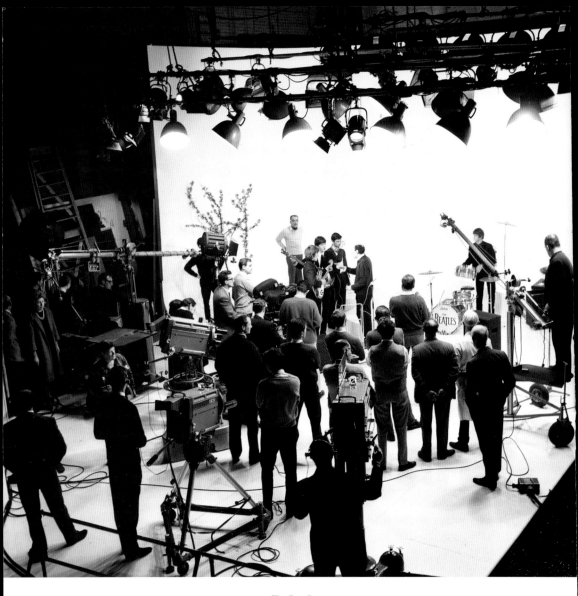

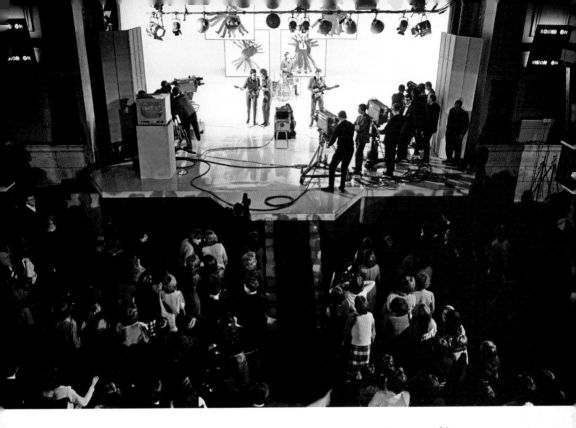

'You know I work all day...'
Left: The Beatles filming the finale of *A Hard Day's Night* at the Scala Theatre off Tottenham Court Road in London.
31st March, 1964

Filming a film
Still from a BBC TV documentary about the making of *A Hard Day's Night*.
March 1964

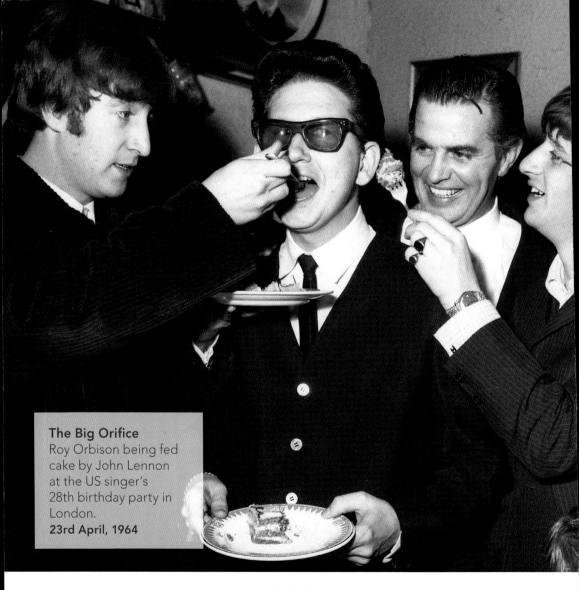

The Big Orifice
Roy Orbison being fed cake by John Lennon at the US singer's 28th birthday party in London.
23rd April, 1964

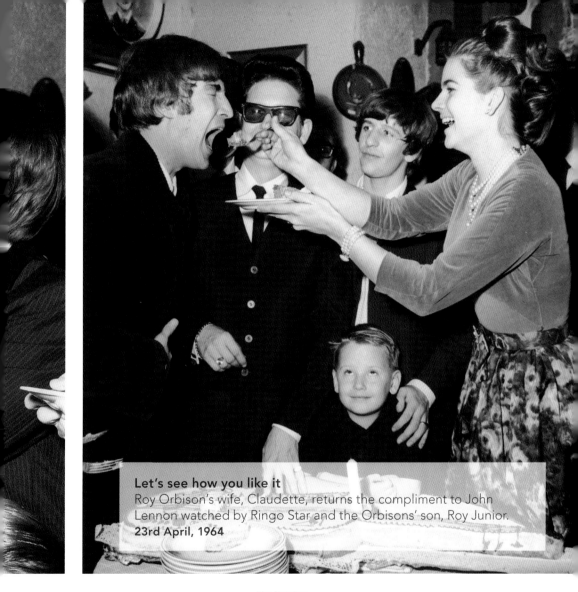

Let's see how you like it
Roy Orbison's wife, Claudette, returns the compliment to John Lennon watched by Ringo Star and the Orbisons' son, Roy Junior.
23rd April, 1964

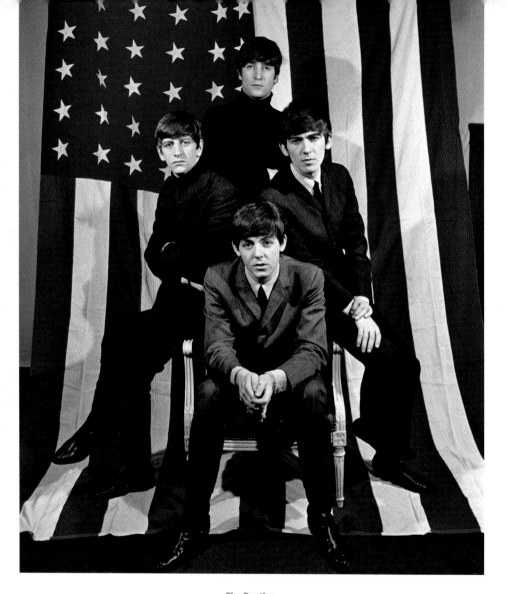

The Beatles

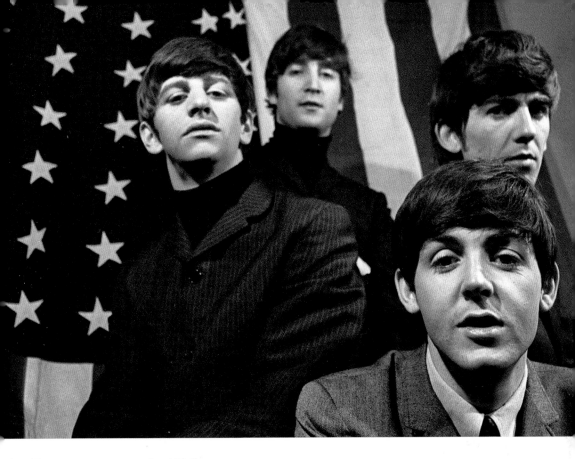

Four new stars on the US flag
The Beatles pose for publicity photographs ahead of
their first US tour, a demanding 34-day itinerary with 32
shows in 24 cities, due to commence in August 1964.
April 1964

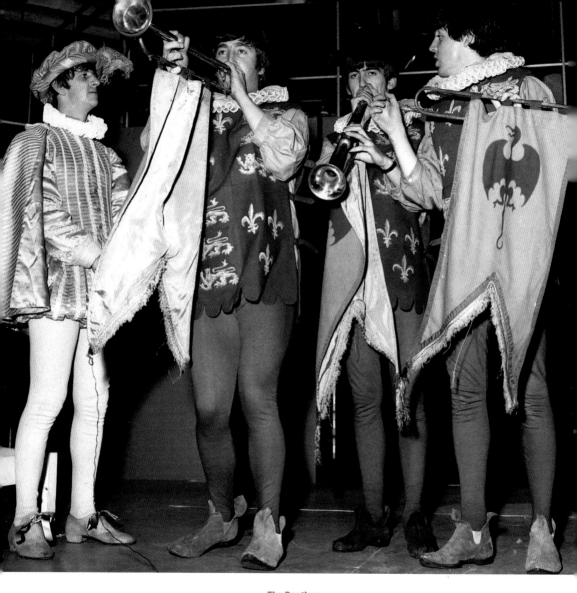

The Beatles

Remaking history
The Beatles in *Around The Beatles*, a TV spectacular recorded at Rediffusion's studios in Wembley, London. While John, George and Paul play heralds, Ringo Starr appears as Sir Francis Drake, firing a cannon at the start of the show.
28th April, 1964

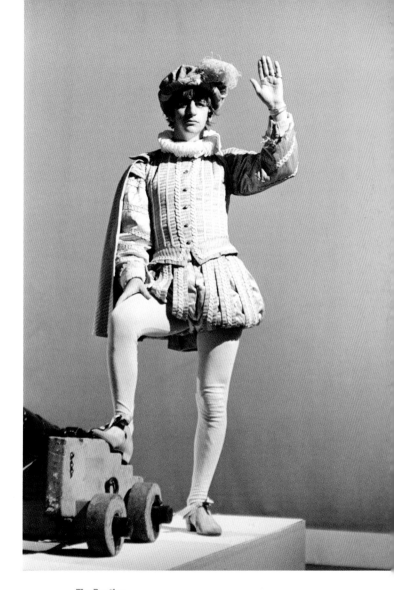

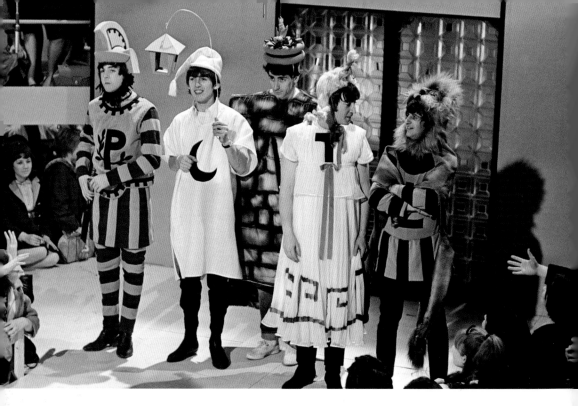

Rude mechanicals
Part of a TV special *Around The Beatles*, filmed at Rediffusion's Wembley Studios, included a spoof of Shakespeare's *A Midsummer Night's Dream* with John (second R) in the female role of Thisbe, love interest to Paul's Pyramus (L), with George (second L) as Moonshine and Ringo (R) as Lion.
28th April, 1964

Group activity
Right: The musical set of *Around The Beatles* featured the four in more familiar garb, miming to a medley of earlier hits and recent singles recorded ten days earlier. They ended with a version of The Isley Brothers' *Shout*.
28th April, 1964

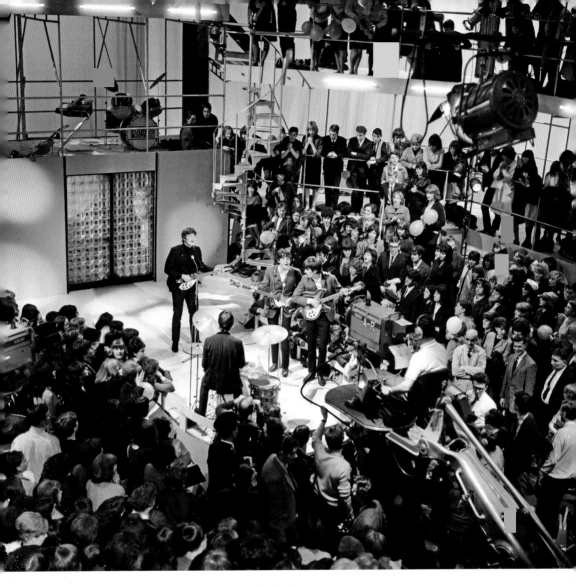

The Beatles

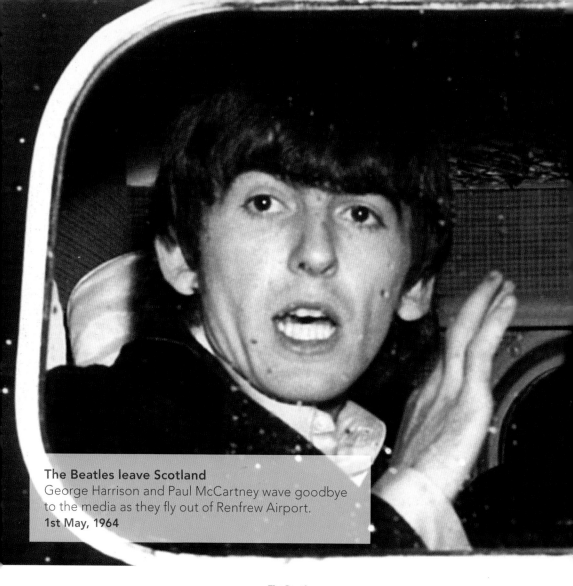

The Beatles leave Scotland
George Harrison and Paul McCartney wave goodbye
to the media as they fly out of Renfrew Airport.
1st May, 1964

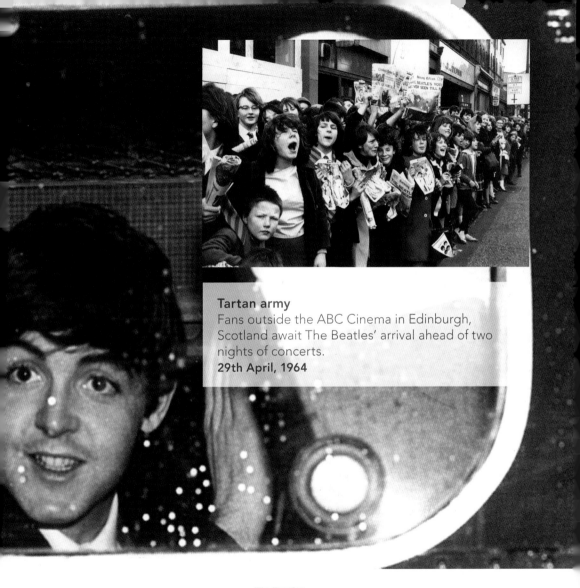

Tartan army
Fans outside the ABC Cinema in Edinburgh, Scotland await The Beatles' arrival ahead of two nights of concerts.
29th April, 1964

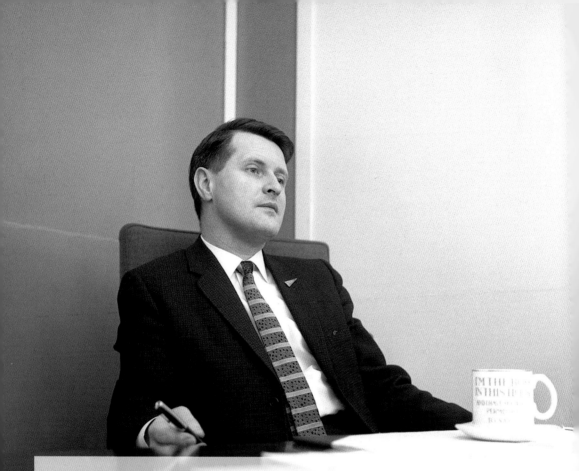

'Wonderlust for your trousers'
Ray McFall in his office at the Cavern Club, which he purchased in 1959. He didn't like acts that appeared on stage in jeans.
15th May, 1964

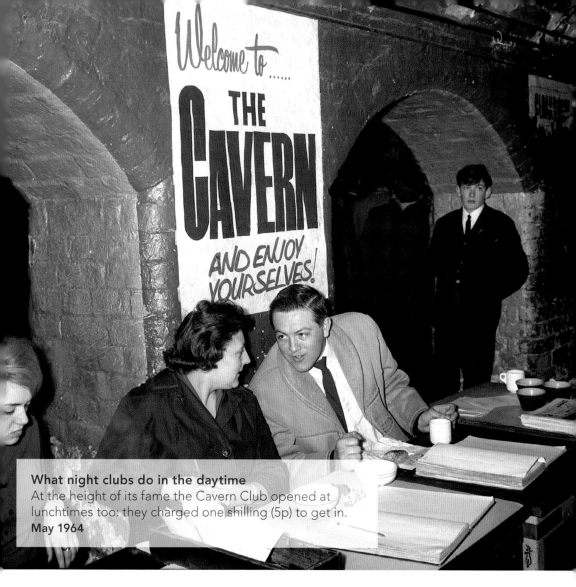

What night clubs do in the daytime
At the height of its fame the Cavern Club opened at
lunchtimes too: they charged one shilling (5p) to get in.
May 1964

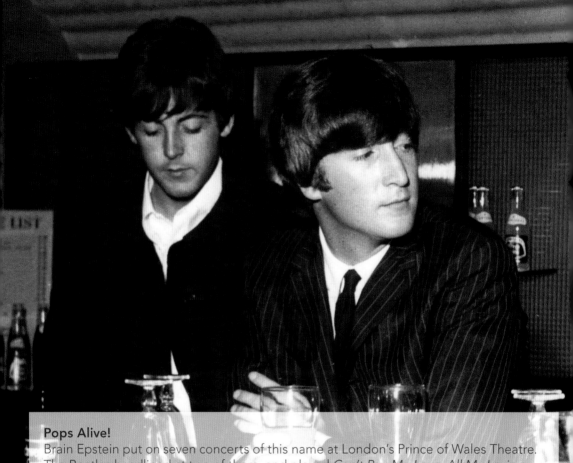

Pops Alive!
Brain Epstein put on seven concerts of this name at London's Prince of Wales Theatre. The Beatles headlined at two of them, and played *Can't Buy Me Love*, *All My Loving*, *This Boy*, *Roll Over Beethoven*, *Till There Was You*, *Twist and Shout* and *Long Tall Sally*. Here the group relax at the bar after their first night at the venue.
31st May, 1964

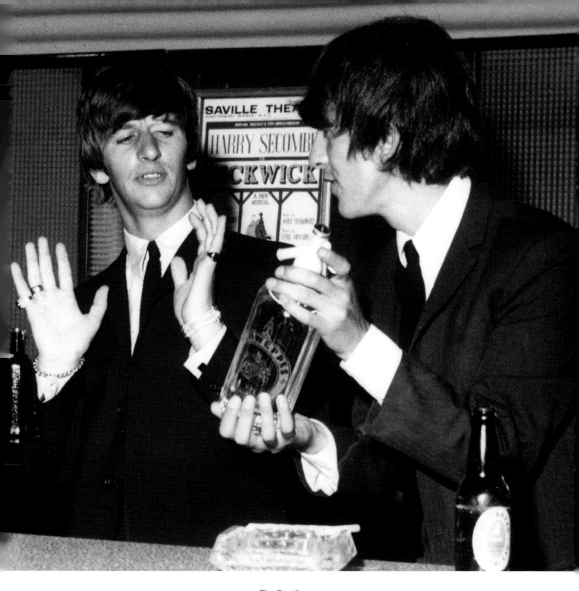

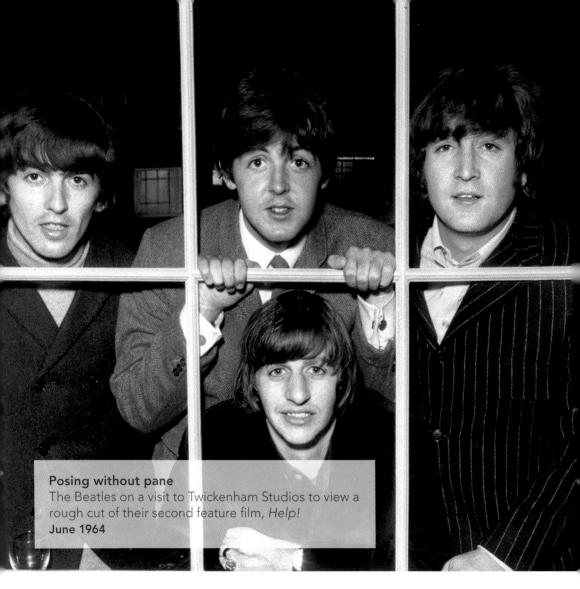

Posing without pane
The Beatles on a visit to Twickenham Studios to view a
rough cut of their second feature film, *Help!*
June 1964

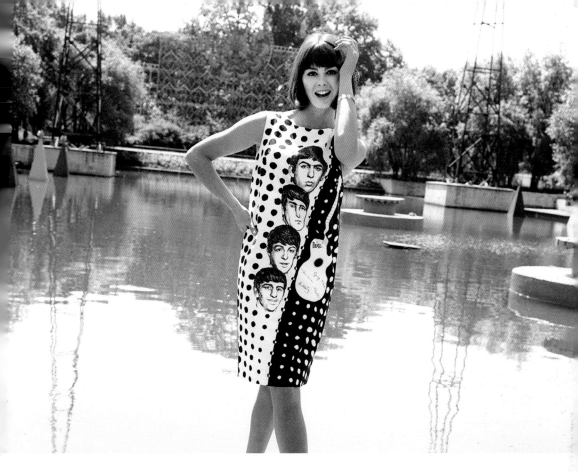

Dress for success

In London's Battersea Park Funfair, fashion model Sandy Hilton shows off C&A's latest effort to cash in on The Beatles' popularity.

9th June, 1964

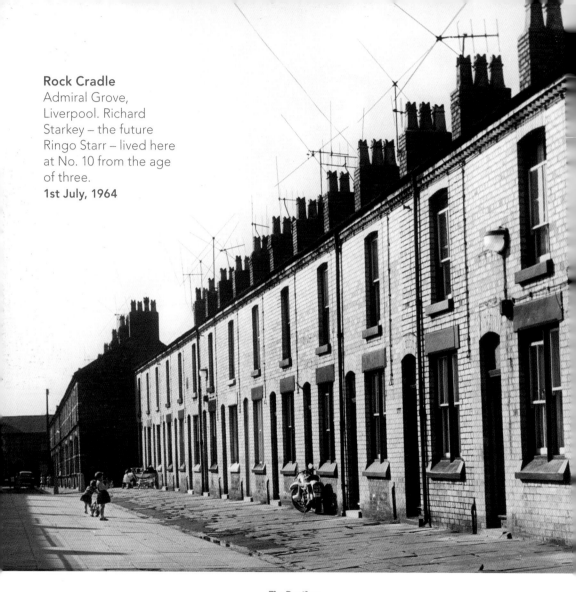

Rock Cradle
Admiral Grove,
Liverpool. Richard
Starkey – the future
Ringo Starr – lived here
at No. 10 from the age
of three.
1st July, 1964

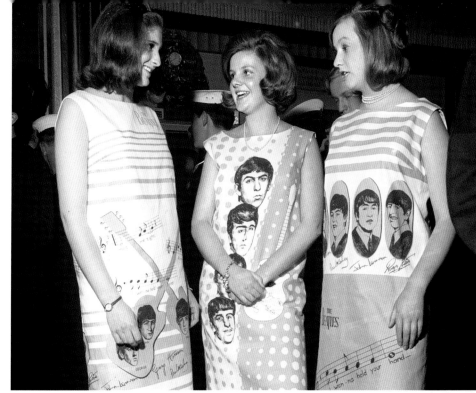

Show of allegiance
Fans Jane Cameron, Rosemary Elphinstone and Phillippa Van
Steraubenzeezo wear Beatles dresses to the royal charity première
of *A Hard Day's Night* at the London Pavilion.
6th July, 1964

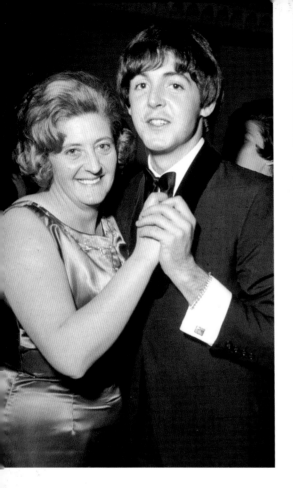

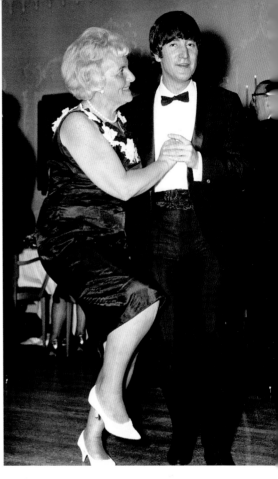

Family affair
Paul McCartney dances with his Aunt
Joan at an after-show reception at The
Dorchester Hotel.
6th July, 1964

Never too ole to rock 'n' roll
John Lennon takes the floor with George
Harrison's mother, Louise.
6th July, 1964

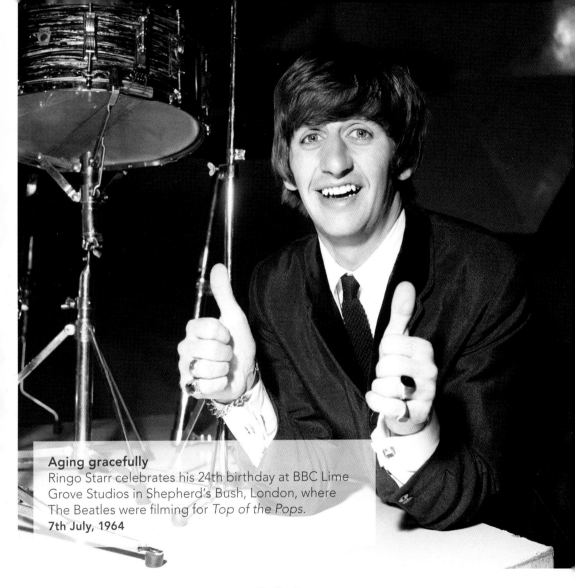

Aging gracefully
Ringo Starr celebrates his 24th birthday at BBC Lime Grove Studios in Shepherd's Bush, London, where The Beatles were filming for *Top of the Pops*.
7th July, 1964

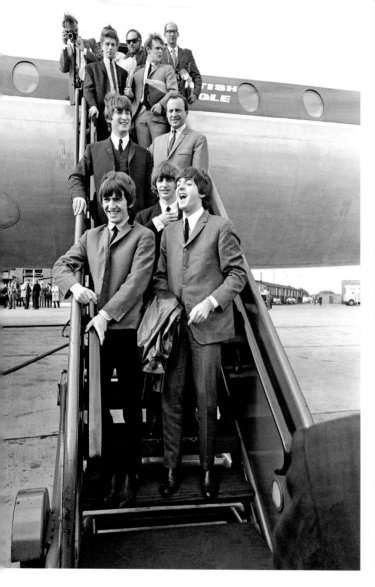

The Beatles

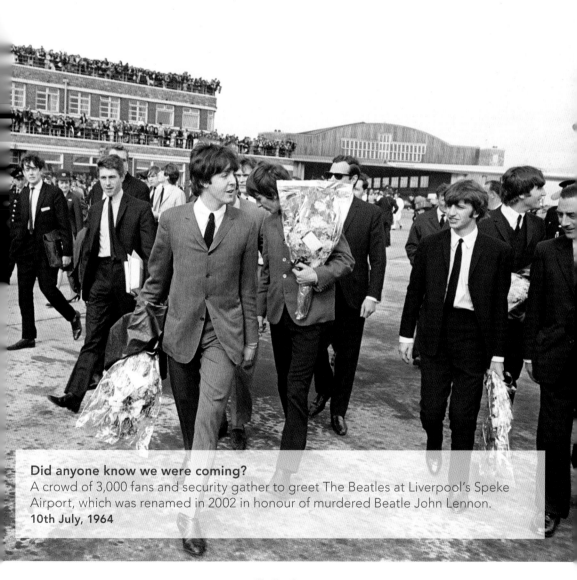

Did anyone know we were coming?
A crowd of 3,000 fans and security gather to greet The Beatles at Liverpool's Speke Airport, which was renamed in 2002 in honour of murdered Beatle John Lennon.
10th July, 1964

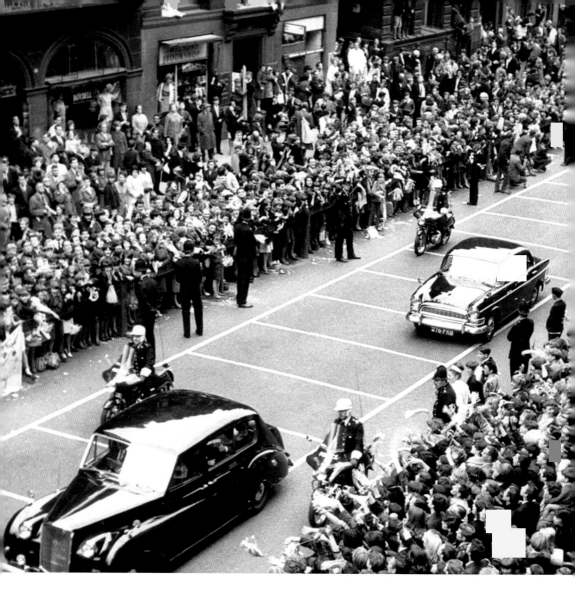

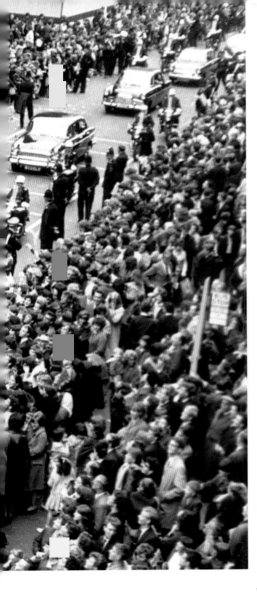

Stately progress
The Beatles are driven down Castle Street en route to Liverpool Town Hall on the evening of the northern première of *A Hard Day's Night*.
10th July, 1964

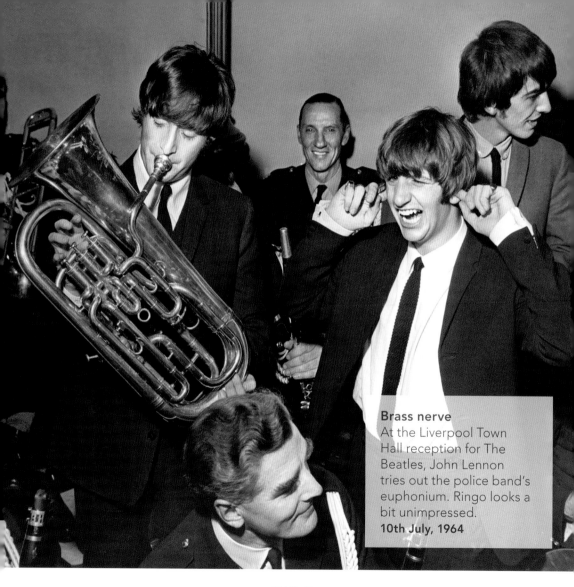

Brass nerve
At the Liverpool Town Hall reception for The Beatles, John Lennon tries out the police band's euphonium. Ringo looks a bit unimpressed.
10th July, 1964

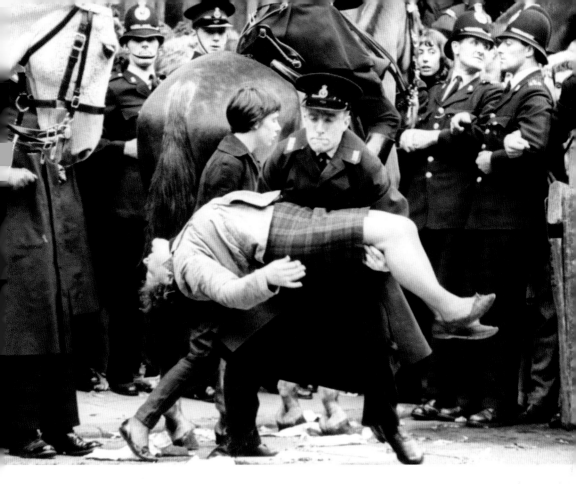

Passing-out ceremony
A girl being carried away by an ambulance man after
she has fainted with excitement at seeing The Beatles
outside Liverpool Town Hall.
10th July, 1964

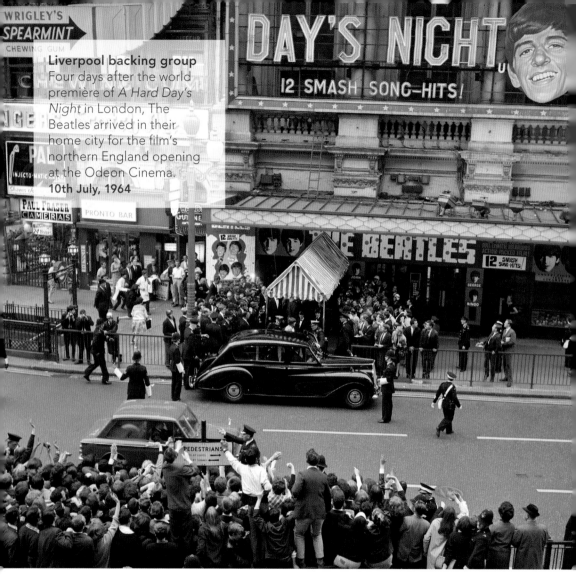

Liverpool backing group
Four days after the world premiere of *A Hard Day's Night* in London, The Beatles arrived in their home city for the film's northern England opening at the Odeon Cinema.
10th July, 1964

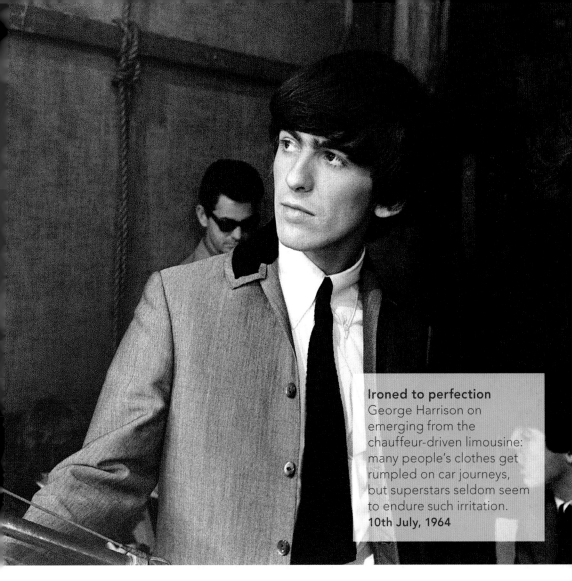

Ironed to perfection
George Harrison on
emerging from the
chauffeur-driven limousine:
many people's clothes get
rumpled on car journeys,
but superstars seldom seem
to endure such irritation.
10th July, 1964

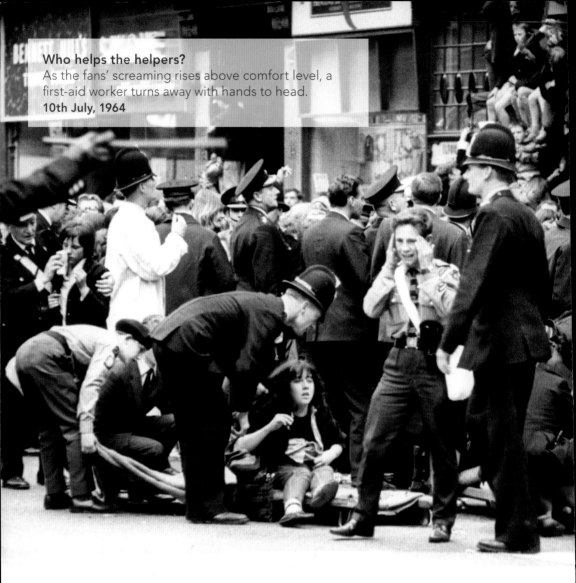

Who helps the helpers?

As the fans' screaming rises above comfort level, a
first-aid worker turns away with hands to head.
10th July, 1964

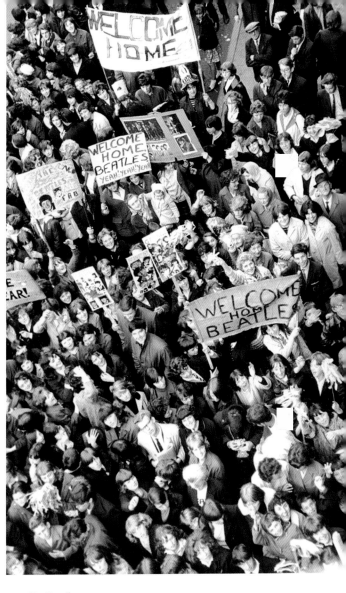

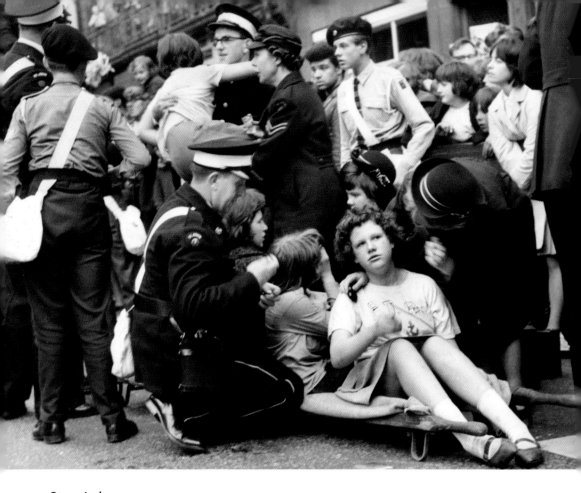

Stars in her eyes

The faraway look in this girl's eyes makes one wonder if she is taking in anything that's being said to her. For Liverpool police and ambulance workers, *A Hard Day's Night* had turned into a pretty tough assignment.

10th July, 1964

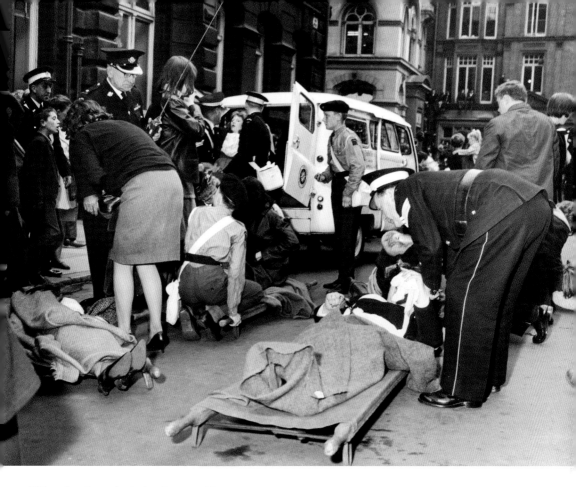

Why do they do it in the road?
Further casualties outside the Liverpool Odeon. At first,
the authorities were bemused by this increasingly common
side-effect of Beatlemania but they quickly learned to cope.
10th July, 1964

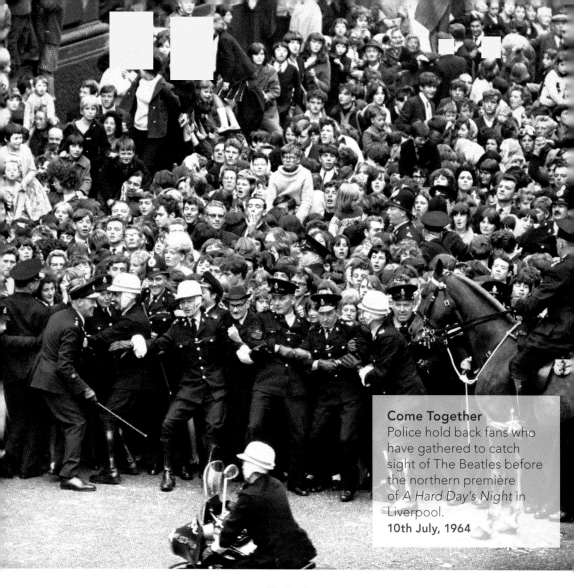

Come Together
Police hold back fans who have gathered to catch sight of The Beatles before the northern première of *A Hard Day's Night* in Liverpool.
10th July, 1964

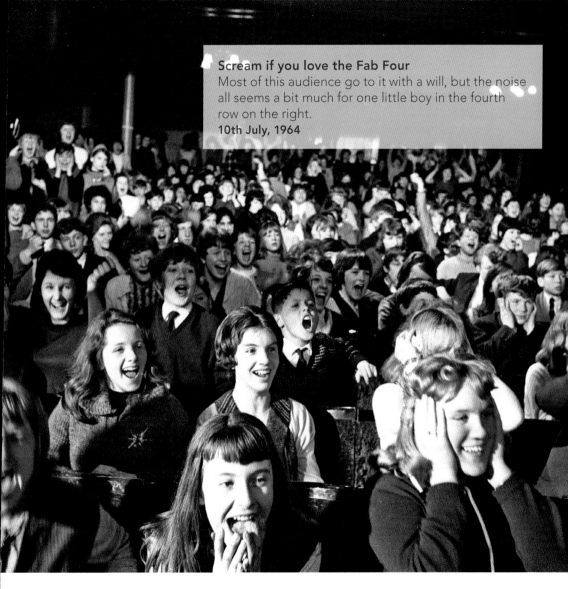

Scream if you love the Fab Four
Most of this audience go to it with a will, but the noise all seems a bit much for one little boy in the fourth row on the right.
10th July, 1964

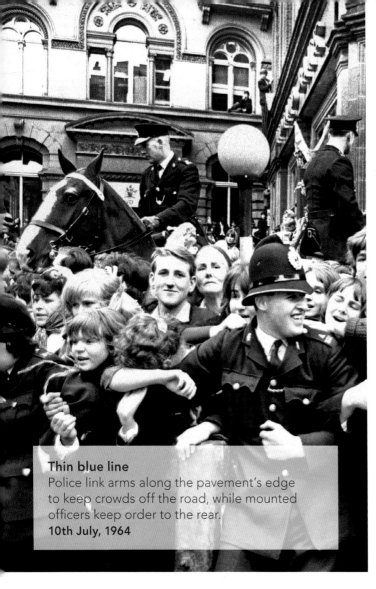
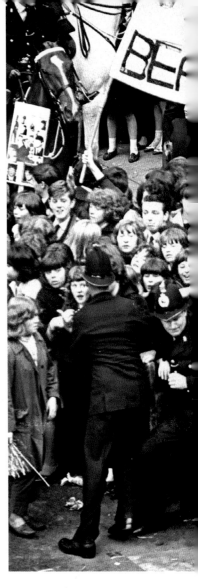

Thin blue line
Police link arms along the pavement's edge to keep crowds off the road, while mounted officers keep order to the rear.
10th July, 1964

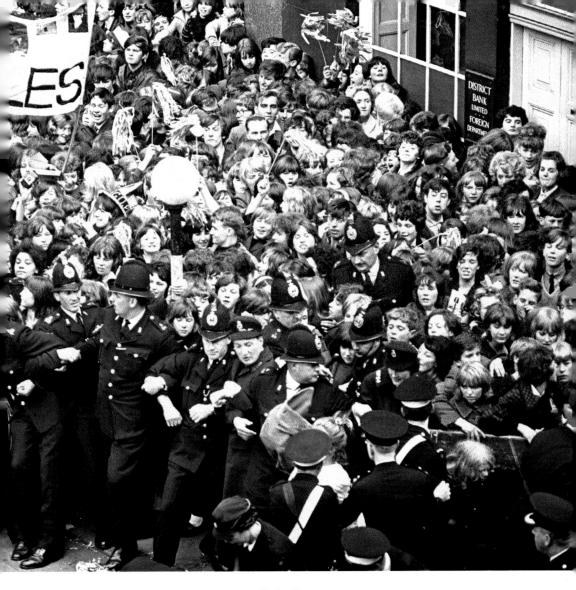

The Beatles
105

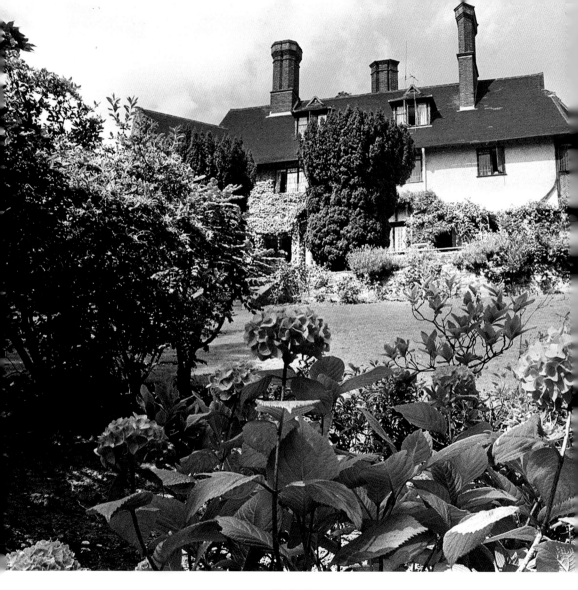

Tudor revival

Two days after this
photograph was taken,
John Lennon became the
second landed Beatle
when he completed the
purchase of Kenwood,
a mock Tudor mansion
in St George's Hill,
Weybridge, Surrey.
13th July, 1964

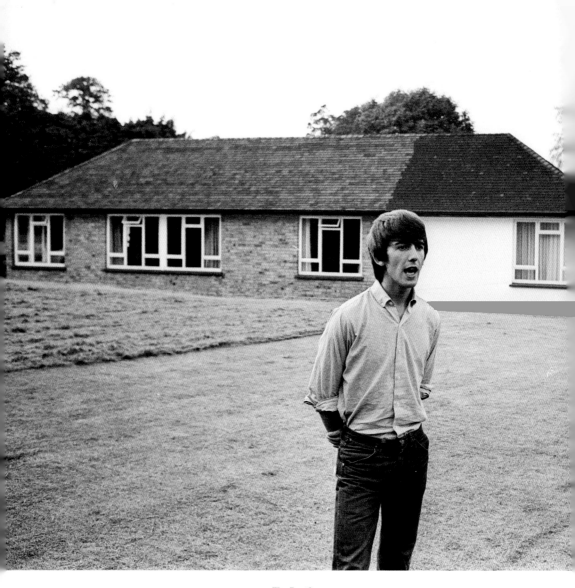

'Money don't get every thing, it's true...'
The Beatles' accountant advised them to invest in property, so George Harrison bought the first house he looked at, Kinfauns, a bungalow on the Claremont Estate in Esher, Surrey.
17th July, 1964

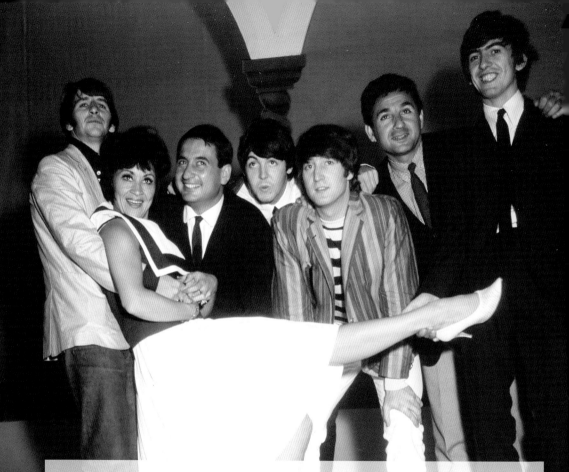

Blackpool Night Out
The Beatles starred in a summer show of this name, which also featured American singer and dancer Chita Rivera and British comic double act Mike and Bernie Winters (respectively second R and third L).
19th July, 1964

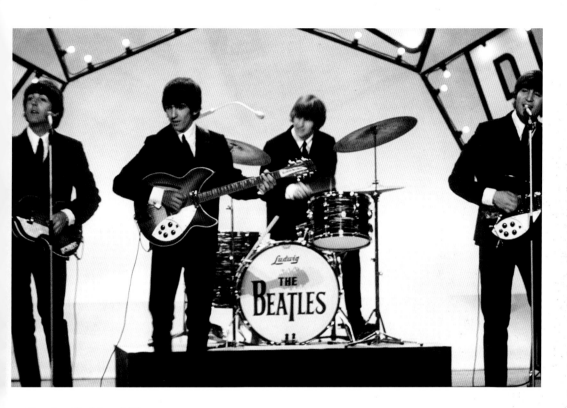

On the Golden Mile
The Beatles on stage at the *Blackpool Night Out,* which
was recorded for later TV broadcast.
19th July, 1964

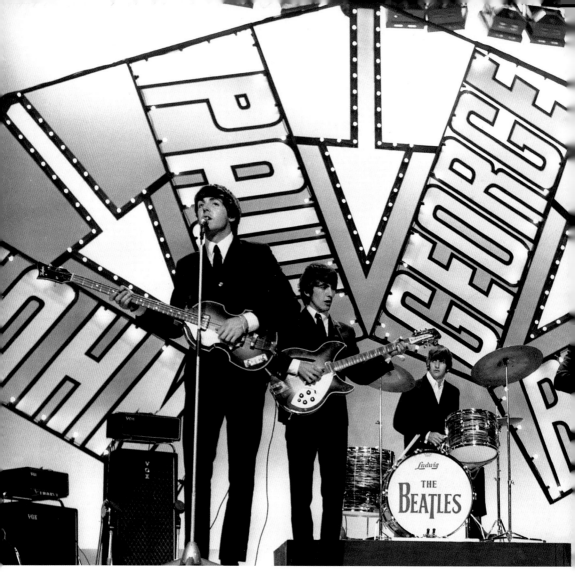

The Beatles

Changes

Another part of The Beatles' Blackpool set. Note Ringo's new Ludwig drum kit (£350' worth) and the costume changes from the previous image.
19 July, 1964

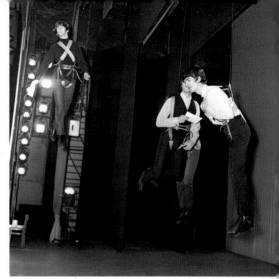

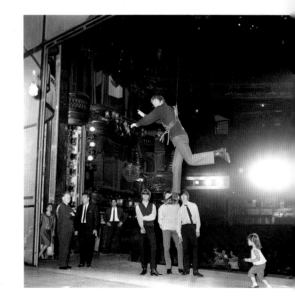

They fly through the air with the greatest of ease...
The Beatles practise their 'Flying Ballet' routine during rehearsals for *The Night Of 100 Stars* charity revue at the London Palladium.
23rd July, 1964

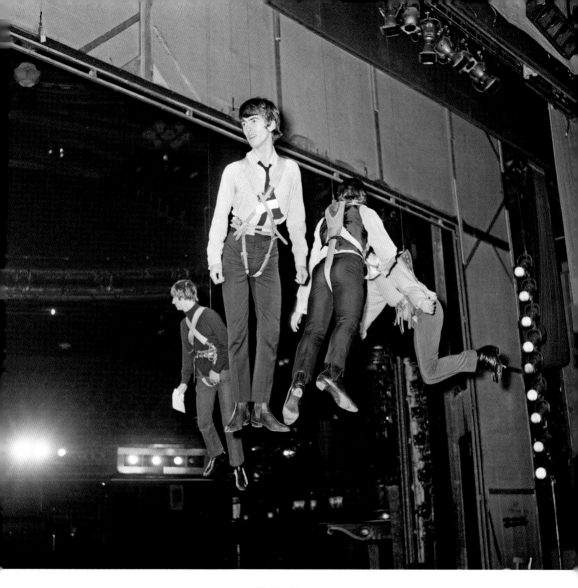

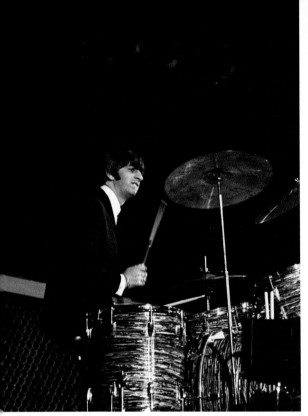
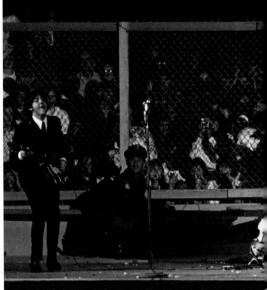

Rocking Las Vegas
Having played in San Francisco on the evening of 19th August, The Beatles flew to Las Vegas, where they landed at 1.30am and were driven to the Sahara Hotel. At 2.30pm they went to the city's Convention Center, did a quick sound check, and then launched into the first of two concerts, one at 4pm the other at 9pm. They were paid $30,000 for the two gigs, but barred from going on to the casinos afterwards because police feared they might be followed by young fans who were too young to gamble.
20th August, 1964

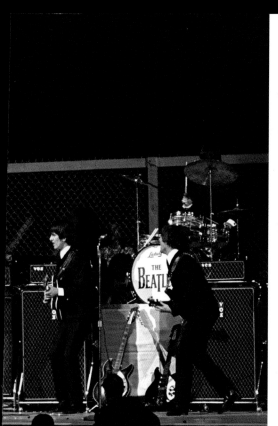

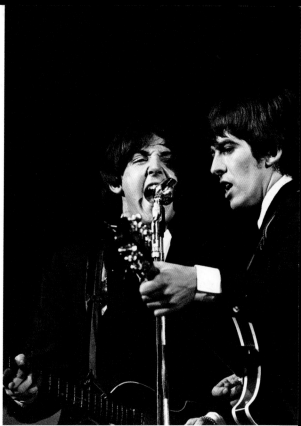

The Beatles

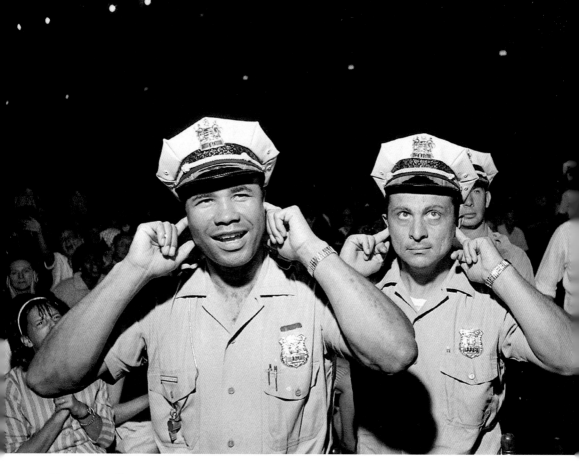

Hear no evil
Two policemen cover their ears at a Beatles' concert during the US tour. Whether the officers are objecting to the band's music or the noise of their fans is a moot point – this syndicated photograph originally got captioned both ways.
August 1964

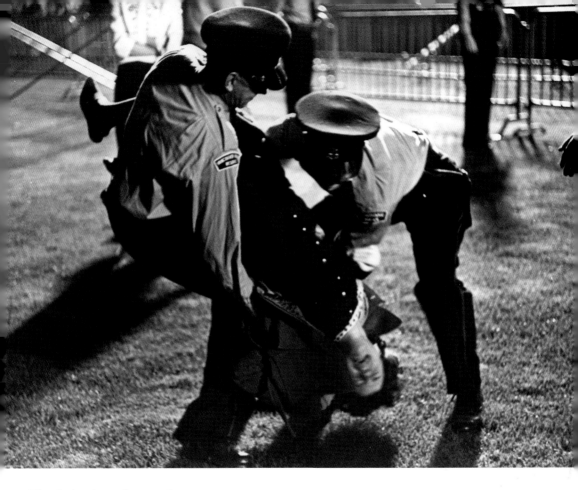

The imitation of an action
Having watched British and US Beatlemania, Canadians were keen not to be outdone, so this was not the only swooning girl the RCMP had to carry out from the group's concert in Vancouver, British Columbia.
22nd August, 1964

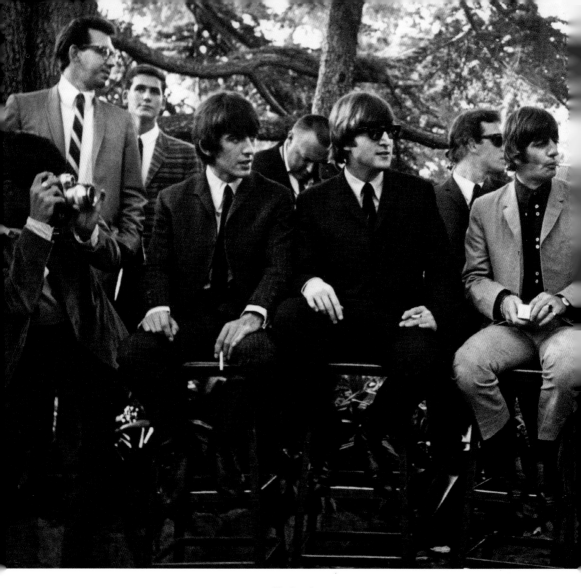

What does your daddy do?
Paul McCartney holds Rebel
Lee Robinson (daughter
of Hollywood star Edward
G. Robinson) in his arms
at a National Hemophilia
Foundation reception at
the Livingston Garden, Los
Angeles, California.
24th August, 1964

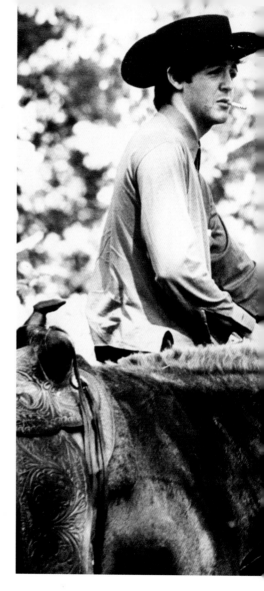

Horseplay

In Los Angeles to play the Hollywood Bowl, The Beatles stay in a rented house in exclusive Bel Air and take advantage of a rare gap in their breakneck schedule to visit a ranch and act like cowboys.

24th August, 1964

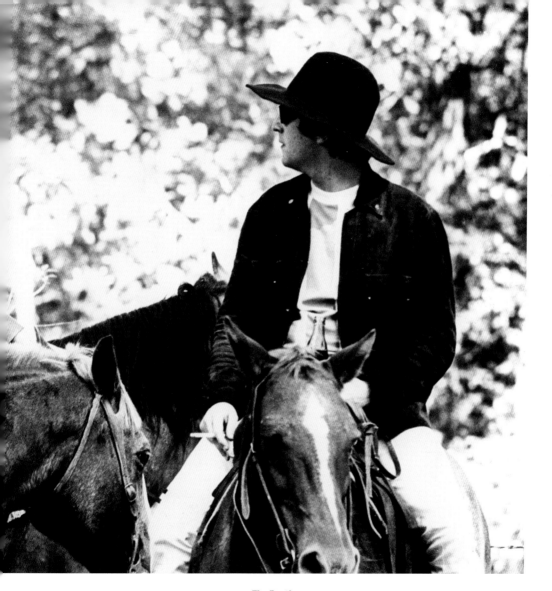

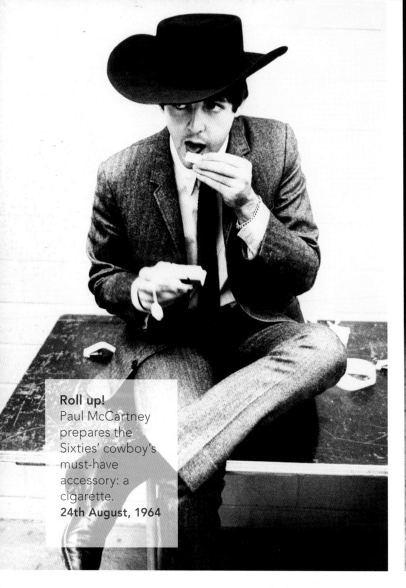

Roll up!
Paul McCartney prepares the Sixties' cowboy's must-have accessory: a cigarette.
24th August, 1964

Happiness is a warm gun
Ringo Starr trades drumsticks for stick-ups: from this it's hard to think he missed his true vocation.
24th August, 1964

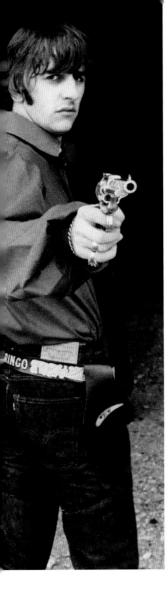

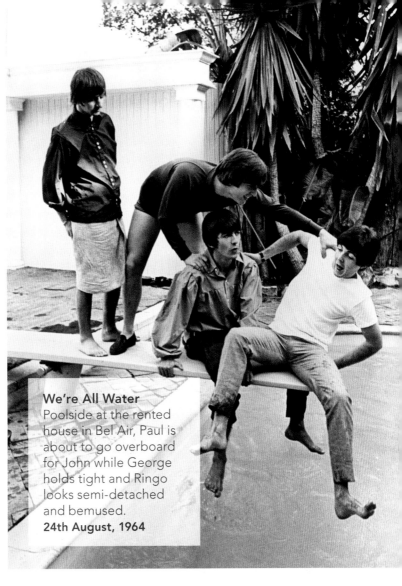

We're All Water
Poolside at the rented house in Bel Air, Paul is about to go overboard for John while George holds tight and Ringo looks semi-detached and bemused.
24th August, 1964

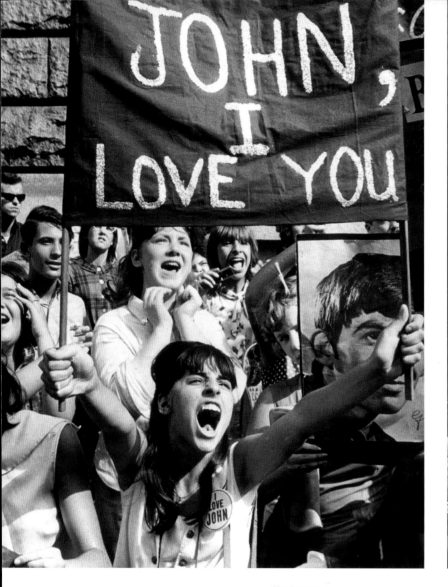

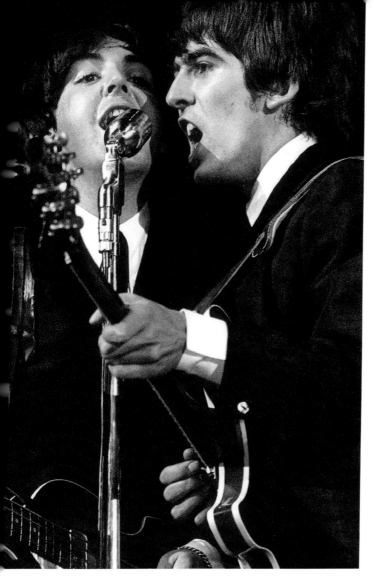

Punctuation USA
Facing page: Fans outside New York's Forest Hills Stadium (the venue until 1977 of the US Open tennis tournament) on the eve of The Beatles' concert. Note the comma!
28th August, 1964

Watching the play
The 16,000 people in the audience at Forest Hills heard (or perhaps, because of all the screaming, just saw) The Beatles play 12 songs, starting with *Twist and Shout* and ending with *Long Tall Sally*.
29th August, 1964

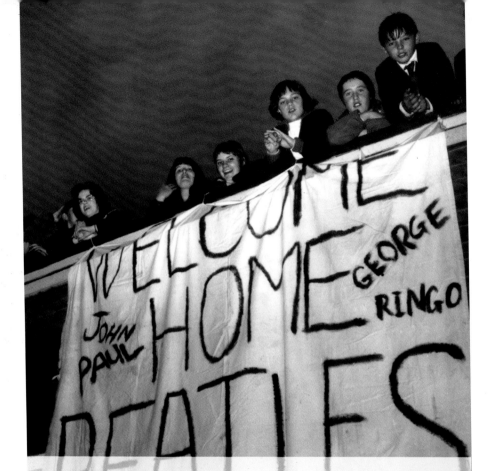

Reception committee
Beatles' fans at London Heathrow Airport look forward to welcoming
their heroes back from North America.
21st September, 1964

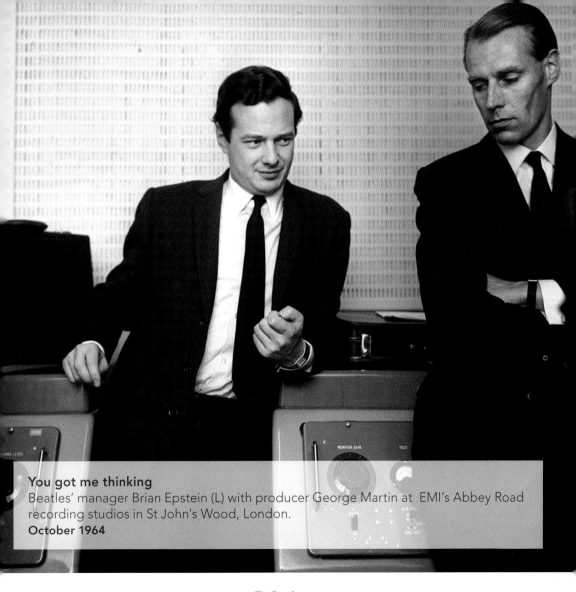

You got me thinking
Beatles' manager Brian Epstein (L) with producer George Martin at EMI's Abbey Road recording studios in St John's Wood, London.
October 1964

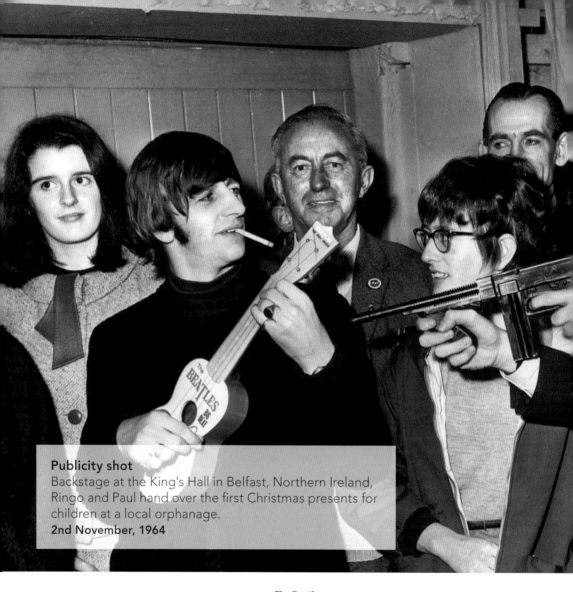

Publicity shot
Backstage at the King's Hall in Belfast, Northern Ireland, Ringo and Paul hand over the first Christmas presents for children at a local orphanage.
2nd November, 1964

Best wishes from The Beatles

[autographs: Ringo Starr, George Harrison, Paul McCartney, John Lennon]

In their own writing
Getting one Beatle's autograph was something to boast about, but getting all of them on a single sheet of paper was no less than a triumph.
7th November, 1964

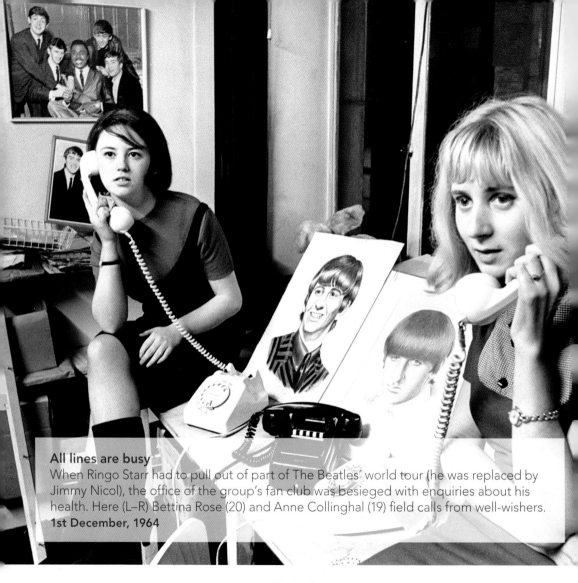

All lines are busy

When Ringo Starr had to pull out of part of The Beatles' world tour (he was replaced by Jimmy Nicol), the office of the group's fan club was besieged with enquiries about his health. Here (L–R) Bettina Rose (20) and Anne Collinghal (19) field calls from well-wishers.

1st December, 1964

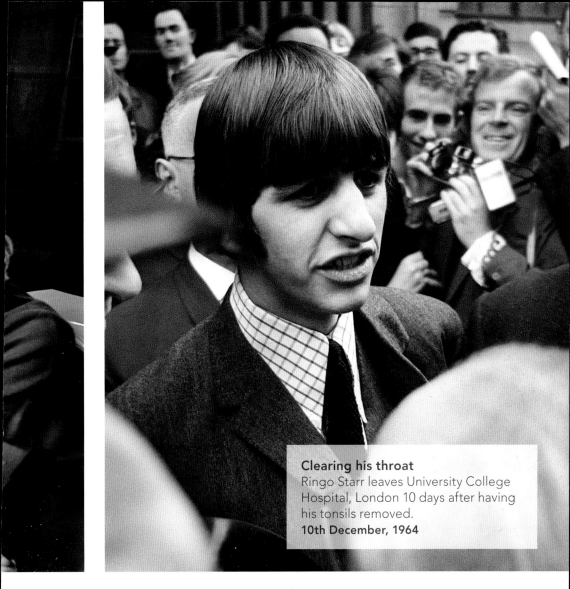

Clearing his throat
Ringo Starr leaves University College Hospital, London 10 days after having his tonsils removed.
10th December, 1964

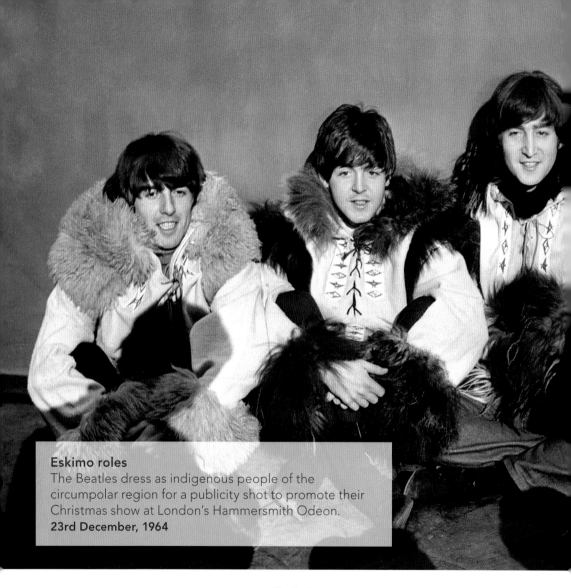

Eskimo roles
The Beatles dress as indigenous people of the circumpolar region for a publicity shot to promote their Christmas show at London's Hammersmith Odeon.
23rd December, 1964

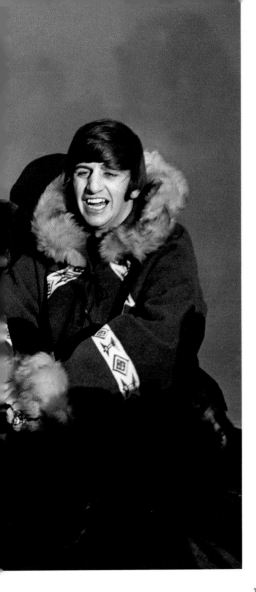

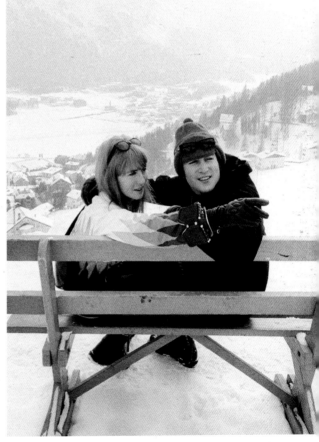

'Come on baby don't be cold as ice'
John and Cynthia Lennon on a skiing
holiday in St Moritz, Switzerland.
28th January, 1965

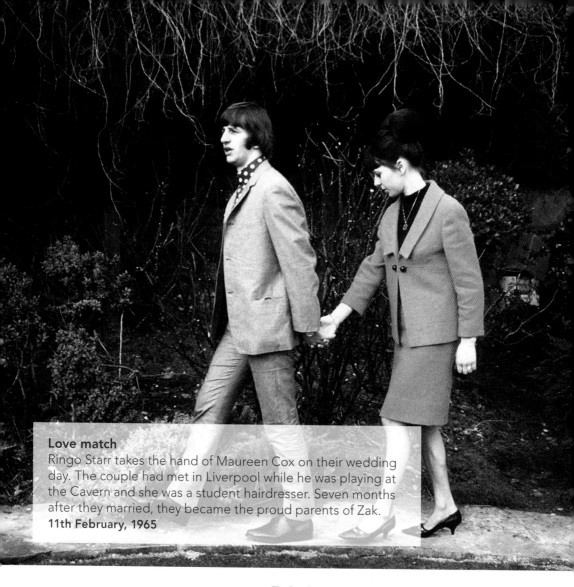

Love match
Ringo Starr takes the hand of Maureen Cox on their wedding day. The couple had met in Liverpool while he was playing at the Cavern and she was a student hairdresser. Seven months after they married, they became the proud parents of Zak.
11th February, 1965

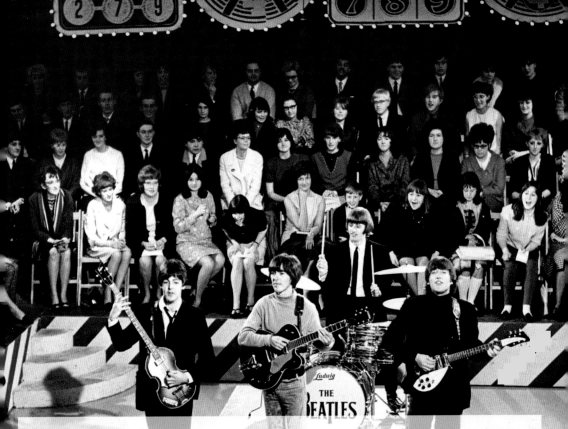

Oi'll give it foive

The Beatles on *Thank Your Lucky Stars*. One of the best remembered parts of this ITV show was a pop panel on which stars and ordinary people marked newly released singles on a scale of one to five. The highest mark became a catchphrase, normally spoken in imitation of the strong Birmingham accent of Janice Nicholls, one of the judges.
28th March, 1965

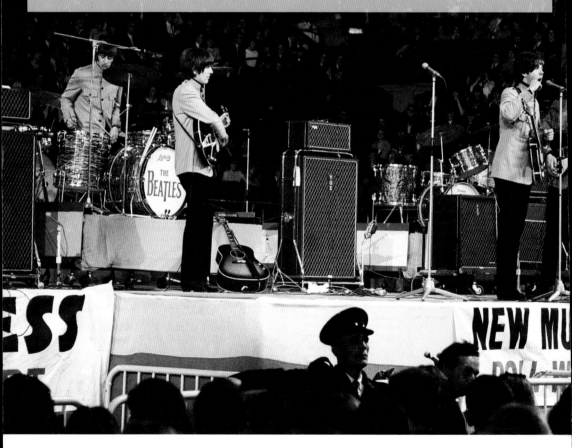

Vote winning
The Beatles topped the bill at this year's annual *New Musical Express* poll winners' concert at the Empire Pool, Wembley. They played *I Feel Fine*, *She's A Woman*, *Baby's in Black*, *Ticket To Ride* and *Long Tall Sally*.
11th April, 1965

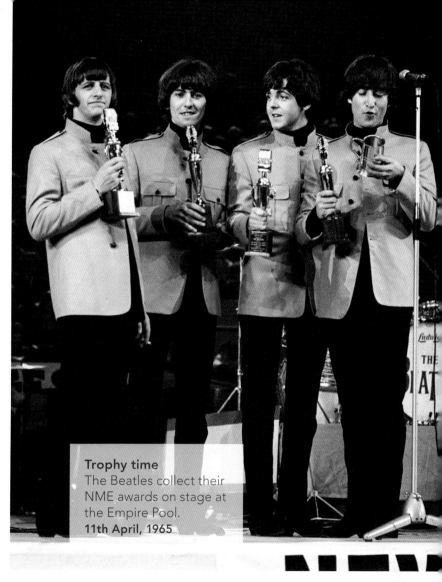

Trophy time
The Beatles collect their
NME awards on stage at
the Empire Pool.
11th April, 1965

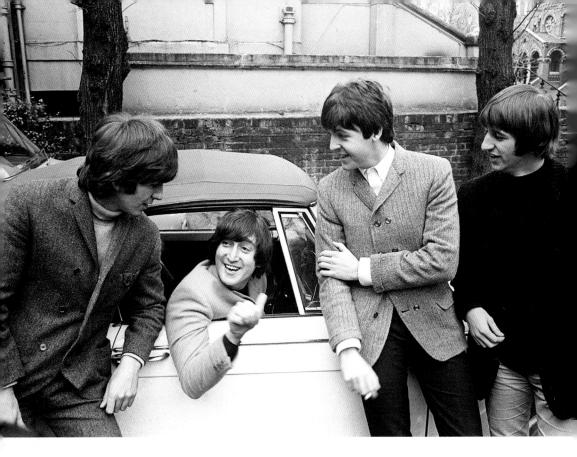

Lennon without the L
When John Lennon passed his driving test, the other
three Beatles joined him to celebrate the removal of the
learner plates from his car.
15th February, 1965

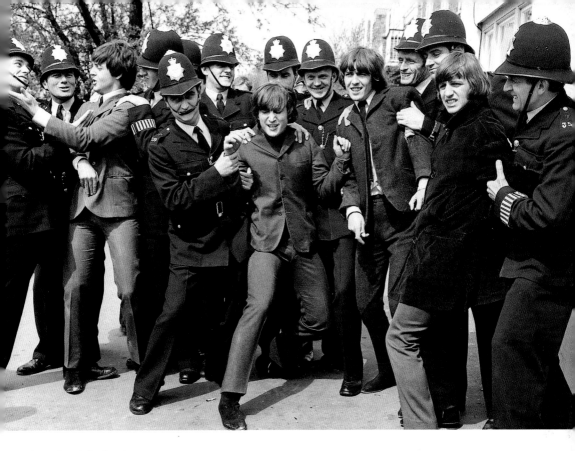

Brush with the law
The Beatles filming a scene from *Help!* outside the City
Barge pub in Chiswick, London. Everyone in the photo is
an actor: no policemen were harmed in the shooting of
this film.
24th April, 1965

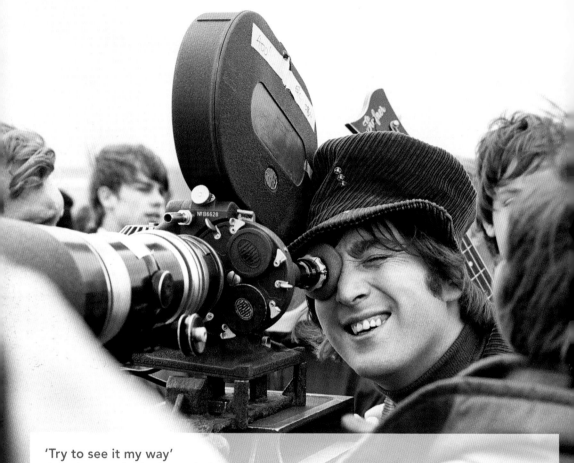

'Try to see it my way'
John Lennon looks through the lens of a camera during shooting of *Help!* at Knighton Down on Salisbury Plain, Wiltshire.
3rd May, 1965

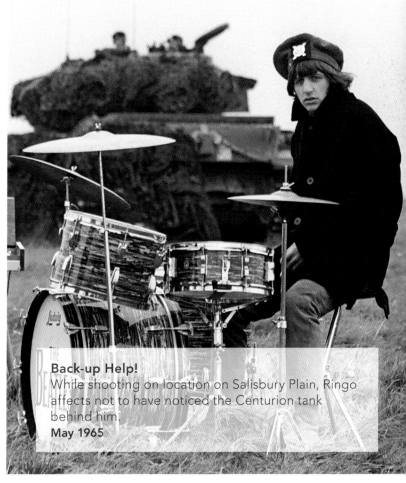

Back-up Help!
While shooting on location on Salisbury Plain, Ringo affects not to have noticed the Centurion tank behind him.
May 1965

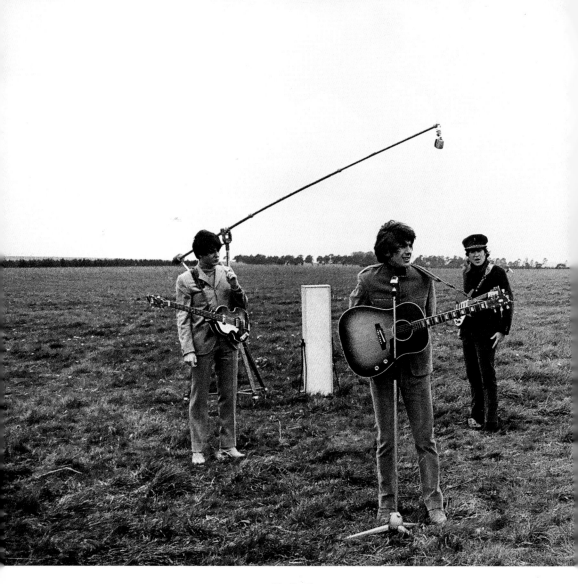

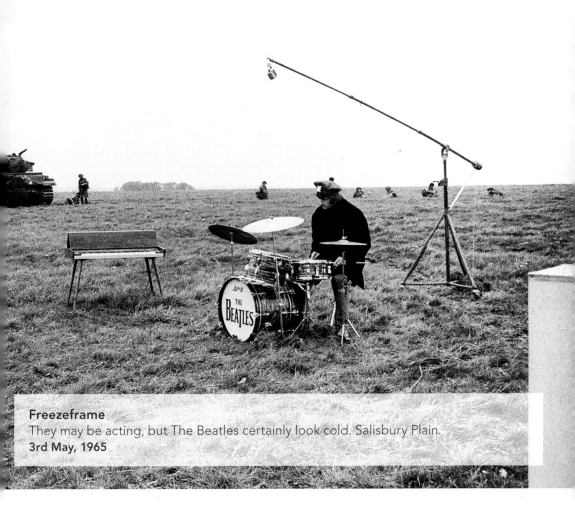

Freezeframe
They may be acting, but The Beatles certainly look cold. Salisbury Plain.
3rd May, 1965

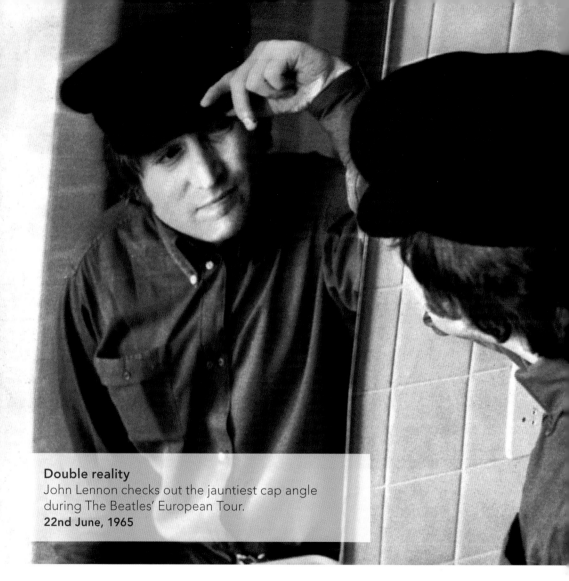

Double reality
John Lennon checks out the jauntiest cap angle during The Beatles' European Tour.
22nd June, 1965

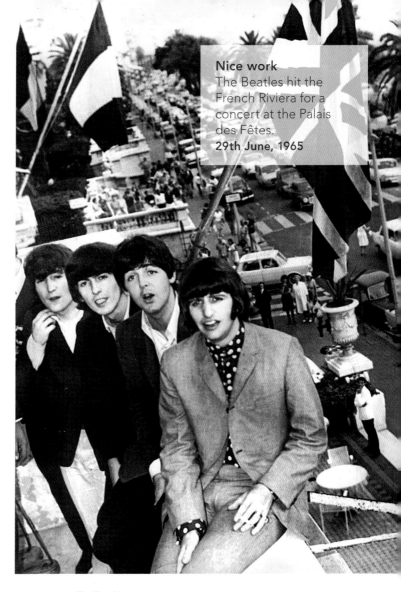

Nice work
The Beatles hit the French Riviera for a concert at the Palais des Fêtes.
29th June, 1965

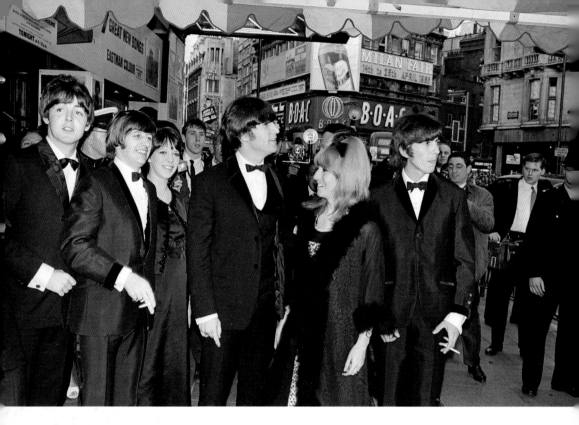

Dressed for the occasion
Tuxed-up Beatles outside the London Pavilion in Piccadilly Circus before the royal première of *Help!* With them are Cynthia Lennon (second R) and Maureen Starkey (third L), who is dressed to hide her bump.
29th July, 1965

Proud father
Ringo tells the press about his son, Zak, born the previous day in Queen Charlotte's Hospital, London.
14th September, 1965

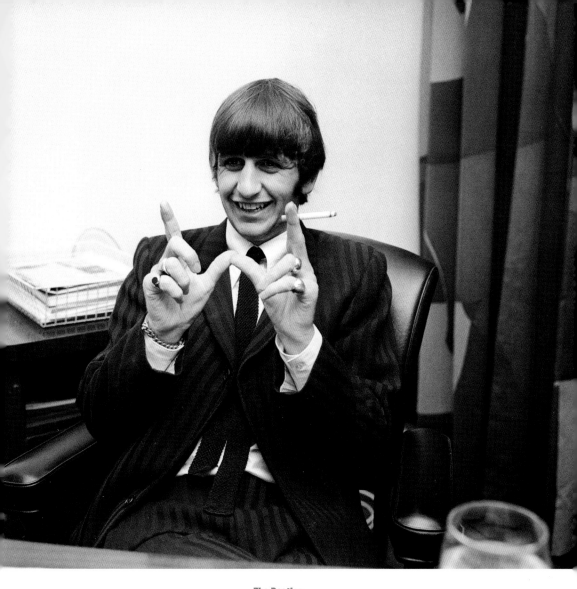

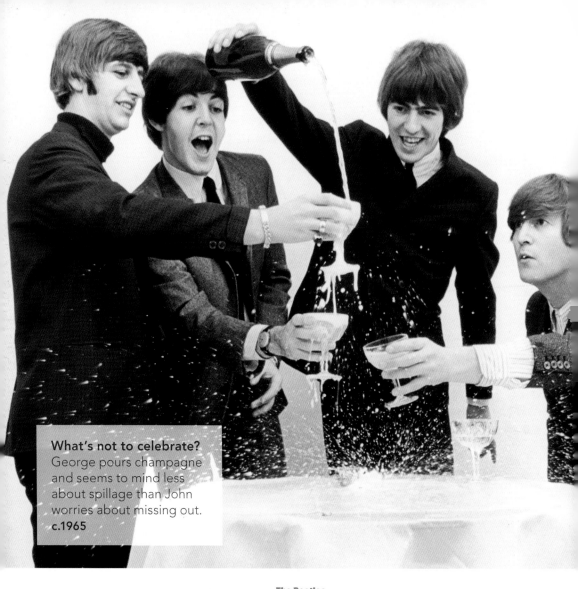

What's not to celebrate?
George pours champagne
and seems to mind less
about spillage than John
worries about missing out.
c.1965

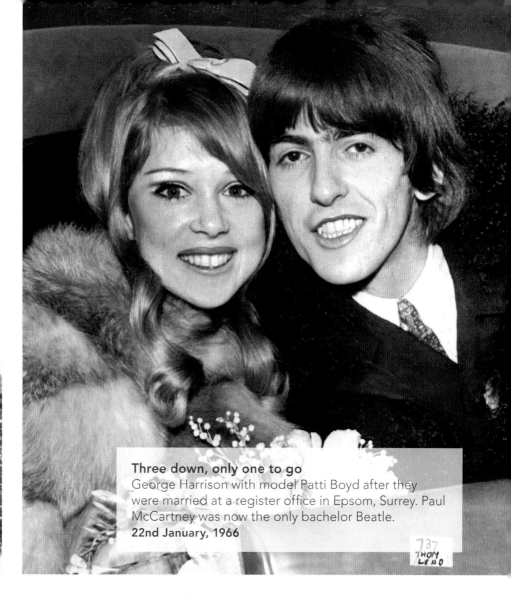

Three down, only one to go
George Harrison with model Patti Boyd after they
were married at a register office in Epsom, Surrey. Paul
McCartney was now the only bachelor Beatle.
22nd January, 1966

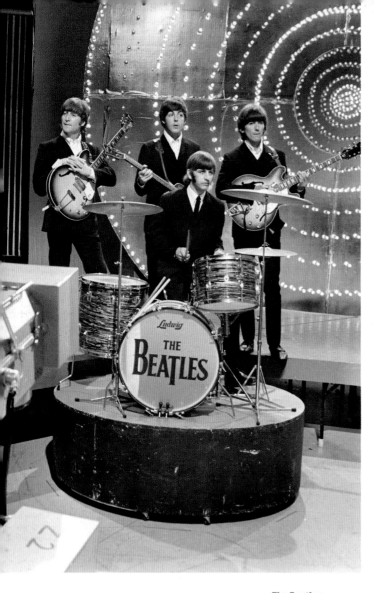

The Beatles
152

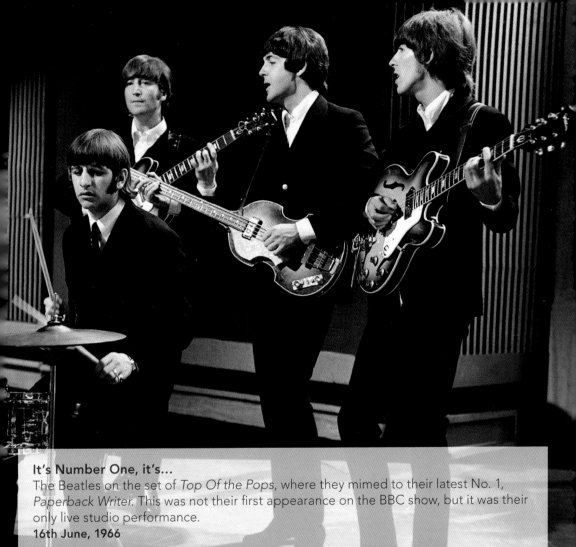

It's Number One, it's...
The Beatles on the set of *Top Of the Pops*, where they mimed to their latest No. 1, *Paperback Writer*. This was not their first appearance on the BBC show, but it was their only live studio performance.
16th June, 1966

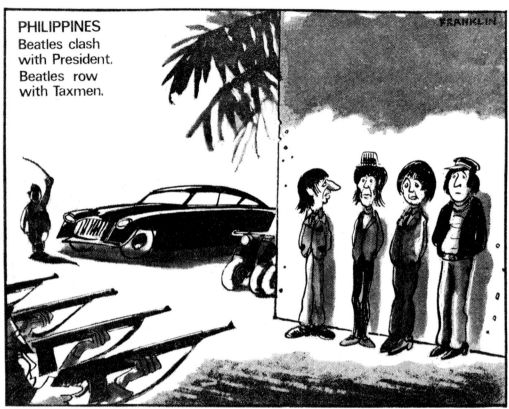

'*I thought it was the usual police escort*'

Diplomatic incident

This Franklin cartoon from the *Daily Mirror* refers to both The Beatles' song *Taxman* and to the hot diplomatic water in which the group landed after declining an invitation to a breakfast reception held by Philippines' President Marcos's wife Imelda. Hugely insulted, the ruler withdrew their police protection and they had to look out for themselves on their way to Manila Airport.

6th July, 1966

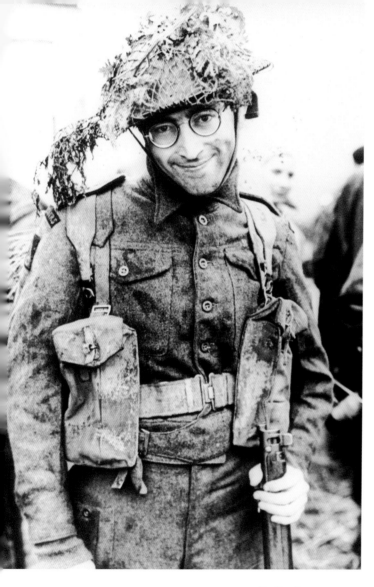

Soldier of Love
On location in Germany, John Lennon dresses in army uniform for his role as Musketeer Gripweed in *How I Won the War*, a black comedy directed by Richard Lester, who had also directed *A Hard Day's Night* and *Help!*
6th September, 1966

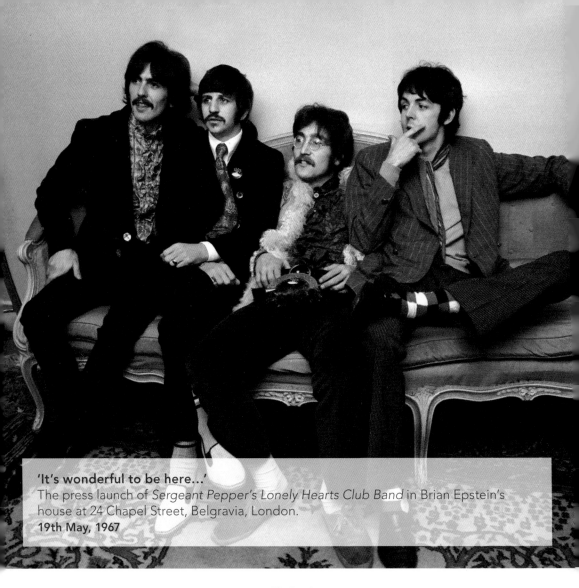

'It's wonderful to be here...'
The press launch of *Sergeant Pepper's Lonely Hearts Club Band* in Brian Epstein's house at 24 Chapel Street, Belgravia, London.
19th May, 1967

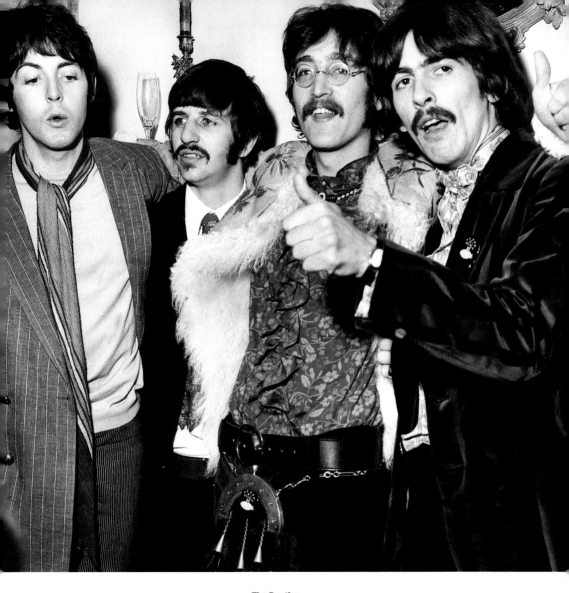

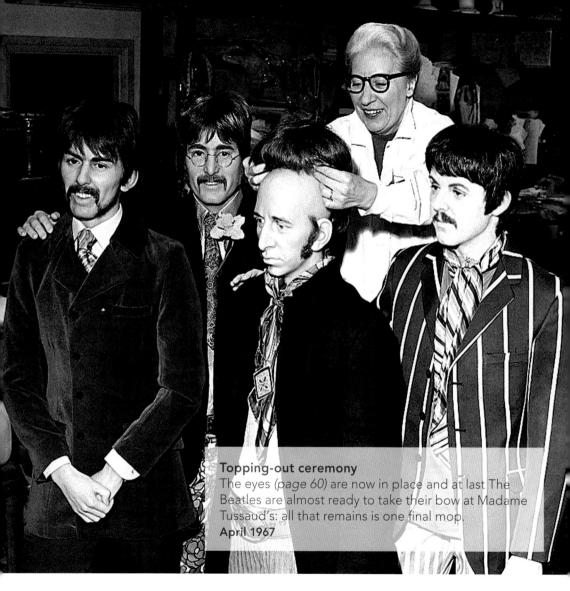

Topping-out ceremony
The eyes (*page 60*) are now in place and at last The Beatles are almost ready to take their bow at Madame Tussaud's: all that remains is one final mop.
April 1967

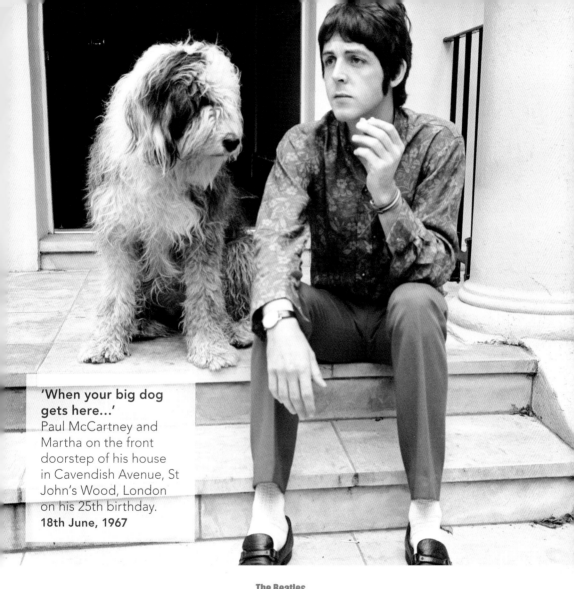

'**When your big dog gets here…**'
Paul McCartney and Martha on the front doorstep of his house in Cavendish Avenue, St John's Wood, London on his 25th birthday.
18th June, 1967

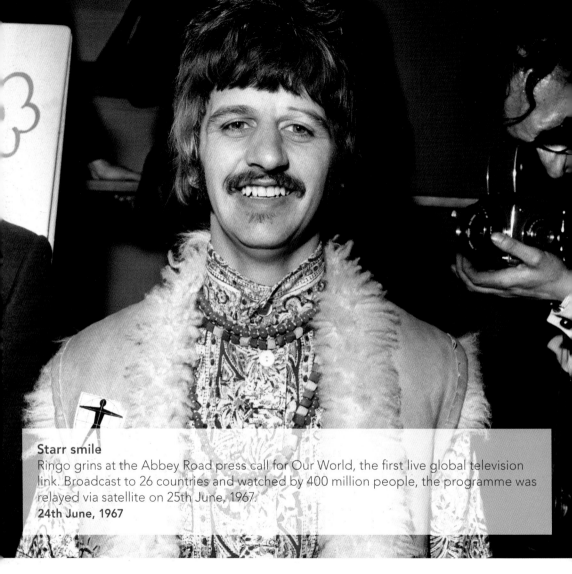

Starr smile
Ringo grins at the Abbey Road press call for Our World, the first live global television link. Broadcast to 26 countries and watched by 400 million people, the programme was relayed via satellite on 25th June, 1967.
24th June, 1967

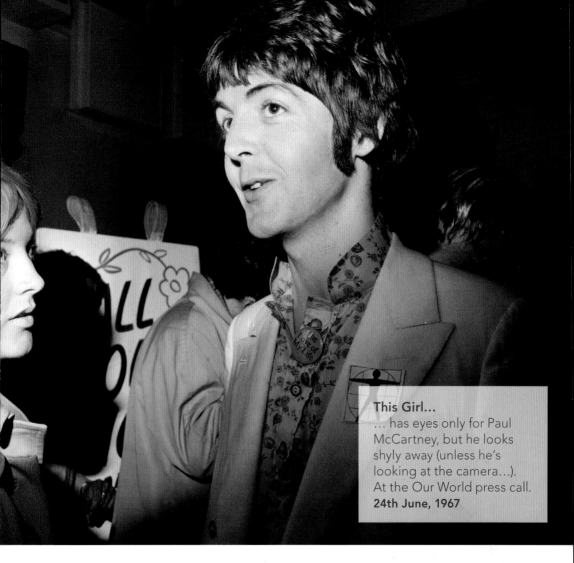

This Girl...
... has eyes only for Paul McCartney, but he looks shyly away (unless he's looking at the camera...). At the Our World press call.
24th June, 1967

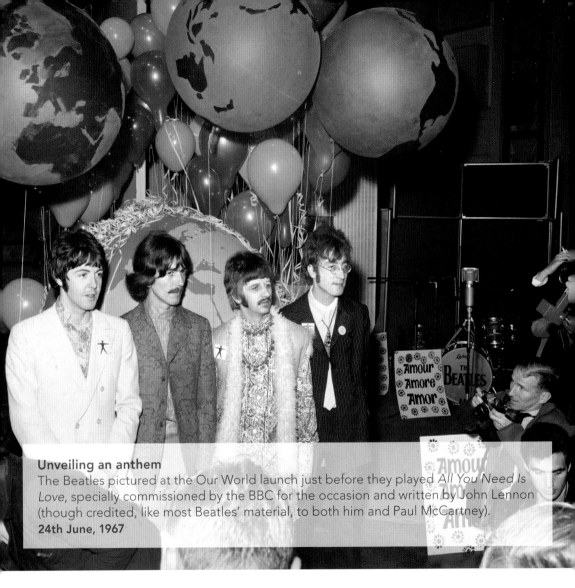

Unveiling an anthem

The Beatles pictured at the Our World launch just before they played *All You Need Is Love*, specially commissioned by the BBC for the occasion and written by John Lennon (though credited, like most Beatles' material, to both him and Paul McCartney).

24th June, 1967

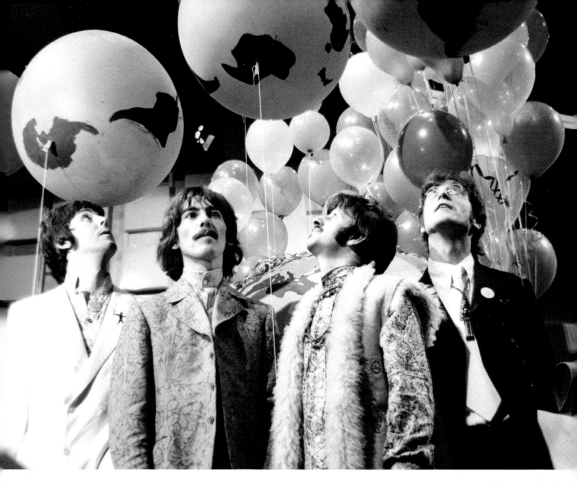

'I look at the world...'
Newspaper photographers seemed to think that the balloons at the launch of Our
World offered almost infinite possibilities. But The Beatles obliged by striking slightly
different poses every time the shutters clicked.
24th June, 1967

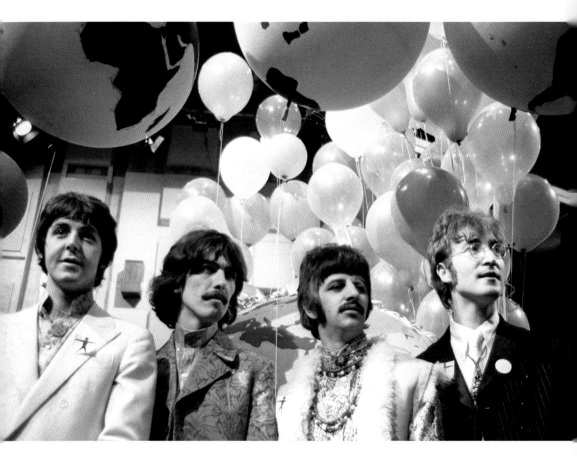

'I look at you all...'
In this shot, the group make like they haven't noticed what's above their heads.
24th June, 1967

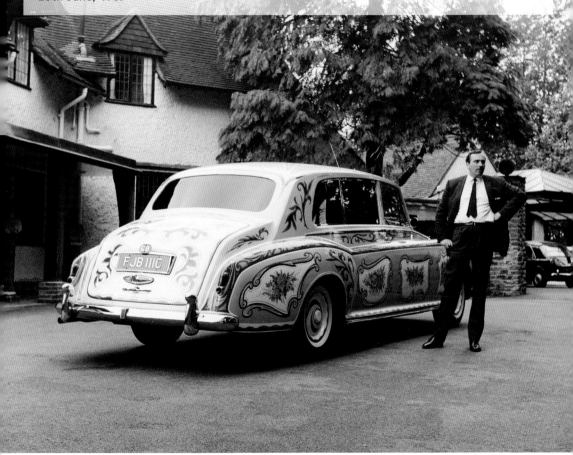

If you've got it, flaunt it
In the driveway of the Lennon residence in Surrey, a chauffeur stands beside the Beatle's understated Rolls-Royce Phantom, in yellow with psychedelic decals.
25th June, 1967

Four-Starr event
Ringo Starr leaving
Queen Charlotte's
Hospital in London the
day after Maureen gave
birth to their second son,
Jason Starkey.
20th August, 1967

Spiritual guru
Far right: Paul, George
and John listen intently
to the Maharishi Mahesh
Yogi's philosophical
teachings, when they met
at London's Hilton Hotel.
24th August, 1967

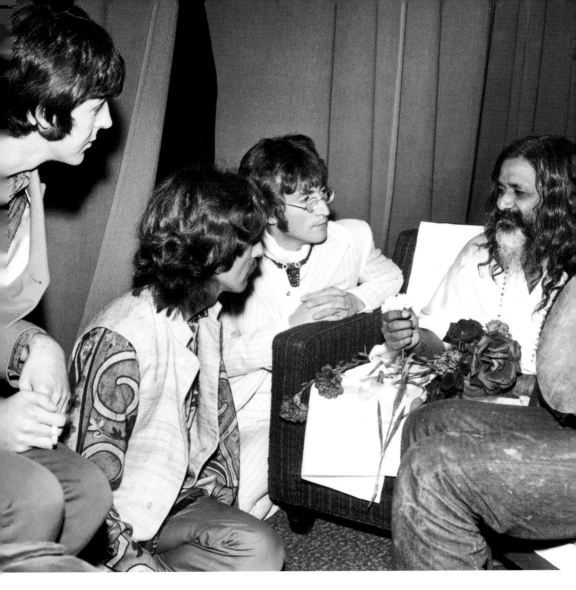

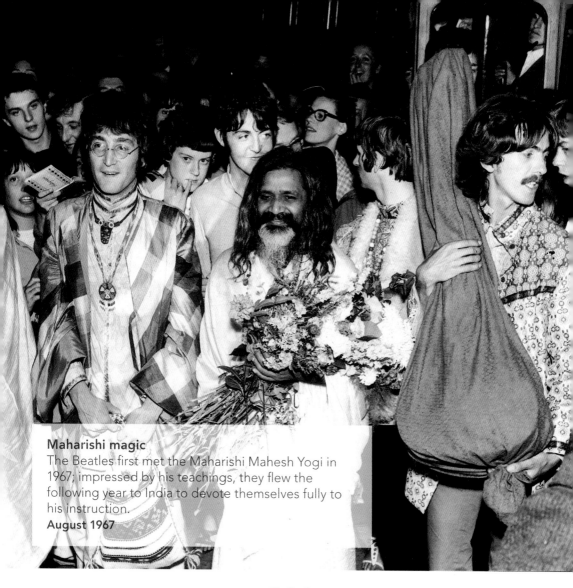

Maharishi magic

The Beatles first met the Maharishi Mahesh Yogi in 1967; impressed by his teachings, they flew the following year to India to devote themselves fully to his instruction.

August 1967

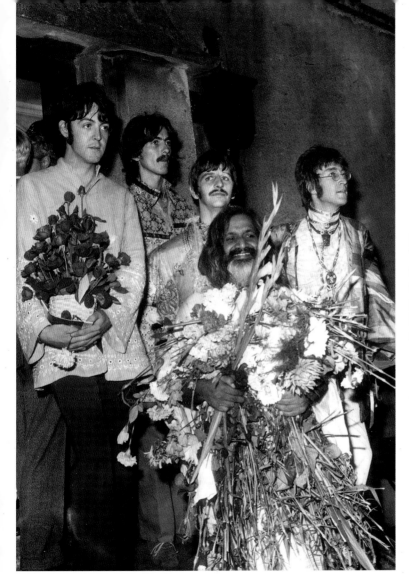

Flower power
The Beatles travelled to Bangor. Wales, to attend a 10-day seminar given by the Maharishi.
August 1967

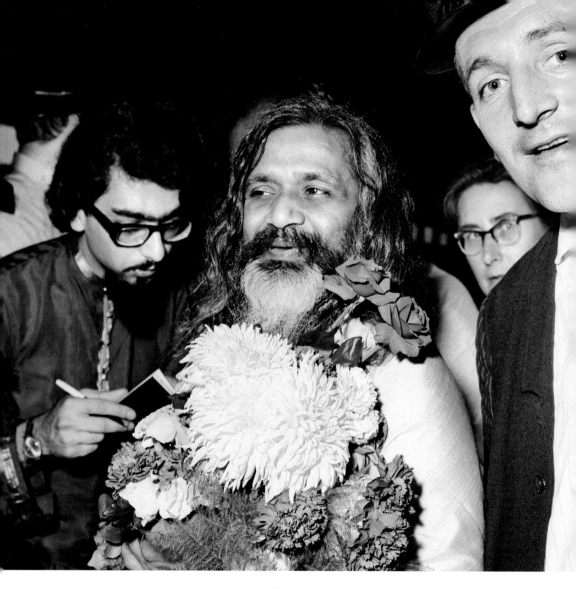

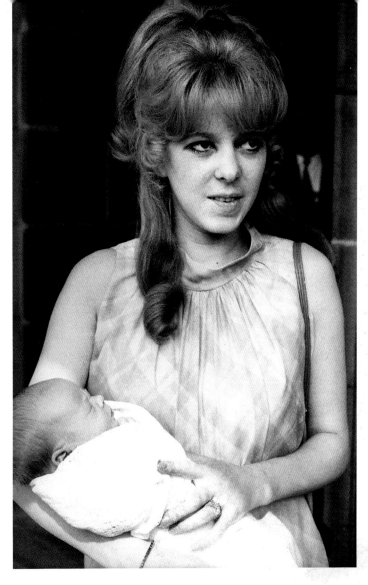

Spiritual trip
Left: Maharishi Mahesh Yogi at Euston Station waiting to leave for his summer school in Bangor, which was attended by members of The Beatles and The Rolling Stones.
25th August, 1967

Baby of a rich man
Maureen Starr leaves hospital with Jason the new Beatle baby, now one week old.
26th August, 1967

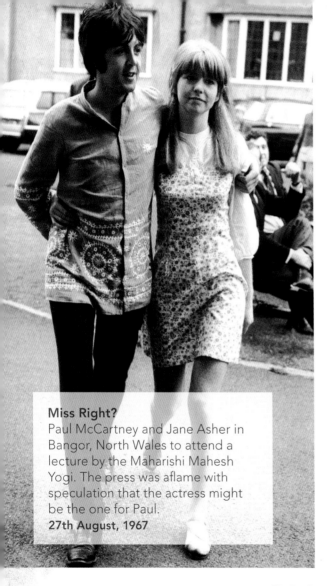

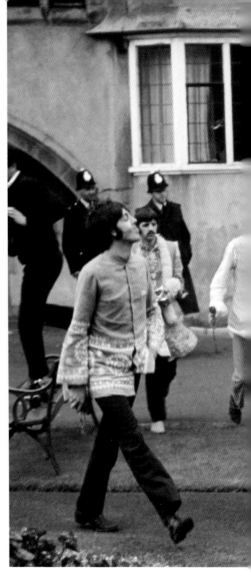

Miss Right?
Paul McCartney and Jane Asher in Bangor, North Wales to attend a lecture by the Maharishi Mahesh Yogi. The press was aflame with speculation that the actress might be the one for Paul.
27th August, 1967

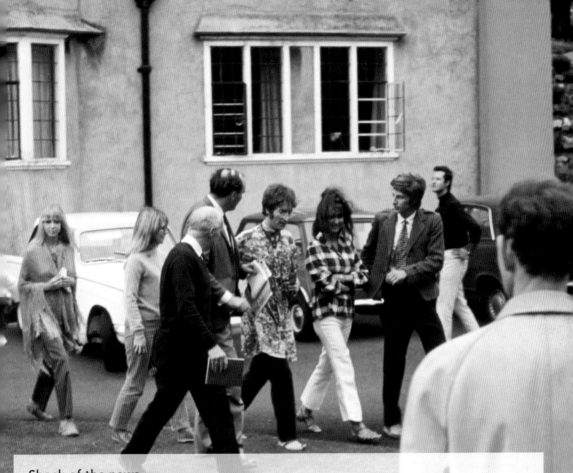

Shock of the news
Having just learned of the death of Brian Epstein, The Beatles cut short their Welsh sojourn and hurry back to London.
27th August, 1967

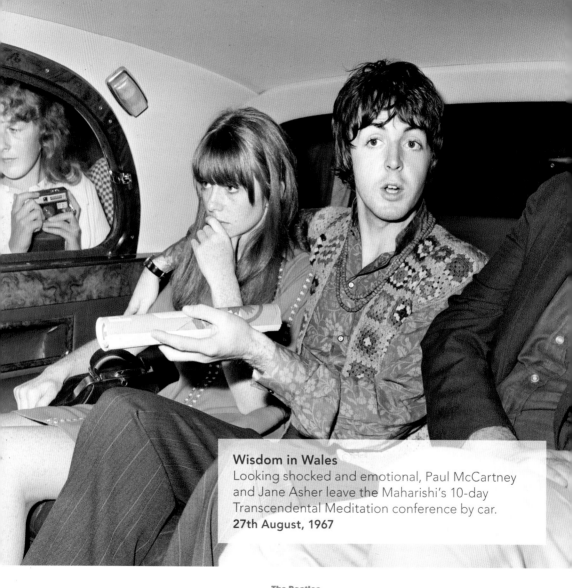

Wisdom in Wales
Looking shocked and emotional, Paul McCartney and Jane Asher leave the Maharishi's 10-day Transcendental Meditation conference by car.
27th August, 1967

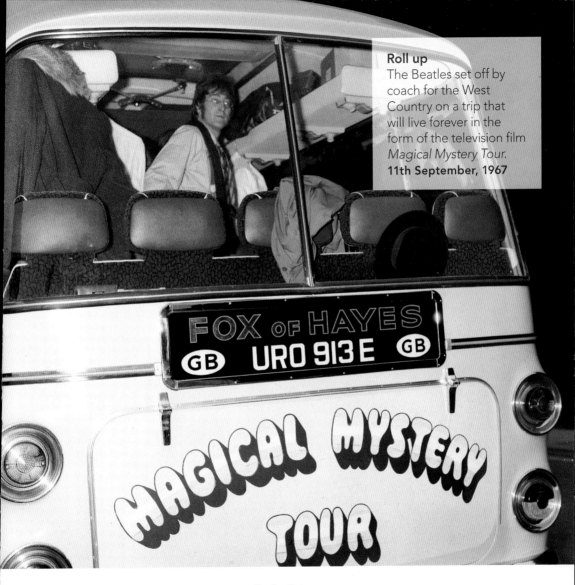

FOX OF HAYES
GB URO 913 E GB

MAGICAL MYSTERY TOUR

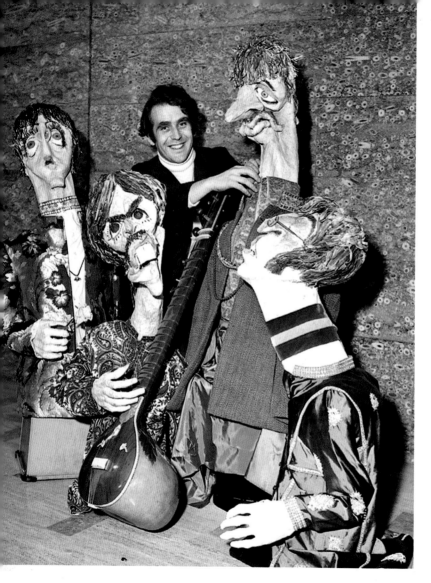

Model citizens
Left: Gerald Scarfe with papier-mâché puppets of The Beatles, which he produced for the cover of *Time* magazine. The cartoonist went on to marry McCartney's ex-girlfriend Jane Asher (whom he had yet to meet).
19th September, 1967

A night at the pictures (1)
George Harrison and wife Patti Boyd arriving at the London première of *How I Won the War (see page 155)*, which features fellow Beatle John Lennon.
18th October, 1967

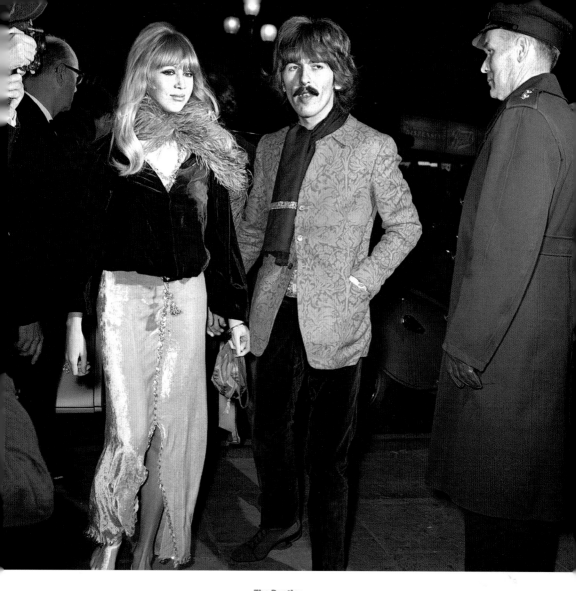

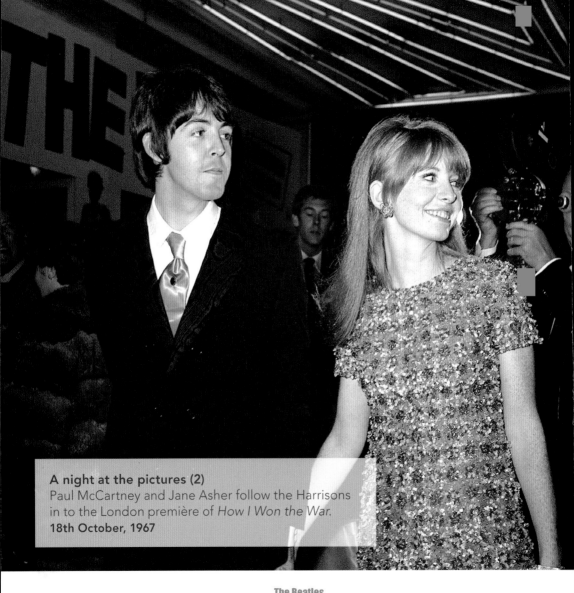

A night at the pictures (2)
Paul McCartney and Jane Asher follow the Harrisons
in to the London première of *How I Won the War*.
18th October, 1967

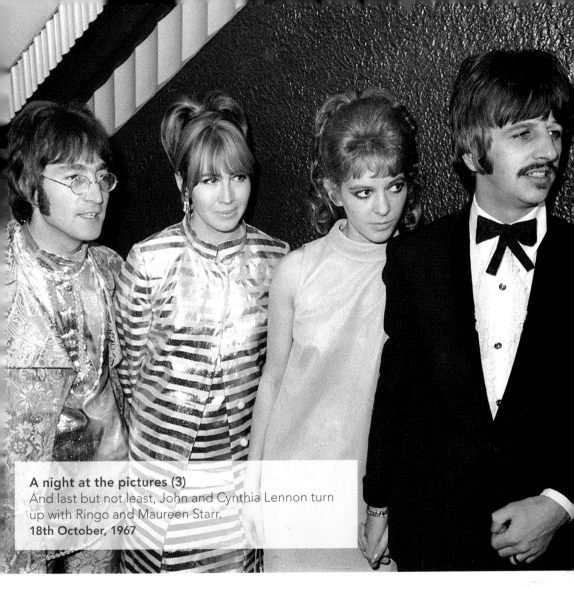

A night at the pictures (3)
And last but not least, John and Cynthia Lennon turn
up with Ringo and Maureen Starr.
18th October, 1967

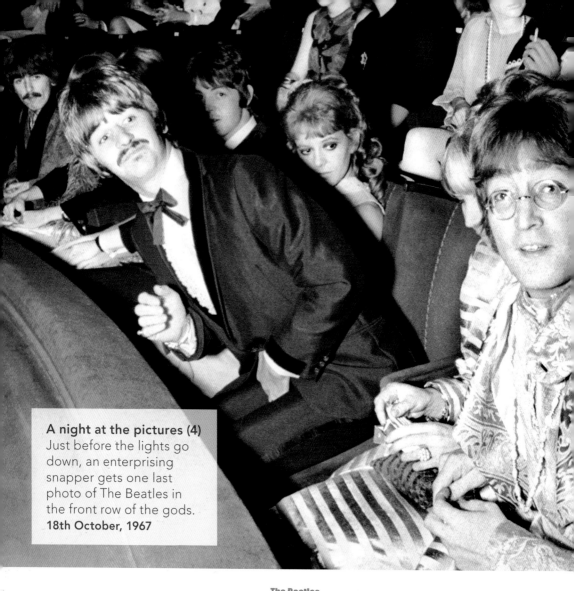

A night at the pictures (4)
Just before the lights go down, an enterprising snapper gets one last photo of The Beatles in the front row of the gods.
18th October, 1967

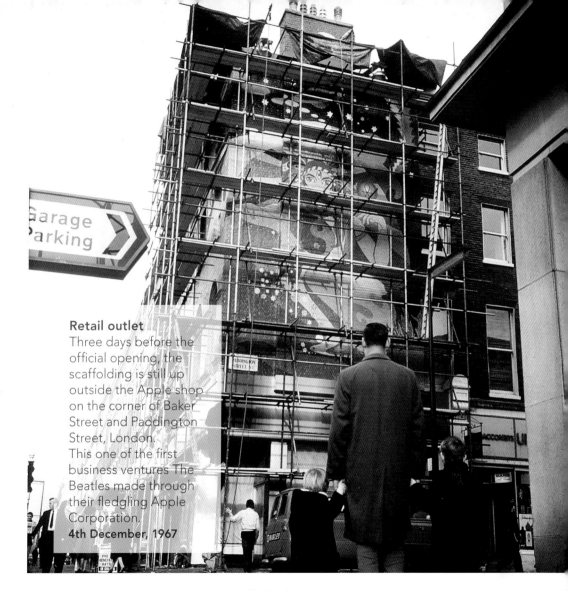

Retail outlet

Three days before the official opening, the scaffolding is still up outside the Apple shop on the corner of Baker Street and Paddington Street, London.
This one of the first business ventures The Beatles made through their fledgling Apple Corporation.
4th December, 1967

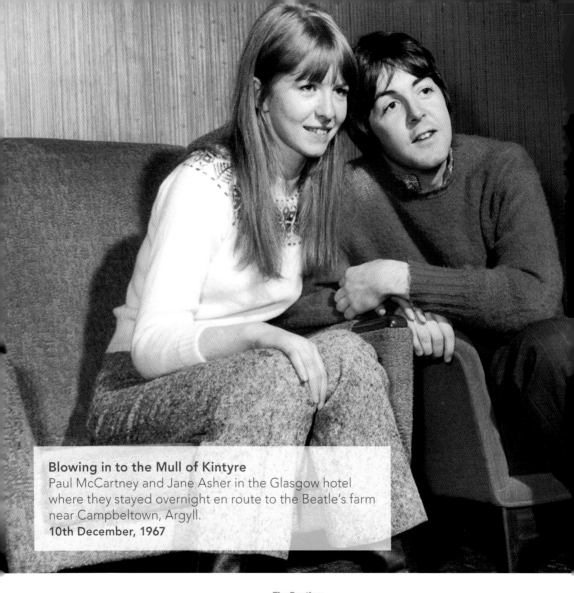

Blowing in to the Mull of Kintyre
Paul McCartney and Jane Asher in the Glasgow hotel
where they stayed overnight en route to the Beatle's farm
near Campbeltown, Argyll.
10th December, 1967

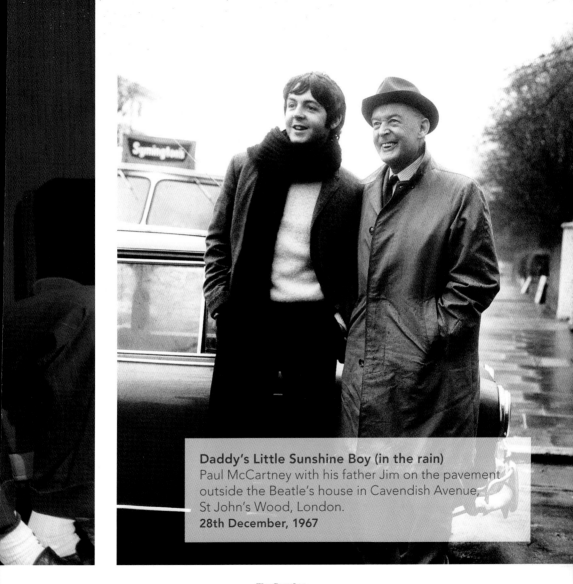

Daddy's Little Sunshine Boy (in the rain)
Paul McCartney with his father Jim on the pavement
outside the Beatle's house in Cavendish Avenue,
St John's Wood, London.
28th December, 1967

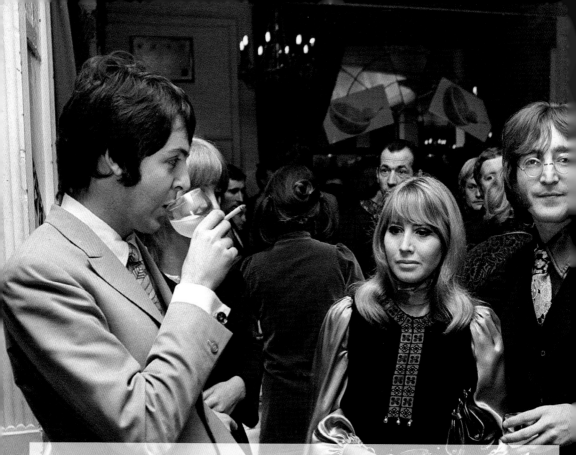

Moving into management
Paul McCartney with a partially obscured Jane Asher and Cynthia and John Lennon at a release-day party for *Dear Delilah*, the debut single by Grapefruit, the first band to be managed by The Beatles. Jane moves out of the shadows, right.
19th January, 1968

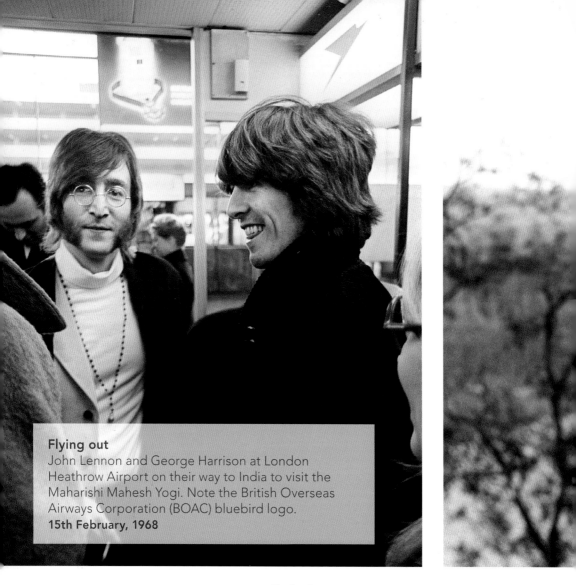

Flying out
John Lennon and George Harrison at London
Heathrow Airport on their way to India to visit the
Maharishi Mahesh Yogi. Note the British Overseas
Airways Corporation (BOAC) bluebird logo.
15th February, 1968

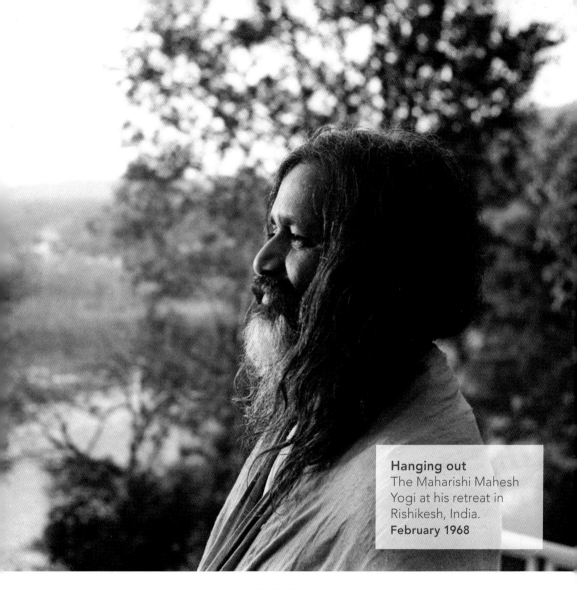

Hanging out
The Maharishi Mahesh Yogi at his retreat in Rishikesh, India.
February 1968

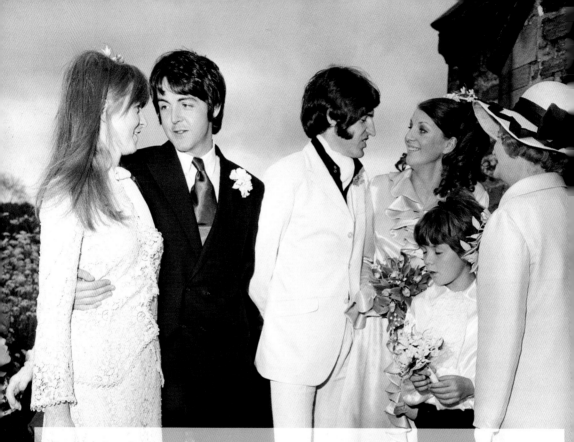

Our kid ties the knot
Paul McCartney and Jane Asher in Carrog, North Wales, at the wedding of Angela Fishwick to Paul's younger brother Mike, who under the stage name Mike McGear was a member of The Scaffold, which would have a No. 1 single the following year with *Lily the Pink*.
8th June, 1968

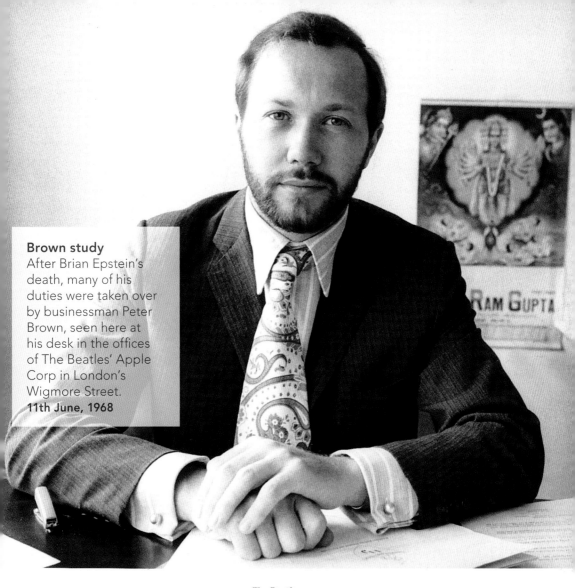

Brown study
After Brian Epstein's death, many of his duties were taken over by businessman Peter Brown, seen here at his desk in the offices of The Beatles' Apple Corp in London's Wigmore Street.
11th June, 1968

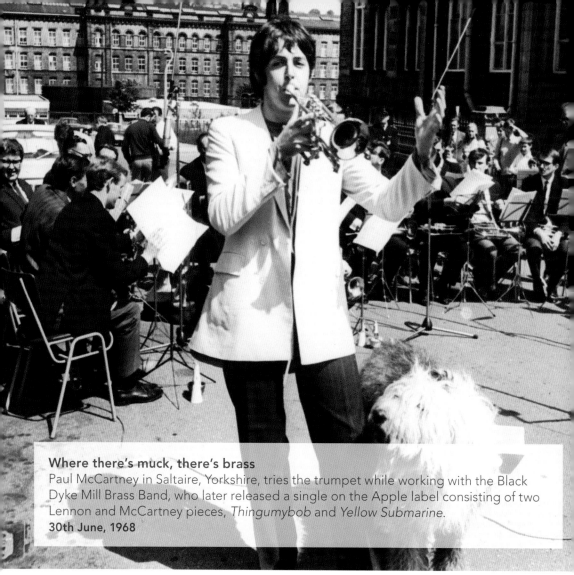

Where there's muck, there's brass
Paul McCartney in Saltaire, Yorkshire, tries the trumpet while working with the Black Dyke Mill Brass Band, who later released a single on the Apple label consisting of two Lennon and McCartney pieces, *Thingumybob* and *Yellow Submarine*.
30th June, 1968

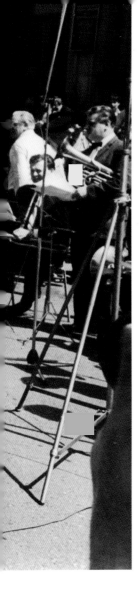

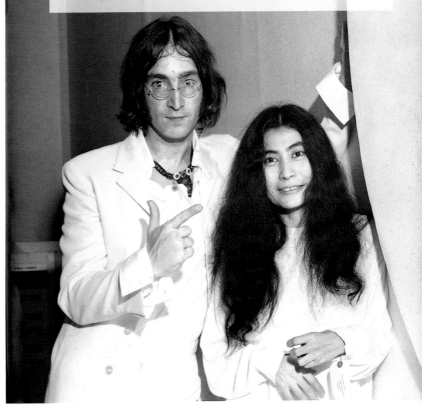

Art lovers

John Lennon first met Yoko Ono in November 1966. As his marriage to Cynthia foundered, he became more involved with the Japanese artist and today they opened an exhibition of her work, entitled *You Are Here*, at a gallery in London's West End.

1st July, 1968

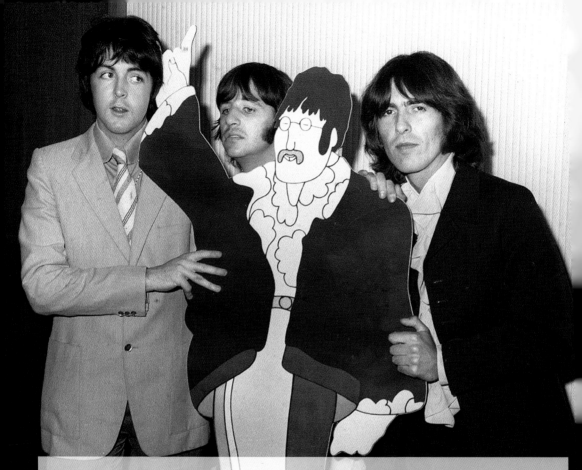

Missing in action movie
A week before the UK release of *Yellow Submarine*, Paul, Ringo and George pose beside a cardboard cut-out of John that featured in the film.
9th July, 1968

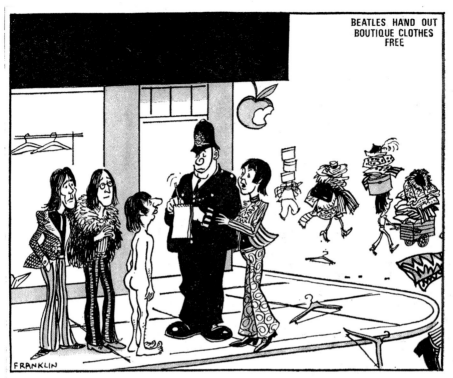

BEATLES HAND OUT
BOUTIQUE CLOTHES
FREE

FRANKLIN

"Ringo got a bit carried away, officer.."

Free as a bird
When The Beatles closed their Apple boutique *(see page 181)*, they announced that all the stock would be given away rather than sold off cheaply. Hundreds queued all night to take advantage of the offer, and the chaos that ensued inspired this Franklin cartoon in the following morning's *Daily Mirror*.
1st August, 1968

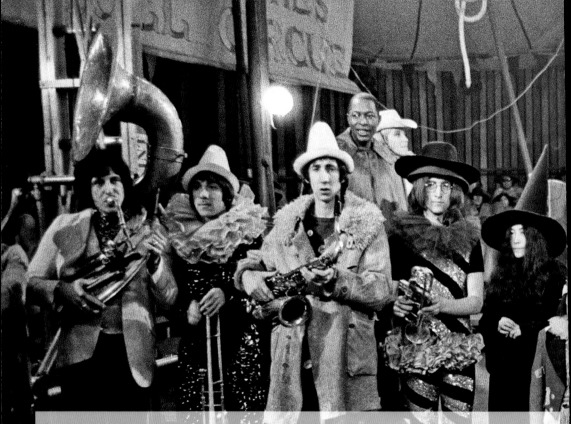

The Rolling Stones Rock 'n' Roll Circus
This extravaganza – two concerts on a circus stage in Stonebridge Park near Wembley, Middlesex – featured a host of stars including (L–R): John Entwistle, Keith Moon and Pete Townshend of The Who; John Lennon and Yoko Ono (now his fiancée); Keith Richards, Mick Jagger, Brian Jones and Bill Wyman (The Rolling Stones); Eric Clapton and Marianne Faithfull.
11th December, 1968

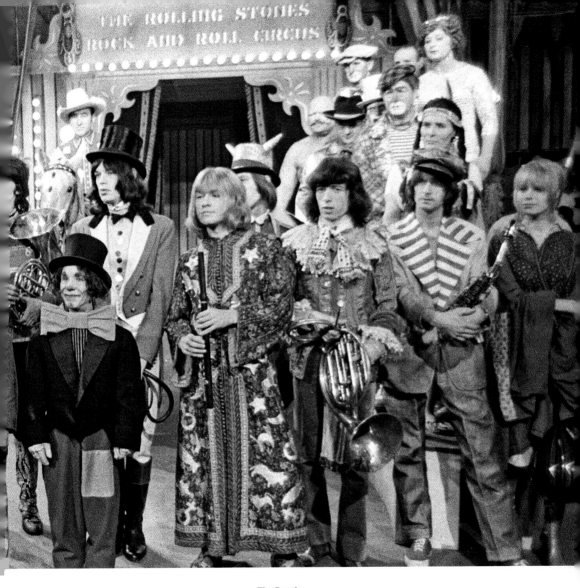

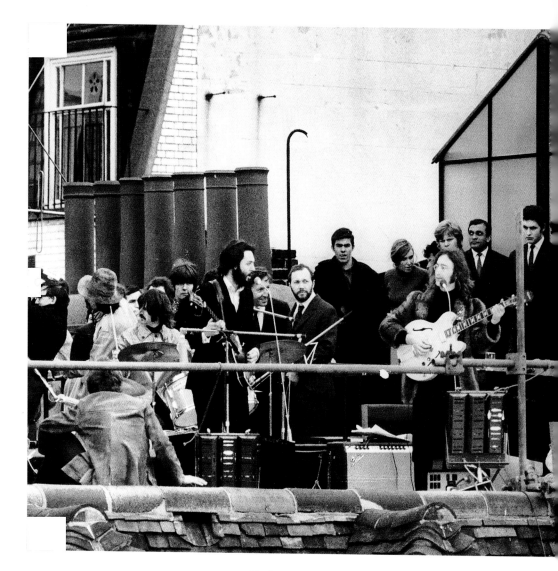

The Beatles

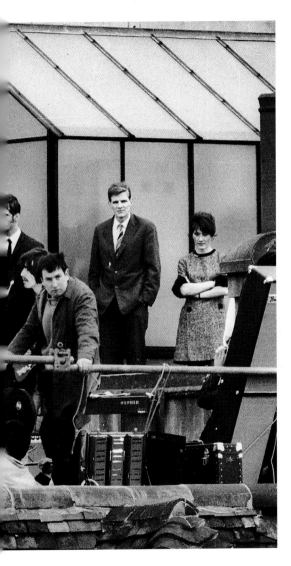

The Rooftop Concert
The Beatles' last-ever live performance, an unannounced gig on top of their Apple headquarters in London's Savile Row.
30th January, 1969

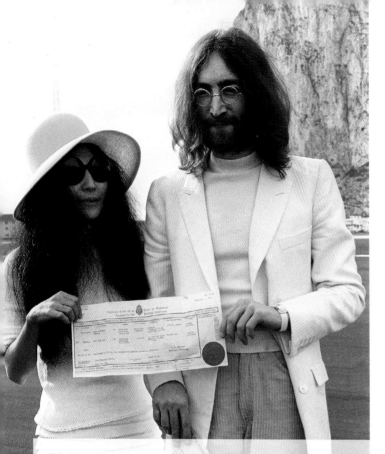

'You can get married in Gibraltar, near Spain'
Which, according to *The Ballad of John and Yoko*, is what Peter Brown (*see page 189*) suggested, so that is what they did, and they are seen here holding their marriage certificate, with the famous rock as backdrop.
20th March, 1969

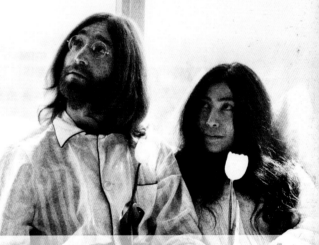

'Drove from Paris to the Amsterdam Hilton...'
... where the newly-weds spent a week in bed to draw attention to the need for world peace.
March 1969

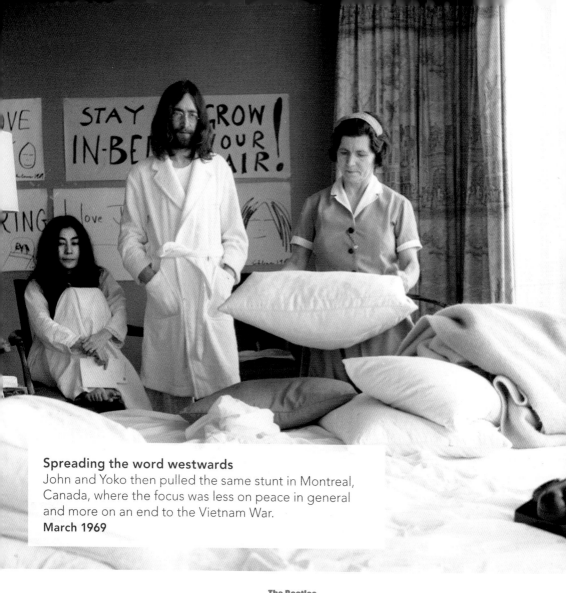

Spreading the word westwards
John and Yoko then pulled the same stunt in Montreal, Canada, where the focus was less on peace in general and more on an end to the Vietnam War.
March 1969

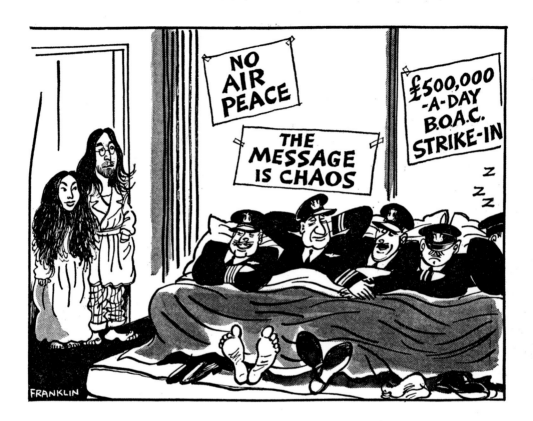

Bedroom antics
This Franklin cartoon from the *Daily Mirror* takes a
sideways look at two of the big news items of the day:
John and Yoko in bed and a BOAC pilots' strike.
1st April, 1969

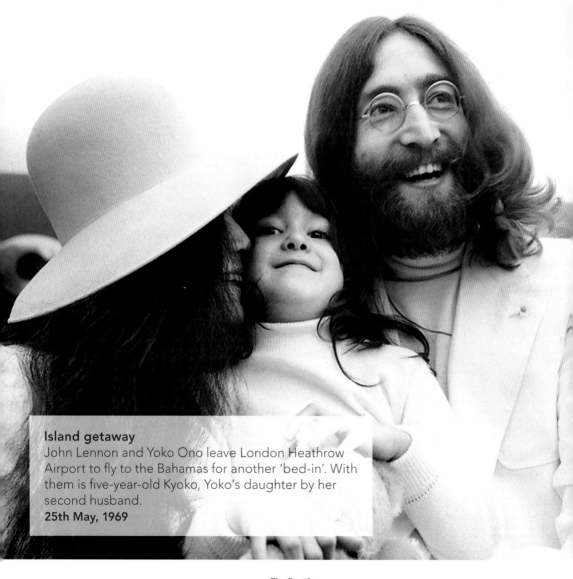

Island getaway
John Lennon and Yoko Ono leave London Heathrow Airport to fly to the Bahamas for another 'bed-in'. With them is five-year-old Kyoko, Yoko's daughter by her second husband.
25th May, 1969

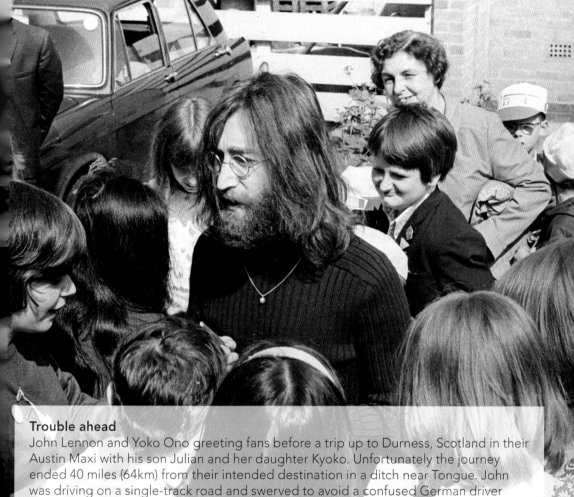

Trouble ahead
John Lennon and Yoko Ono greeting fans before a trip up to Durness, Scotland in their Austin Maxi with his son Julian and her daughter Kyoko. Unfortunately the journey ended 40 miles (64km) from their intended destination in a ditch near Tongue. John was driving on a single-track road and swerved to avoid a confused German driver coming the other way.
27th June, 1969

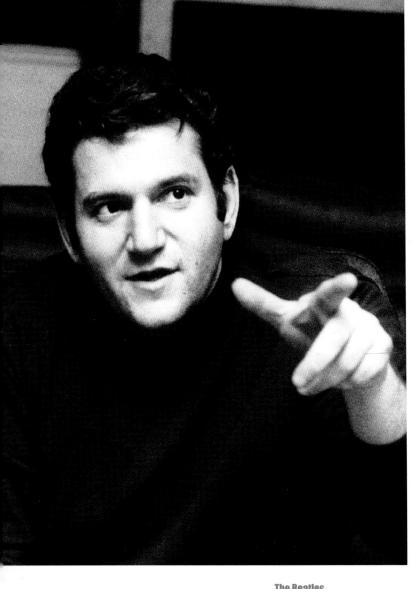

Allen Klein
Without Brian Epstein to guide them, The Beatles did not manage their money well. The Apple Corp was heading for disaster when Lennon, Harrison and Starr brought in Allen Klein to save them. McCartney, however, was unimpressed by the American businessman and never signed up with him.
1st July, 1969

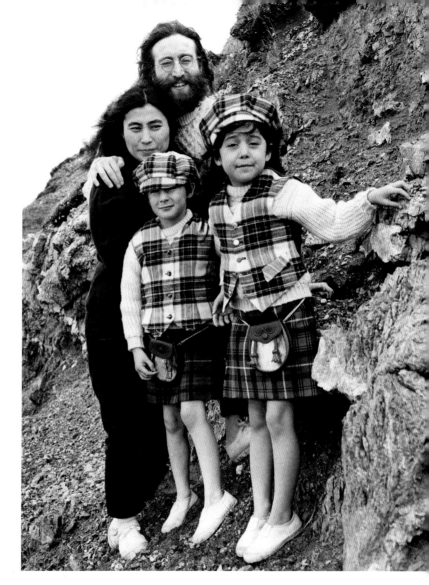

Highland fling
John Lennon and
Yoko Ono stand on a
Scottish mountainside
with his son Julian and
her daughter Kyoko.
2nd July, 1969

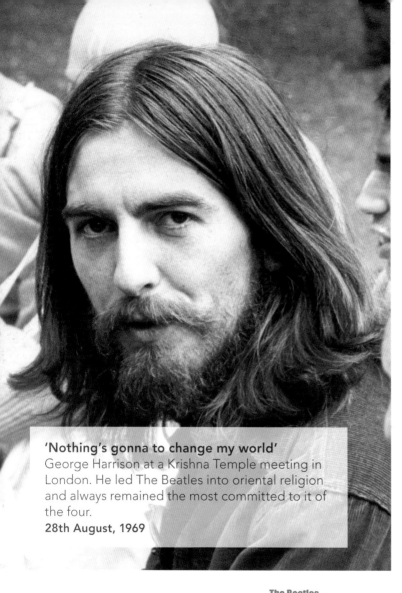
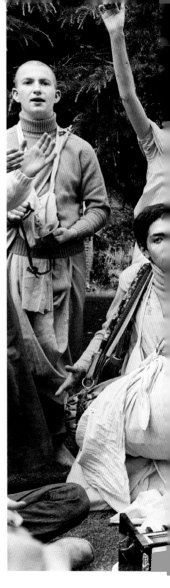

'Nothing's gonna to change my world'
George Harrison at a Krishna Temple meeting in
London. He led The Beatles into oriental religion
and always remained the most committed to it of
the four.
28th August, 1969

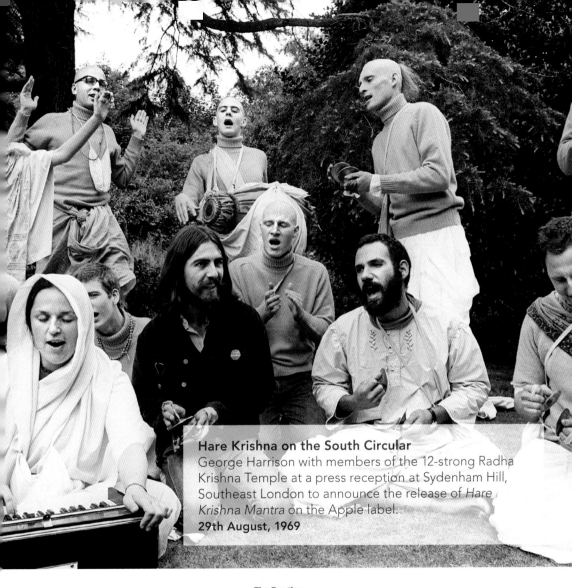

Hare Krishna on the South Circular
George Harrison with members of the 12-strong Radha Krishna Temple at a press reception at Sydenham Hill, Southeast London to announce the release of *Hare Krishna Mantra* on the Apple label.
29th August, 1969

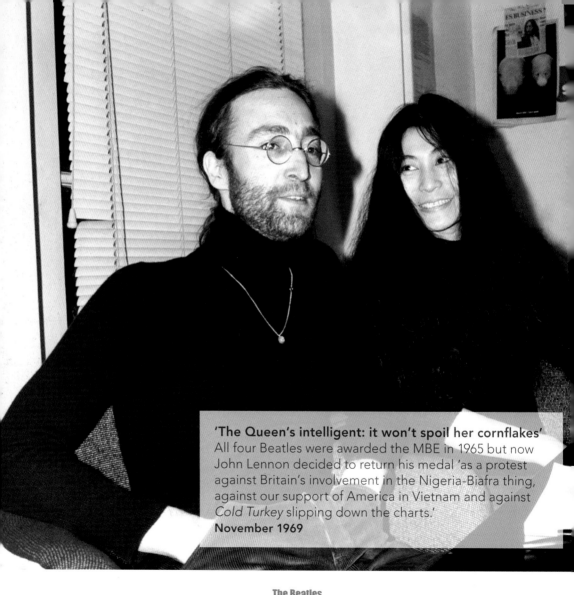

'The Queen's intelligent: it won't spoil her cornflakes'
All four Beatles were awarded the MBE in 1965 but now
John Lennon decided to return his medal 'as a protest
against Britain's involvement in the Nigeria-Biafra thing,
against our support of America in Vietnam and against
Cold Turkey slipping down the charts.'
November 1969

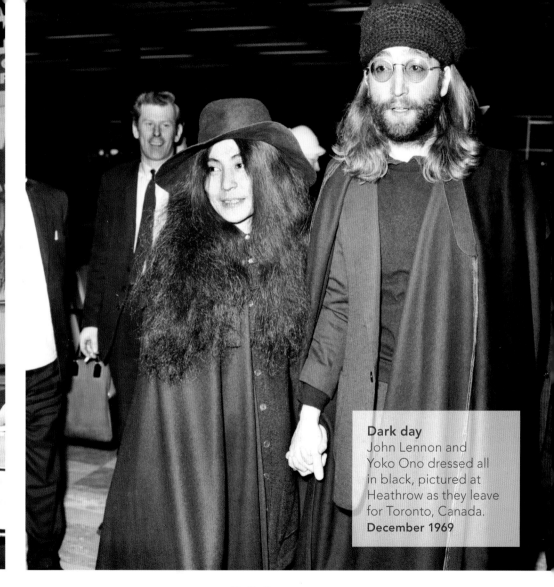

Dark day
John Lennon and
Yoko Ono dressed all
in black, pictured at
Heathrow as they leave
for Toronto, Canada.
December 1969

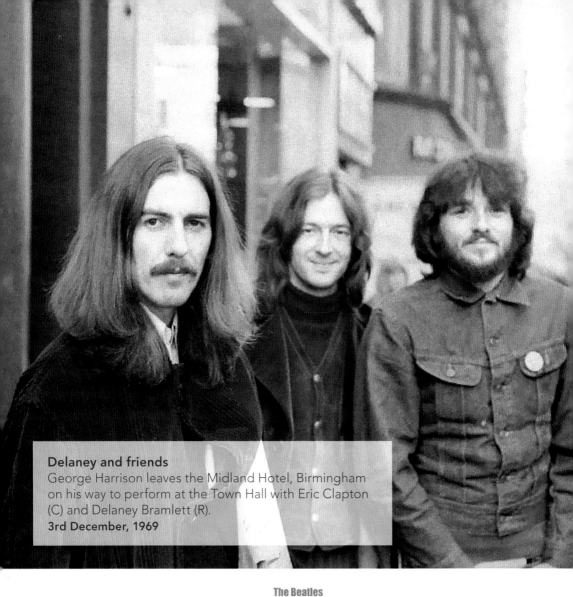

Delaney and friends
George Harrison leaves the Midland Hotel, Birmingham on his way to perform at the Town Hall with Eric Clapton (C) and Delaney Bramlett (R).
3rd December, 1969

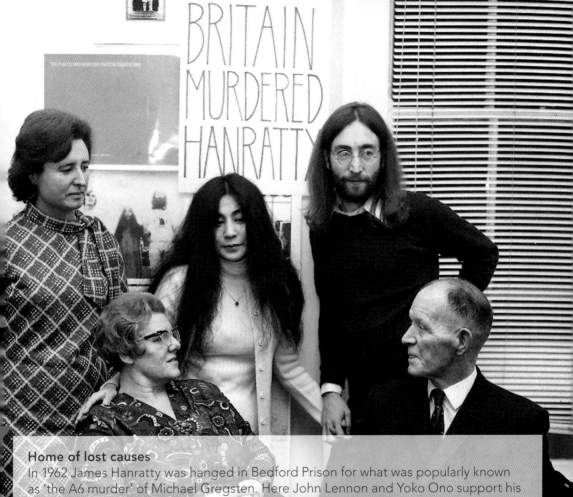

Home of lost causes

In 1962 James Hanratty was hanged in Bedford Prison for what was popularly known as 'the A6 murder' of Michael Gregsten. Here John Lennon and Yoko Ono support his parents in the unsuccessful campaign for a posthumous pardon.

14th December, 1969

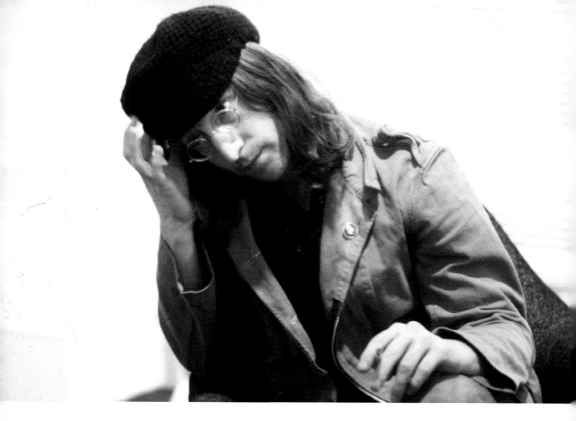

It's all in here
John Lennon in somewhat
pensive mood.
1970

Power to the people
Right: John Lennon and Yoko Ono pictured on the roof
of Black House, a Black Power commune in Holloway
Road, North London, to which they donated a sack full of
their hair for a fund-raising auction. With them is Michael
X, the first man to be imprisoned in Britain under the
Race Relations Act, who was later convicted of murder in
Guyana and hanged in 1975.
4th February, 1970

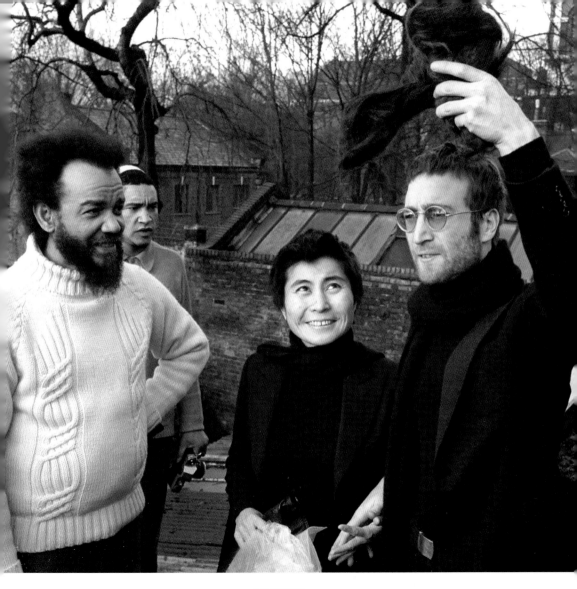

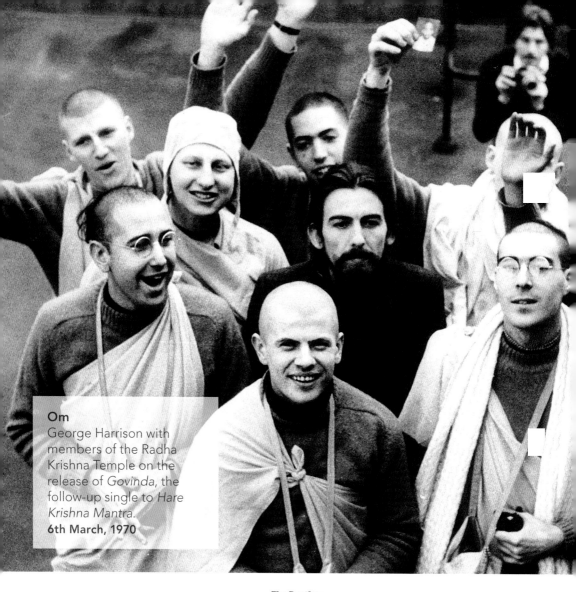

Om
George Harrison with members of the Radha Krishna Temple on the release of *Govinda*, the follow-up single to *Hare Krishna Mantra*.
6th March, 1970

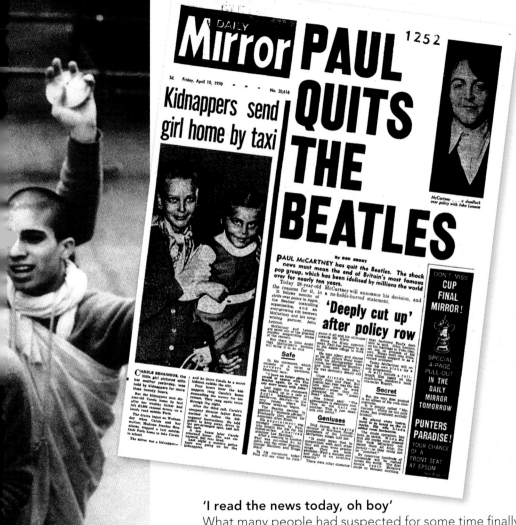

'I read the news today, oh boy'
What many people had suspected for some time finally became public: the end of an era.
10th April, 1970

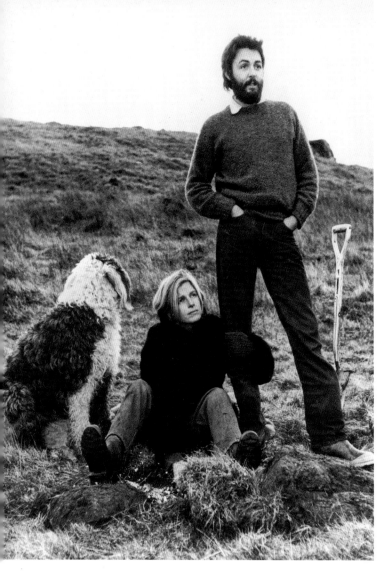

Spreading Wings

Paul McCartney finally married in 1969. His wife Linda (née Eastman) became increasingly involved in his music and joined him in his new band, Wings. Here they are with dog Ringo on their farm near Campbeltown, Scotland. **1971**

'Remember I'll always be true'
The Beatles had split but their official fan club lived on. This is its official secretary, Freda Kelly, in her Liverpool office.
11th January, 1971

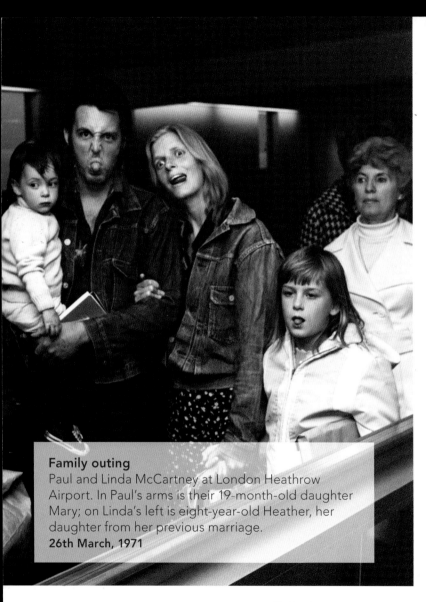

Family outing
Paul and Linda McCartney at London Heathrow Airport. In Paul's arms is their 19-month-old daughter Mary; on Linda's left is eight-year-old Heather, her daughter from her previous marriage.
26th March, 1971

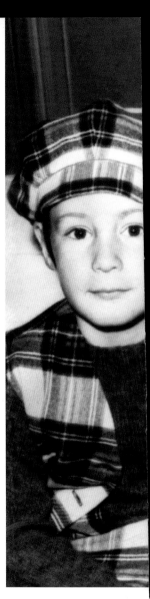

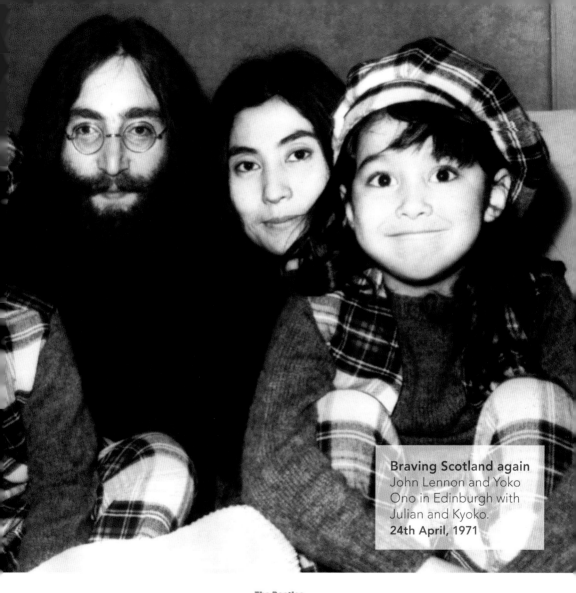

Braving Scotland again
John Lennon and Yoko
Ono in Edinburgh with
Julian and Kyoko.
24th April, 1971

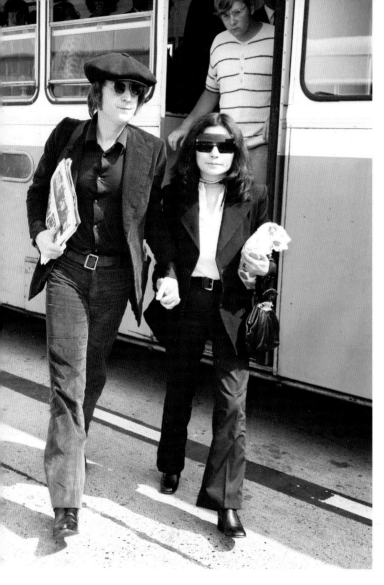

Joining hands across the ocean

John Lennon and Yoko Ono arrive back at London Heathrow Airport from the United States.
1st July, 1971

RORing fire

Ringo Starr teamed up with furniture designer Robin Cruickshank to form a company named ROR (Ringo Or Robin) Ltd. This is one of their earliest creations, a fireplace that sold for £480.
13th September, 1971

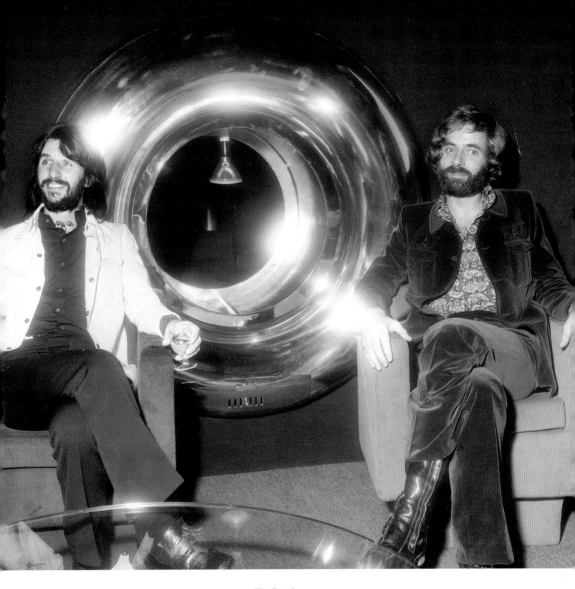

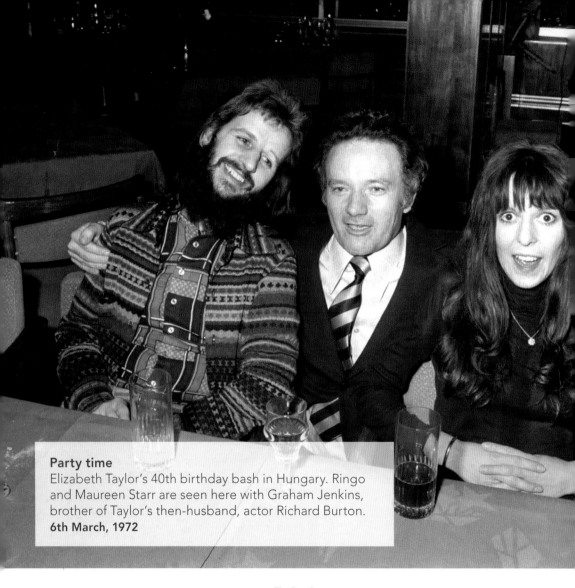

Party time
Elizabeth Taylor's 40th birthday bash in Hungary. Ringo and Maureen Starr are seen here with Graham Jenkins, brother of Taylor's then-husband, actor Richard Burton.
6th March, 1972

Office time
Ringo Starr in his office in the Apple Corporation building.
15th March, 1972

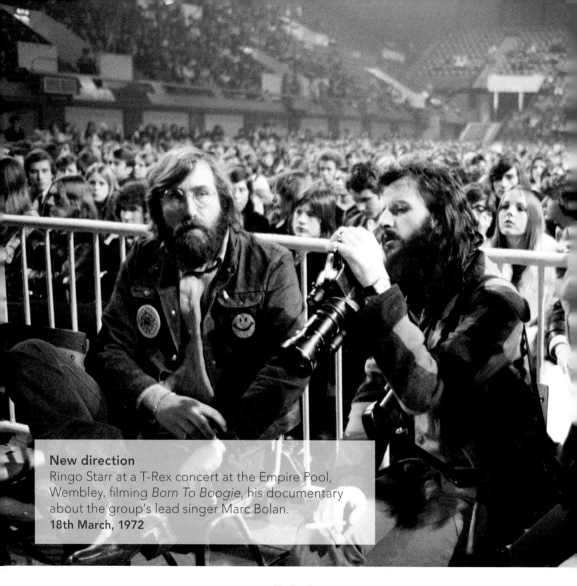

New direction
Ringo Starr at a T-Rex concert at the Empire Pool, Wembley, filming *Born To Boogie*, his documentary about the group's lead singer Marc Bolan.
18th March, 1972

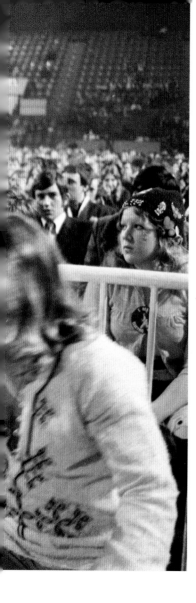

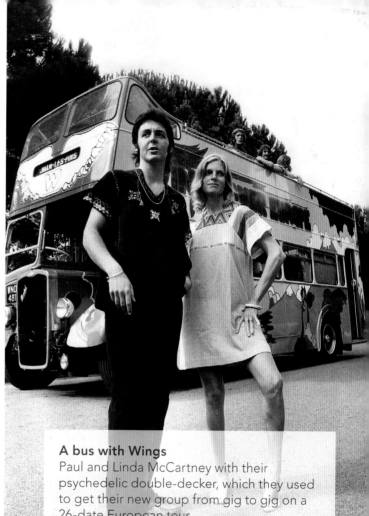

A bus with Wings
Paul and Linda McCartney with their psychedelic double-decker, which they used to get their new group from gig to gig on a 26-date European tour.
14th July, 1972

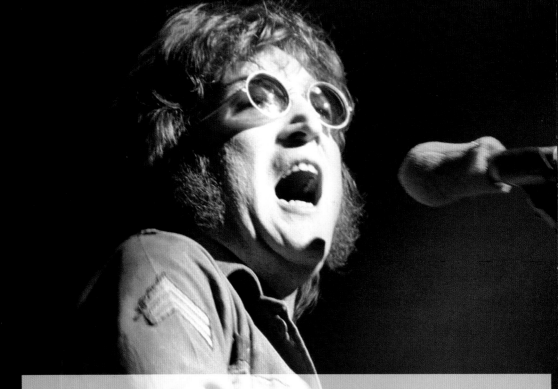

Last chance to see...
John Lennon and Yoko Ono on stage at New York's Madison Square Garden for one of two charity concerts on the same day in aid of the local Willowbrook School, a state-run institute for children with mental disabilities. These were Lennon's last full-scale performances in public.
30th August, 1972

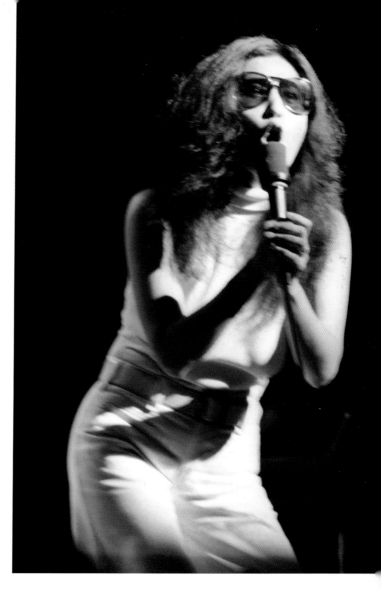

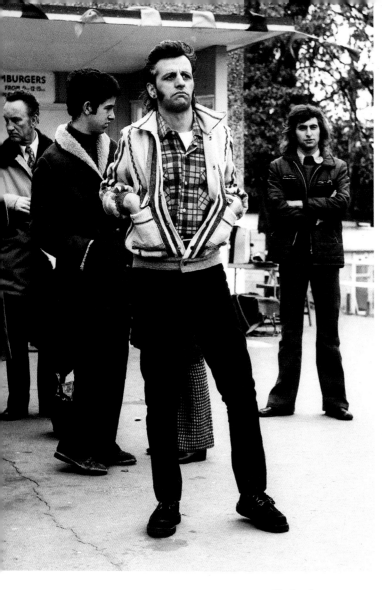

That'll Be The Day
Ringo Starr on location playing a Teddy boy in this 1973 film, which also starred David Essex and Billy Fury.
24th October, 1972

Mixed reception
A still from *That'll Be The Day*. The movie was panned by critics, but grossed more than £400,000.
1st February, 1973

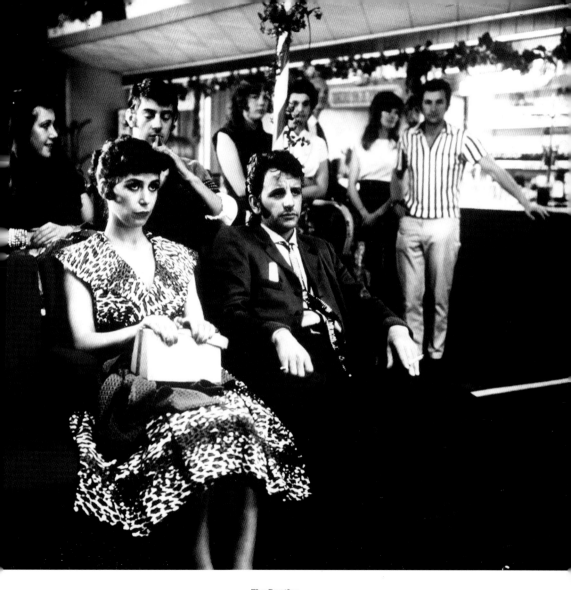

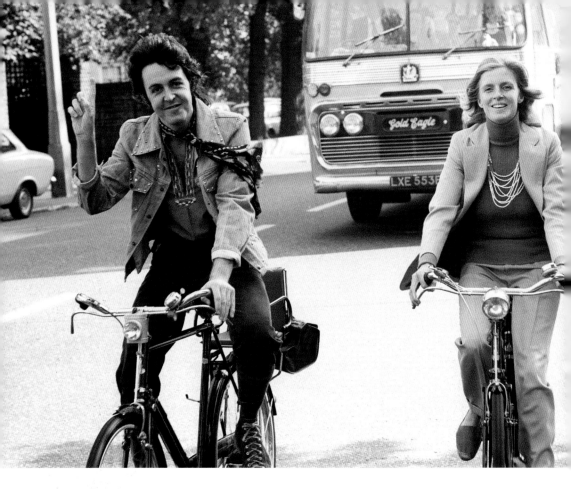

Two wheels good
Paul and Linda McCartney cycling round London on an
unseasonably sunny day.
6th February, 1973

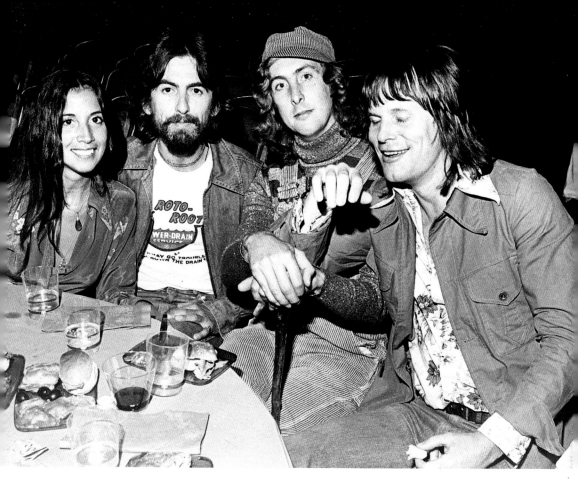

'A busy life in Camelot'

George Harrison with Olivia Arias, whom he later married, at the Hollywood première of *Monty Python and the Holy Grail*. With them are actor Eric Idle (second R) and the film's co-director Terry Gilliam.

18th July, 1975

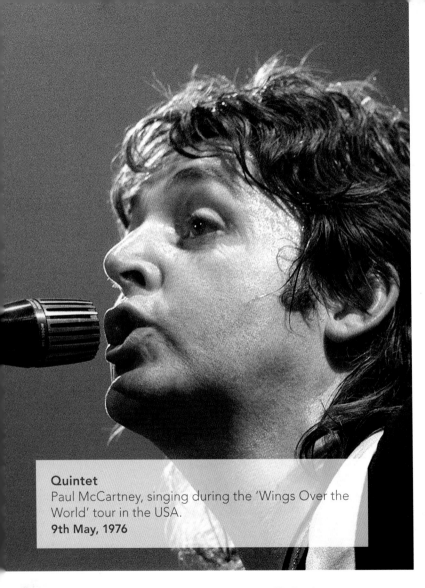

Quintet
Paul McCartney, singing during the 'Wings Over the World' tour in the USA.
9th May, 1976

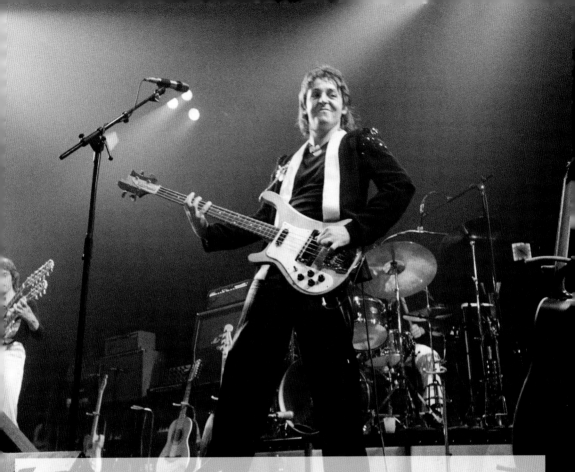

Quintet set
Wings' line-up for the '76 tour comprised Paul and Linda McCartney, Jimmy McCulloch (L), Denny Laine (C) and, hidden behind the drum kit, Joe English.
9th May, 1976

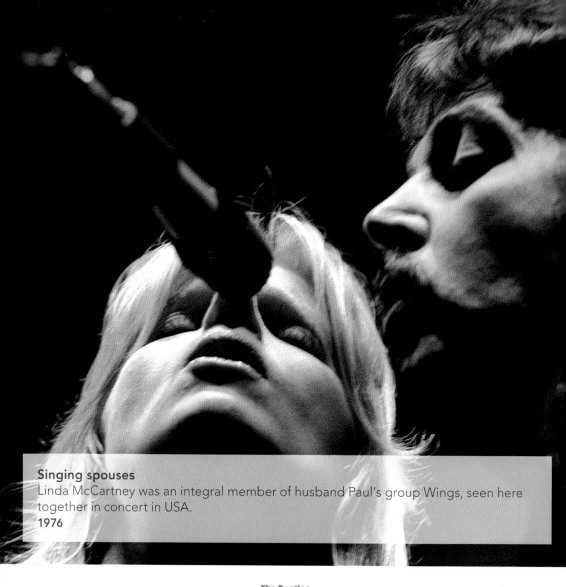

Singing spouses
Linda McCartney was an integral member of husband Paul's group Wings, seen here together in concert in USA.
1976

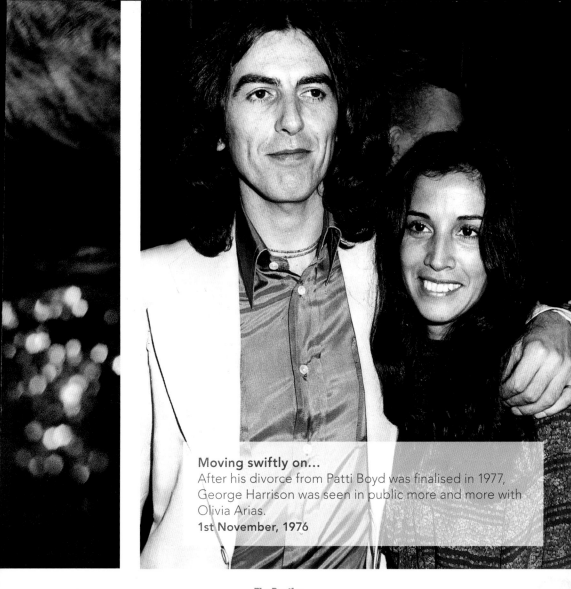

Moving swiftly on...
After his divorce from Patti Boyd was finalised in 1977,
George Harrison was seen in public more and more with
Olivia Arias.
1st November, 1976

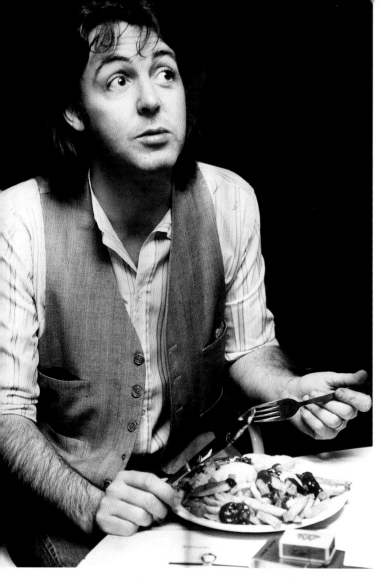

The perfect repast
Paul McCartney in a greasy spoon with fish and chips, a packet of Benson and Hedges Special Filter and a box of Bryant and May matches.
9th November, 1977

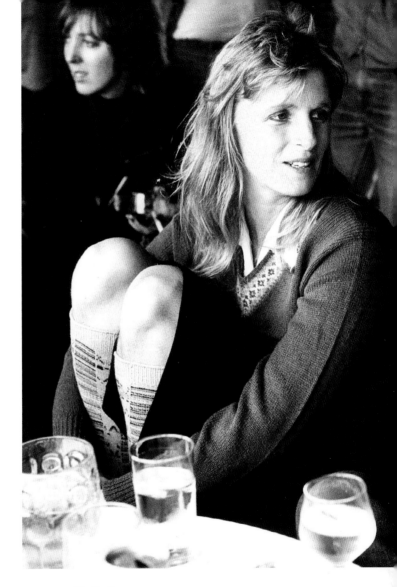

Knees up down the boozer
Linda McCartney relaxes in a pub.
22nd March, 1978

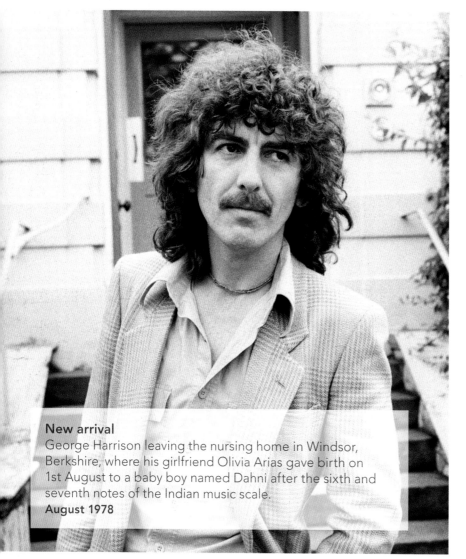

New arrival
George Harrison leaving the nursing home in Windsor, Berkshire, where his girlfriend Olivia Arias gave birth on 1st August to a baby boy named Dahni after the sixth and seventh notes of the Indian music scale.
August 1978

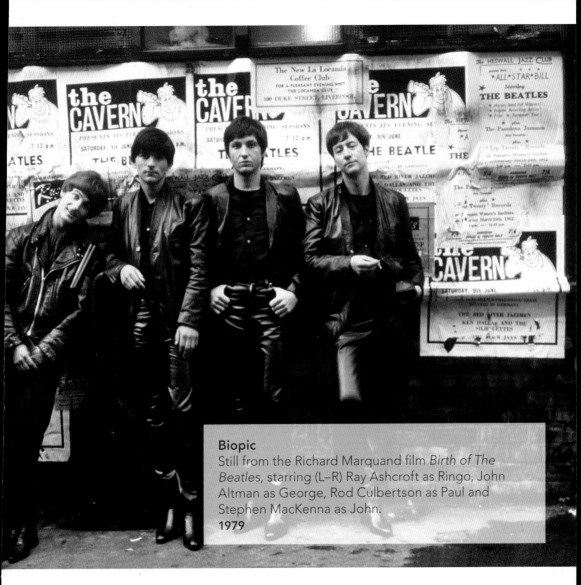

Biopic
Still from the Richard Marquand film *Birth of The Beatles*, starring (L–R) Ray Ashcroft as Ringo, John Altman as George, Rod Culbertson as Paul and Stephen MacKenna as John.
1979

Lobe star
Ringo sporting an apt earring.
c.1980s

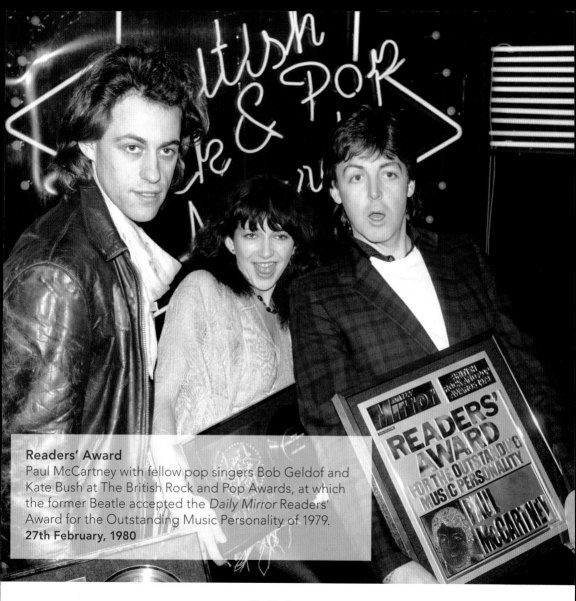

Readers' Award
Paul McCartney with fellow pop singers Bob Geldof and
Kate Bush at The British Rock and Pop Awards, at which
the former Beatle accepted the *Daily Mirror* Readers'
Award for the Outstanding Music Personality of 1979.
27th February, 1980

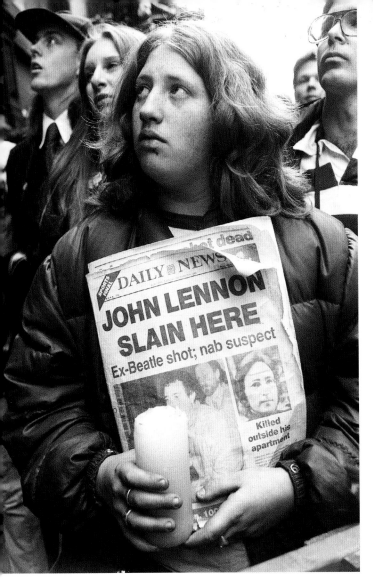

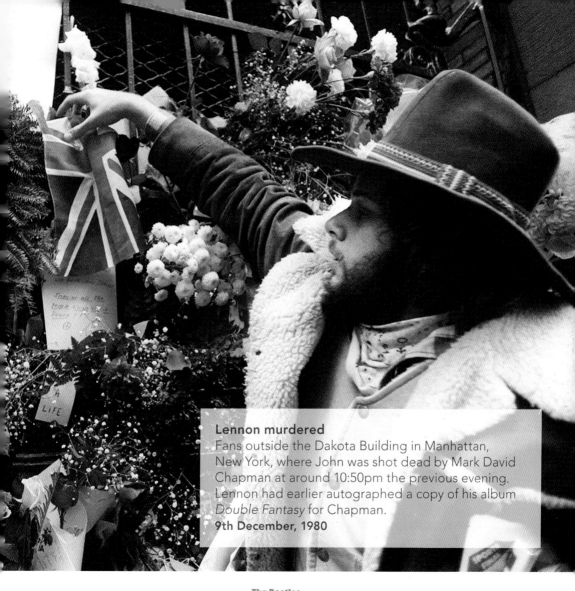

Lennon murdered
Fans outside the Dakota Building in Manhattan,
New York, where John was shot dead by Mark David
Chapman at around 10:50pm the previous evening.
Lennon had earlier autographed a copy of his album
Double Fantasy for Chapman.
9th December, 1980

SPECIAL ISSUE

Wednesday, December 10, 1980 12p

JOHN LENNON shot dead in New York Dec 8 1980 DEATH OF A HERO

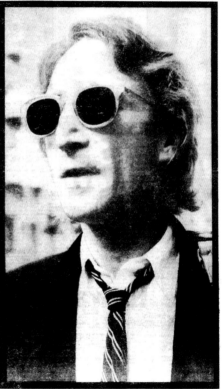

MURDERED SUPERSTAR: One of the last pictures of ex-Beatle John Lennon, taken in New York three weeks ago.

Daily Record

12p SCOTLAND'S BIGGEST DAILY SALE No. 26,589

FAREWELL TO JOHN LENNON

THE KISS

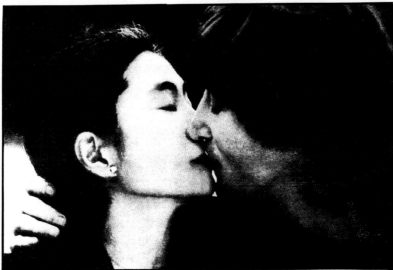

AND THE KILLER

THE GUNMAN ...
Mark Chapman

THIS picture, of John Lennon kissing his wife Yoko Ono, is how he will be remembered ... how he would want to be remembered.

For it sums up his tenderness, his love, his inner peace—his real nature hidden beneath the outward cynicism of his rebel image.

John liked the picture so much that he chose it for the cover of his latest record.

Tragically, it was partly because of that record that he died —gunned down at the age of 40 by a religious maniac who had earlier bought the album and got him to autograph it.

I'VE JUST SHOT JOHN LENNON

PAGES 2 AND 3

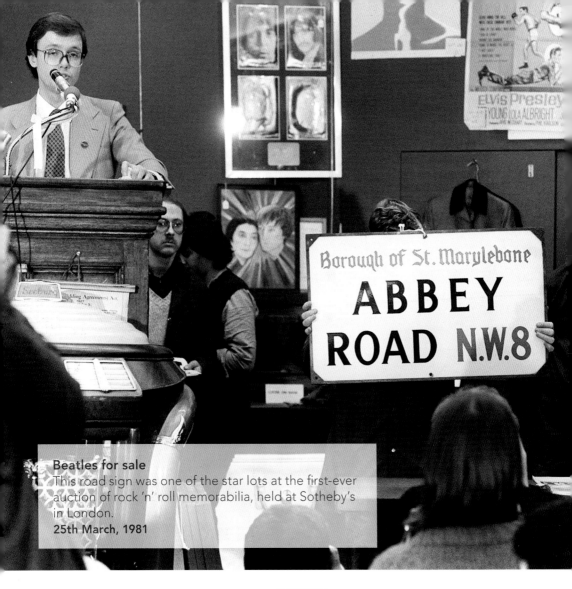

Beatles for sale
This road sign was one of the star lots at the first-ever auction of rock 'n' roll memorabilia, held at Sotheby's in London.
25th March, 1981

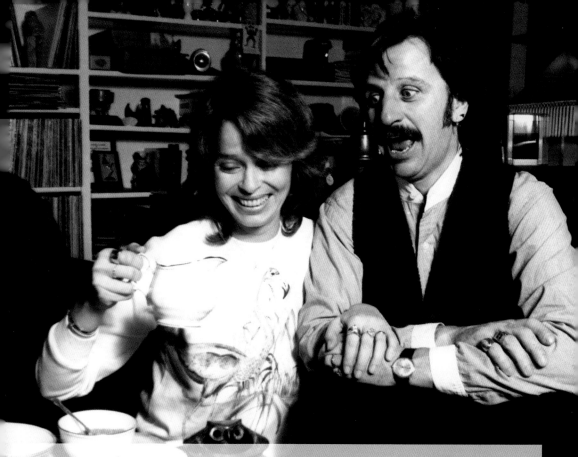

House of memories
Six years after divorcing Maureen, Ringo Starr married American actress Barbara Bach.
Here the newly-weds are seen in the mansion in Ascot that had previously been the
home of John Lennon.
22nd November, 1981

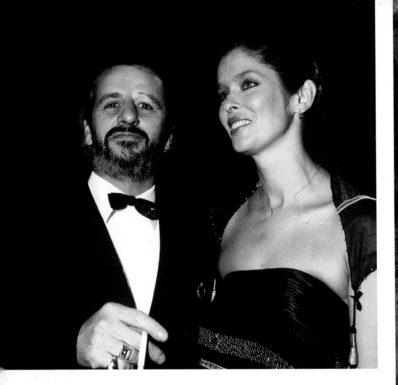

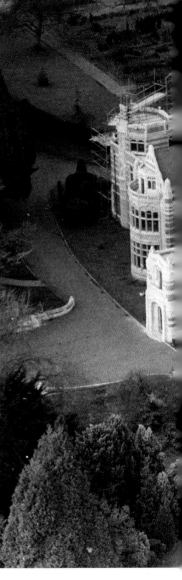

Inveterate movie-goers
Ringo Starr and Barbara
Bach at the British
première of *Gandhi*, a
film directed by Richard
Attenborough and
starring Ben Kingsley in
the title role.
2nd December, 1982

Crackerbox Palace
This was George
Harrison's affectionate
name for Friar Park, the
120-room neo-Gothic
mansion in Henley-on-
Thames, Oxfordshire,
which he bought in
January 1970.
12th February, 1984

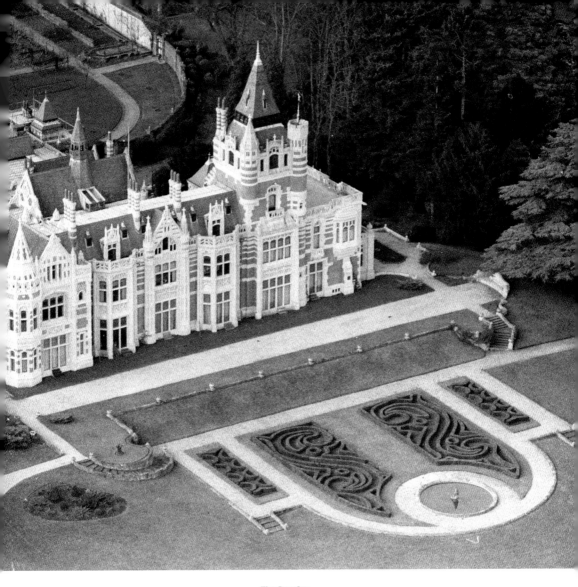

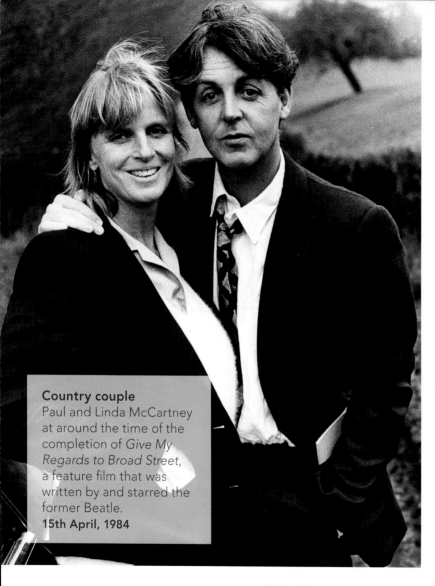

Country couple
Paul and Linda McCartney
at around the time of the
completion of *Give My
Regards to Broad Street*,
a feature film that was
written by and starred the
former Beatle.
15th April, 1984

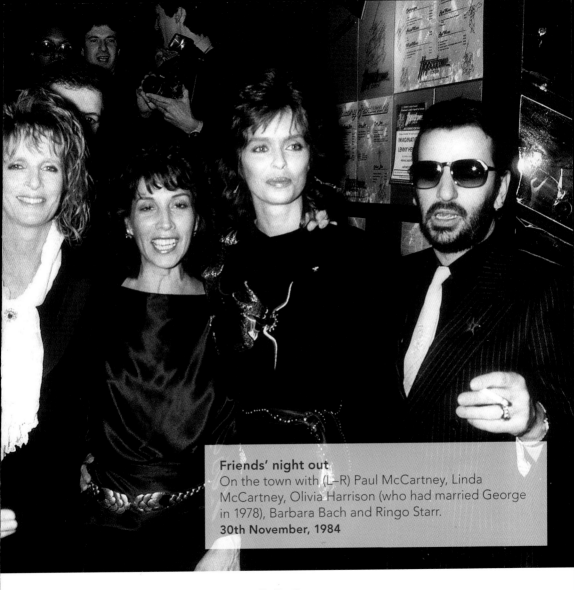

Friends' night out
On the town with (L–R) Paul McCartney, Linda McCartney, Olivia Harrison (who had married George in 1978), Barbara Bach and Ringo Starr.
30th November, 1984

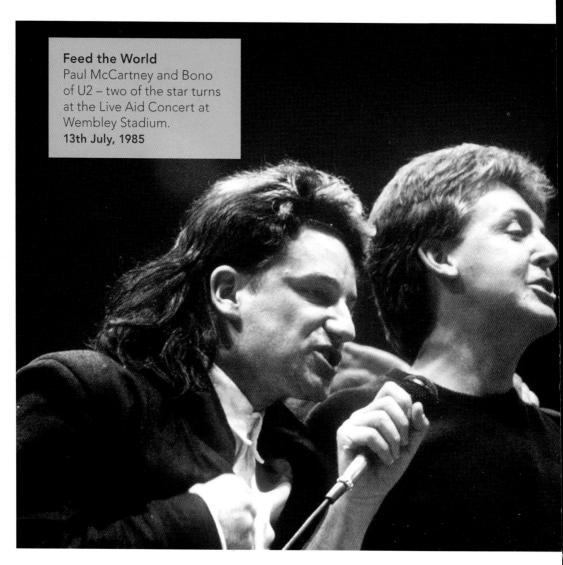

Feed the World
Paul McCartney and Bono
of U2 – two of the star turns
at the Live Aid Concert at
Wembley Stadium.
13th July, 1985

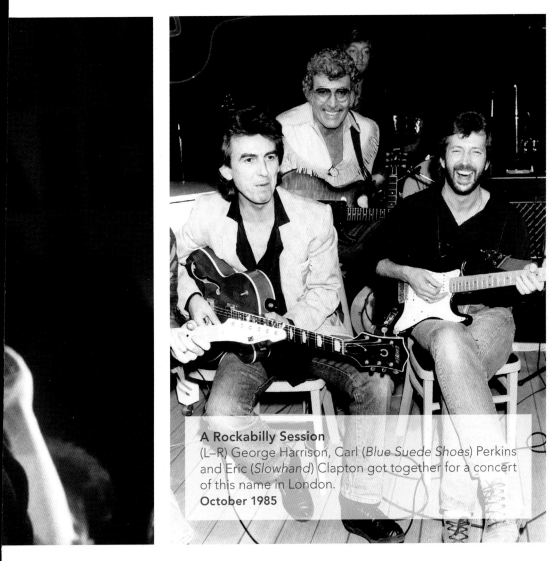

A Rockabilly Session
(L–R) George Harrison, Carl (*Blue Suede Shoes*) Perkins and Eric (*Slowhand*) Clapton got together for a concert of this name in London.
October 1985

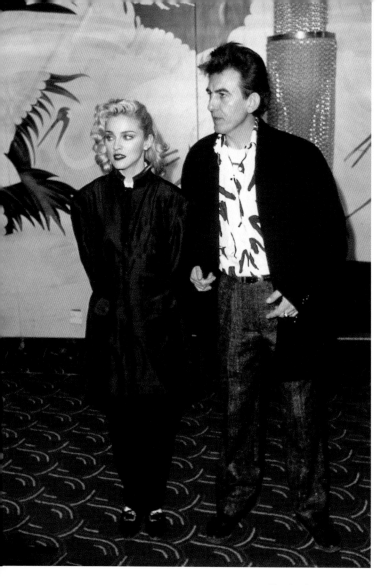

Material encounter
George Harrison (*Living in the Material World*, 1973) with Madonna (*Material Girl*, 1985) in the year of the release of the film *Shanghai Surprise*, which he produced and in which she starred.
March 1986

Posthumous revelations
Cynthia Lennon hit the headlines when her account of life with John detailed his jealous rages and ill-treatment of their son Julian.
26th October, 1988

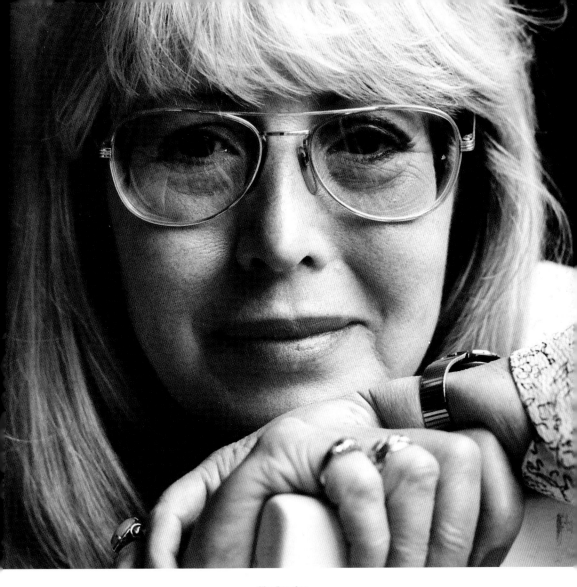

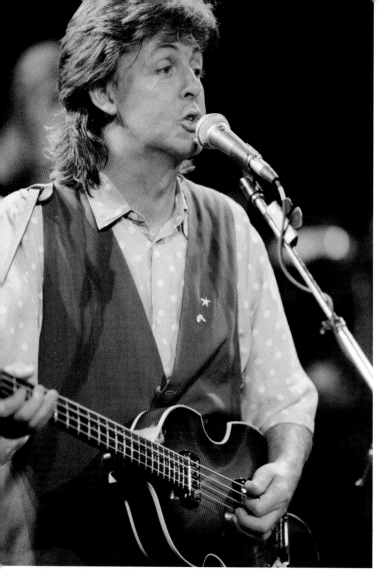

Coming to terms with the past

Paul McCartney performs live at London's Playhouse Theatre at the start of another world tour. This was the first time since The Beatles broke up that he had incorporated their material into his act.
27th July, 1989

Summer break

George, Olivia and Dhani Harrison at London Heathrow Airport.
2nd August, 1989

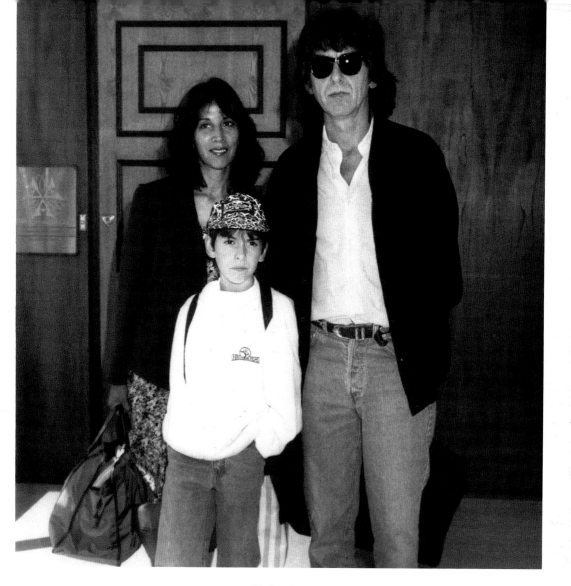

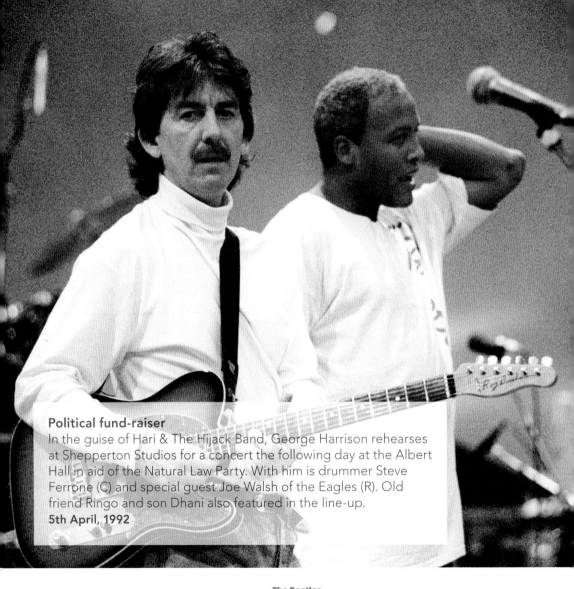

Political fund-raiser
In the guise of Hari & The Hijack Band, George Harrison rehearses at Shepperton Studios for a concert the following day at the Albert Hall in aid of the Natural Law Party. With him is drummer Steve Ferrone (C) and special guest Joe Walsh of the Eagles (R). Old friend Ringo and son Dhani also featured in the line-up.
5th April, 1992

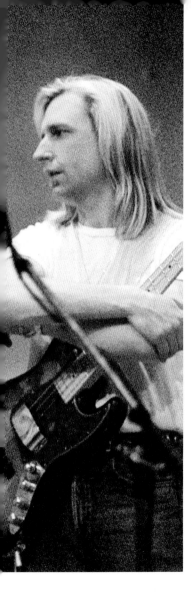
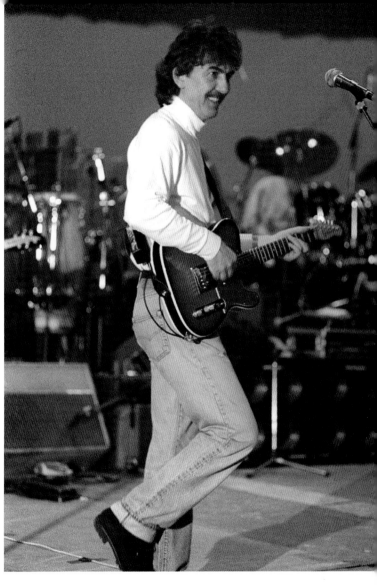

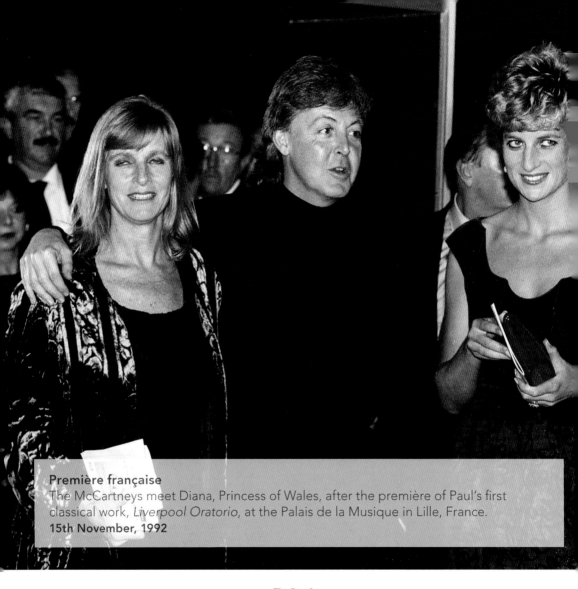

Première française
The McCartneys meet Diana, Princess of Wales, after the première of Paul's first classical work, *Liverpool Oratorio*, at the Palais de la Musique in Lille, France.
15th November, 1992

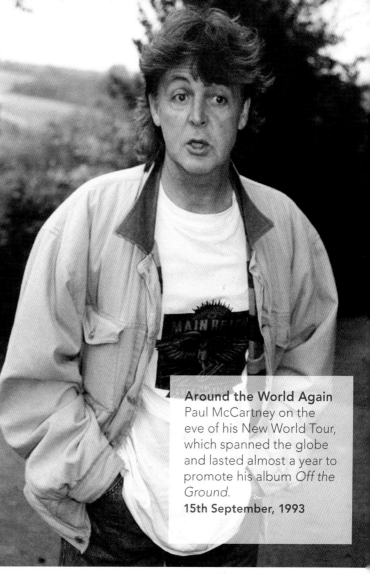

Around the World Again
Paul McCartney on the eve of his New World Tour, which spanned the globe and lasted almost a year to promote his album *Off the Ground*.
15th September, 1993

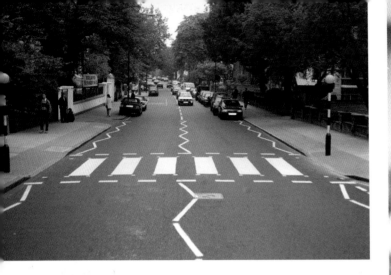

A cross to bear

The zebra crossing that appeared on the cover of *Abbey Road*, photographed almost exactly 25 years after the album's original release. Later it became not only the world's most famous pedestrian crossing but also one of the more dangerous, as motorists were faced almost daily with people imitating The Beatles.

25th September, 1994

Feats of clay

Groggs are clay caricatures created by John Hughes of Pontypridd, Wales, depicting celebrities. These are among his best-selling lines.

November 1996

GEORGE HARRISON

RINGO STARR PAUL McCARTNEY JOHN LENNON

THE BEATLES

The Beatles

Designer daughter

Paul and Linda McCartney applaud their daughter Stella at the end of her first show for Chloe in Paris. Diagnosed with breast cancer in 1995, Linda had only five months left to live.

15th October, 1997

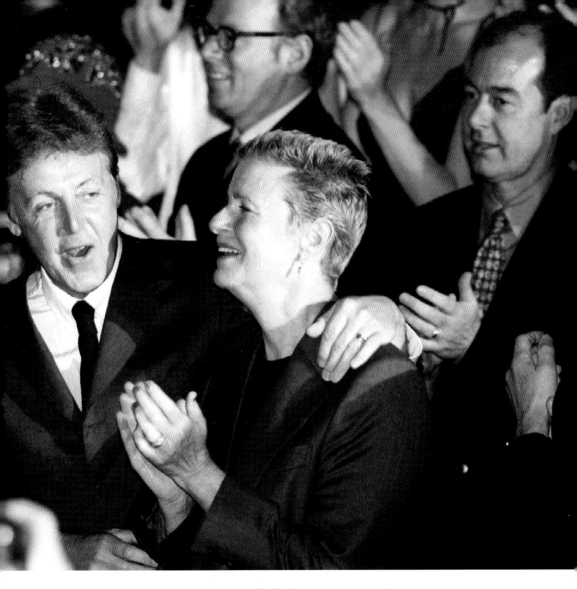

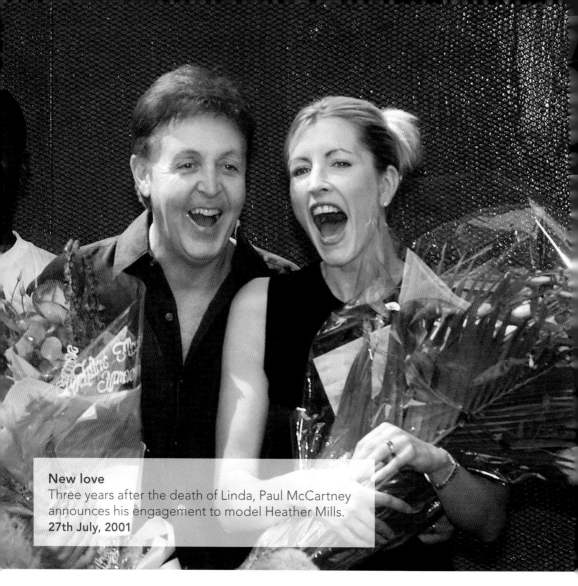

New love
Three years after the death of Linda, Paul McCartney announces his engagement to model Heather Mills.
27th July, 2001

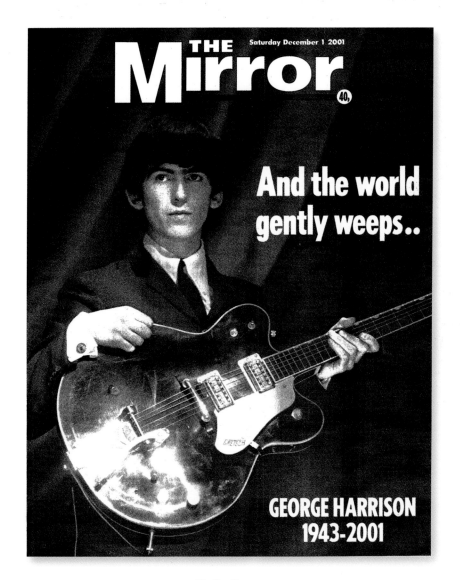

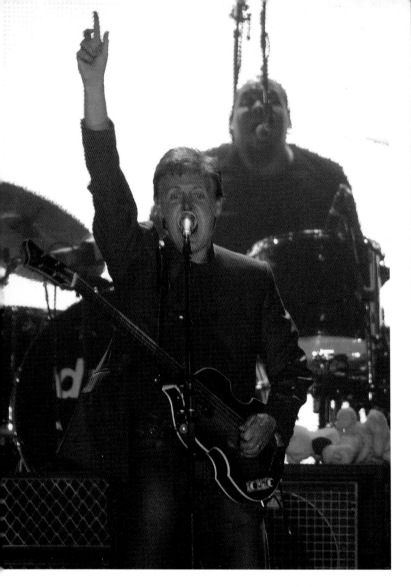

Today Sheffield, tomorrow...
Paul McCartney plays live on stage at the
Hallam FM Arena at the start of his Back In
The World tour.
6th April, 2003

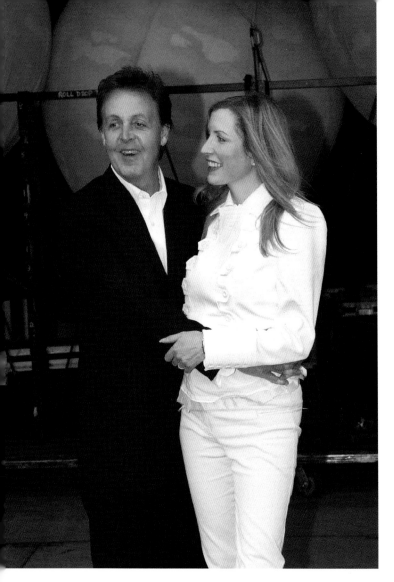

Letting out a big secret
Paul McCartney married Heather Mills on 11th June, 2002. Today the couple announced that they are expecting their first child.
29th May, 2003

Blooming in Glasgow
Paul and Heather Mills McCartney, the latter now visibly pregnant, at Prestwick Airport. Their daughter, Beatrice Milly, was born on 28th October, 2003.
2003

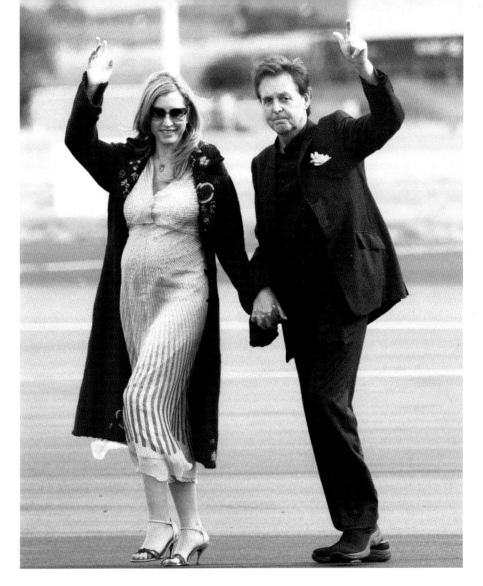

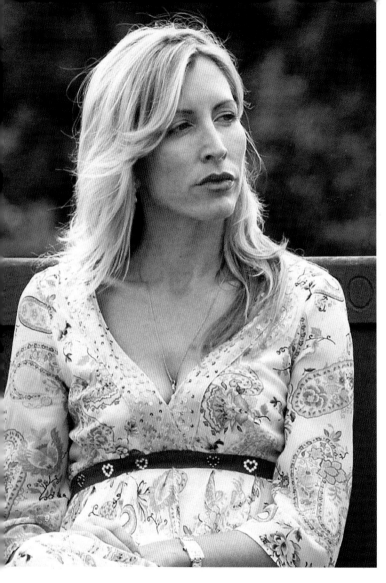

Moment of tranqulity
Heather Mills McCartney
looks reflective during the
three-year gap between
becoming a mother and
separating from her
husband.
2nd July, 2005

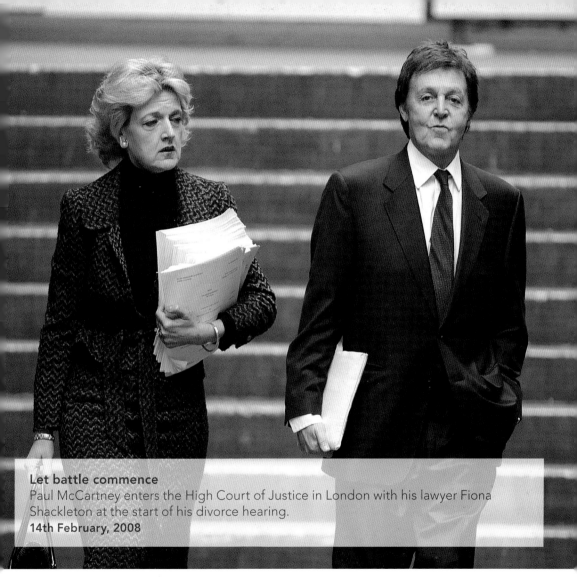

Let battle commence
Paul McCartney enters the High Court of Justice in London with his lawyer Fiona Shackleton at the start of his divorce hearing.
14th February, 2008

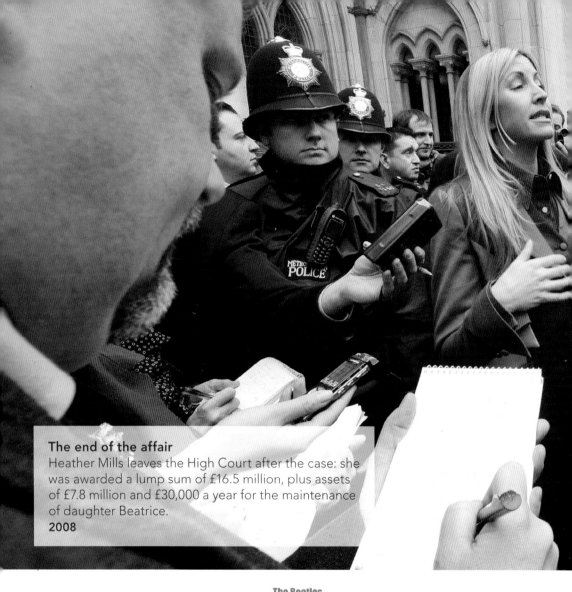

The end of the affair
Heather Mills leaves the High Court after the case: she
was awarded a lump sum of £16.5 million, plus assets
of £7.8 million and £30,000 a year for the maintenance
of daughter Beatrice.
2008

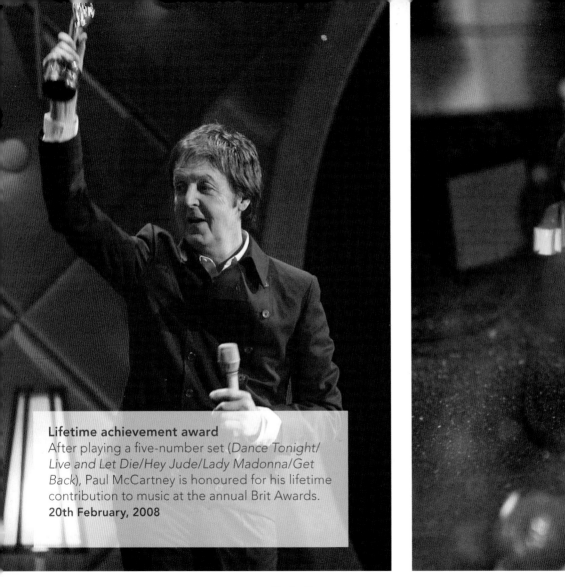

Lifetime achievement award
After playing a five-number set (*Dance Tonight/ Live and Let Die/Hey Jude/Lady Madonna/Get Back*), Paul McCartney is honoured for his lifetime contribution to music at the annual Brit Awards.
20th February, 2008

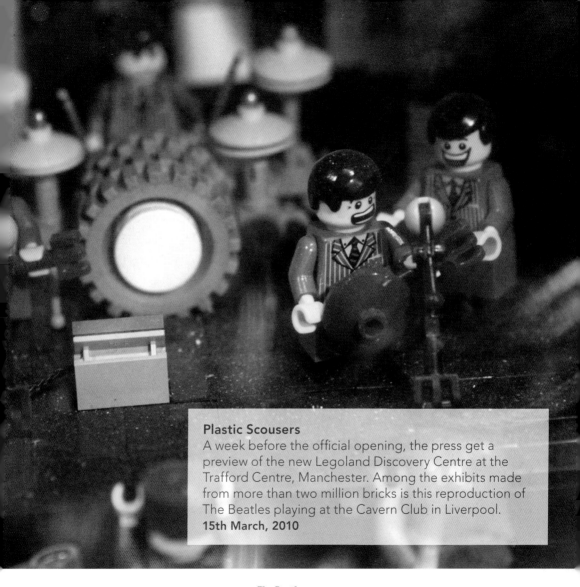

Plastic Scousers
A week before the official opening, the press get a preview of the new Legoland Discovery Centre at the Trafford Centre, Manchester. Among the exhibits made from more than two million bricks is this reproduction of The Beatles playing at the Cavern Club in Liverpool.
15th March, 2010

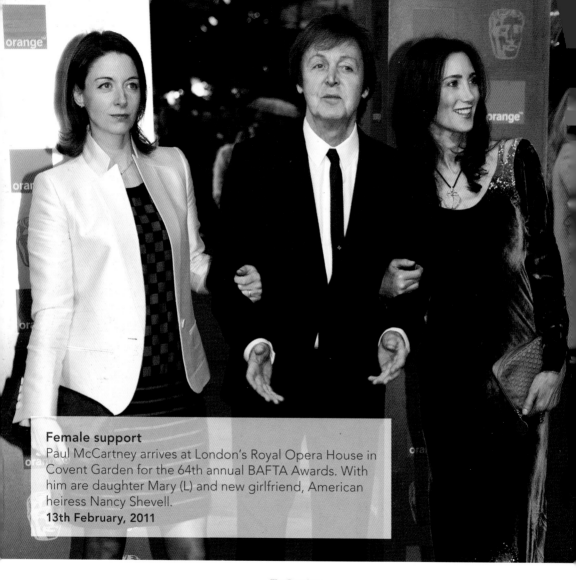

Female support

Paul McCartney arrives at London's Royal Opera House in Covent Garden for the 64th annual BAFTA Awards. With him are daughter Mary (L) and new girlfriend, American heiress Nancy Shevell.

13th February, 2011

Perfect fits
Stella McCartney at the launch of the kit she designed for the Great Britain team at the 2012 London Olympics. Modelling the outfits are triple-jumper Phillips Idowu and heptathlete Jessica Ennis.
23rd March, 2011

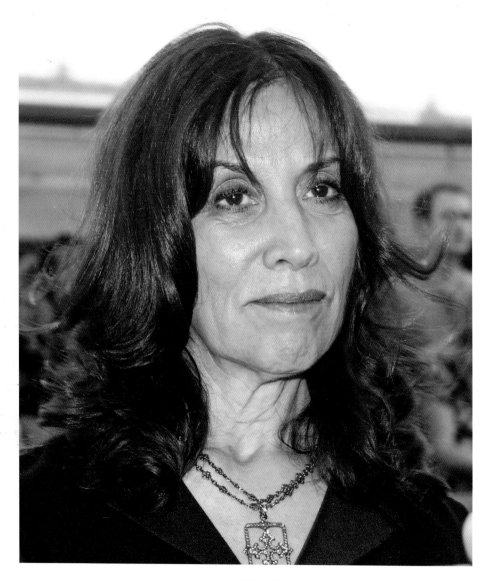

Looking back
Left: Ten years after the death of her husband, Olivia Harrison attends the London première of *George Harrison: Living in the Material World*, directed by Martin Scorsese.
2nd October, 2011

The B-Side
Paul McCartney and Nancy Shevell arrive at the same event. Does she know there are cameras everywhere?
2nd October, 2011

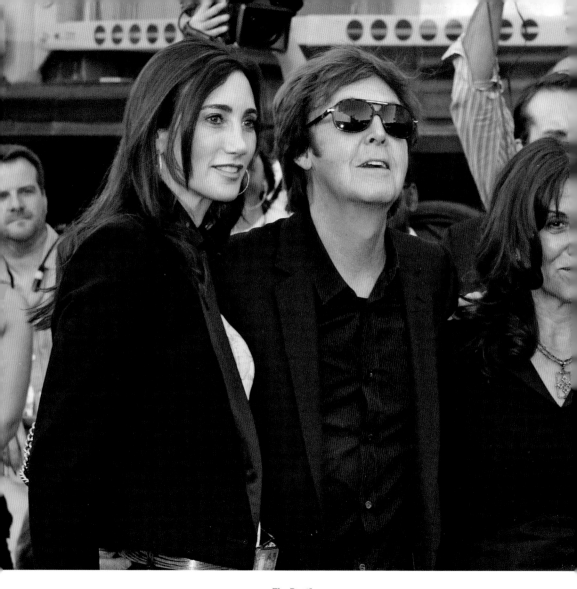

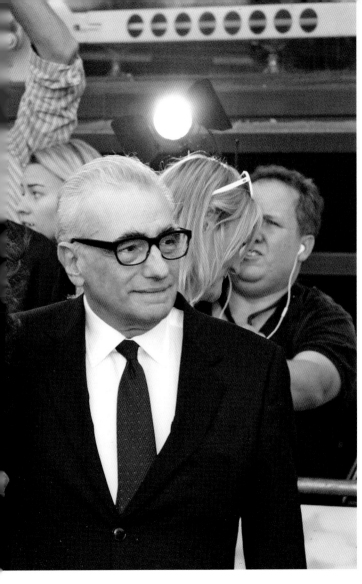

Scorsese score
(L–R) Nancy Shevell, Paul McCartney, Olivia Harrison and Martin Scorsese at the London première of *George Harrison: Living in the Material World*.
2nd October, 2011

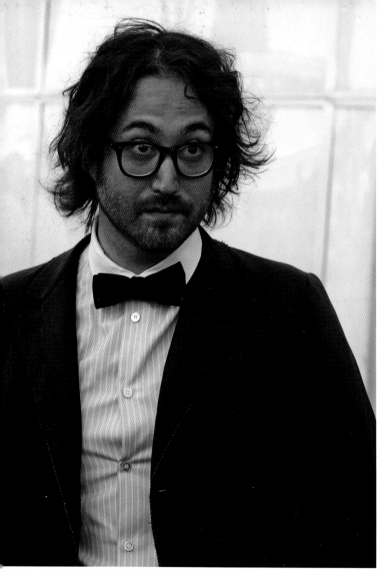

Lennon's lad
Sean Lennon, singer, songwriter, musician and actor, and the only child of John Lennon and Yoko Ono, was among the guests at the première of the Scorsese biopic.
2nd October, 2011

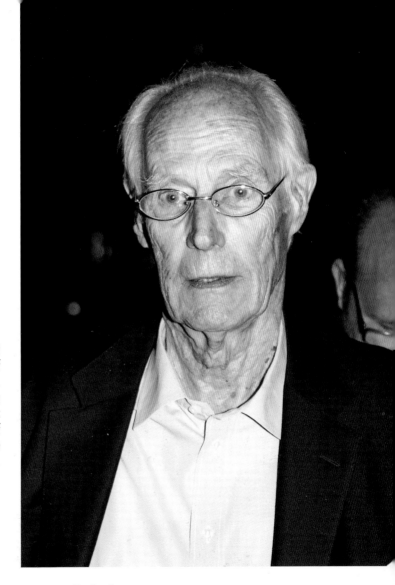

The Fifth Beatle (4)
Producer of much of
The Beatles' best work,
George Martin is among
the honoured guests at
the London première of
*George Harrison: Living in
the Material World.*
2nd October, 2011

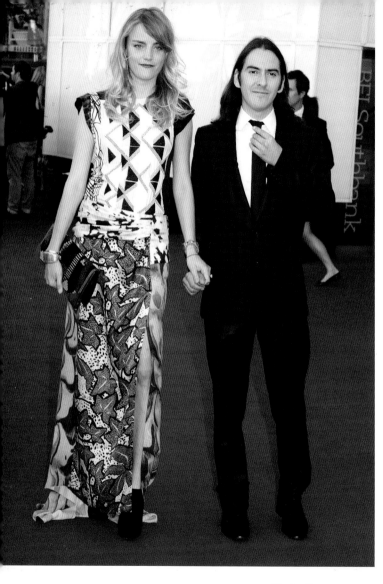

Harrison's son
Dhani Harrison and girlfriend Icelandic model Sólveig Káradottir at the London première of *George Harrison: Living in the Material World*. 'Sola' and Harrison married in June 2012.
2nd October 2011

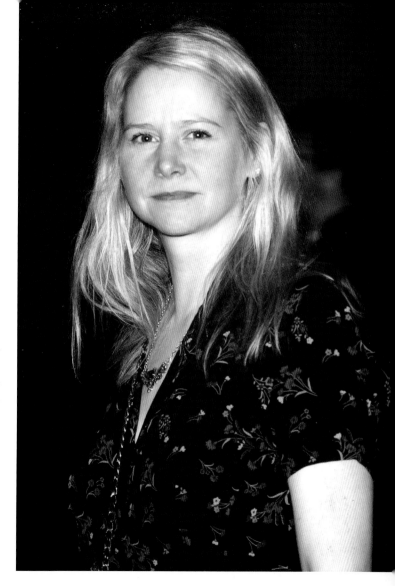

Late arrival
Ringo Starr's daughter Lee Starkey at the London première of *George Harrison: Living in the Material World*. Lee was born in 1970, just after The Beatles' official break-up.
2nd October, 2011

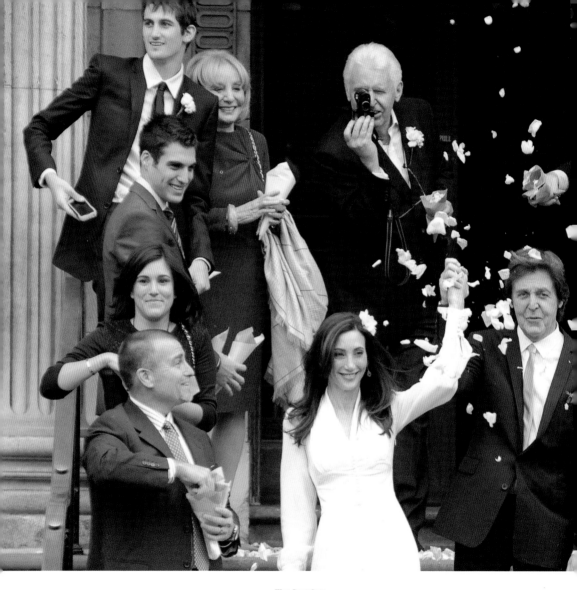

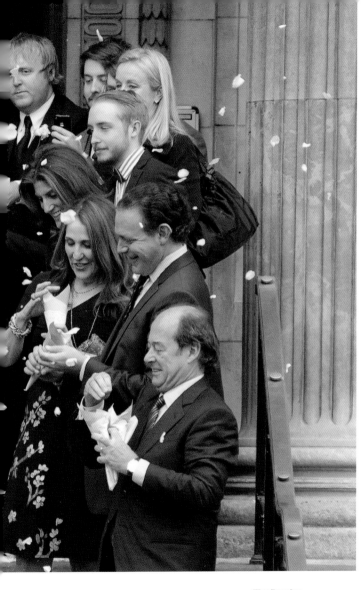

Fraternal frame
As the happy couple
leave the register office,
the groom's brother Mike
(Mike McGear) snaps
them one-handed at the
top of the steps.
9th October, 2011

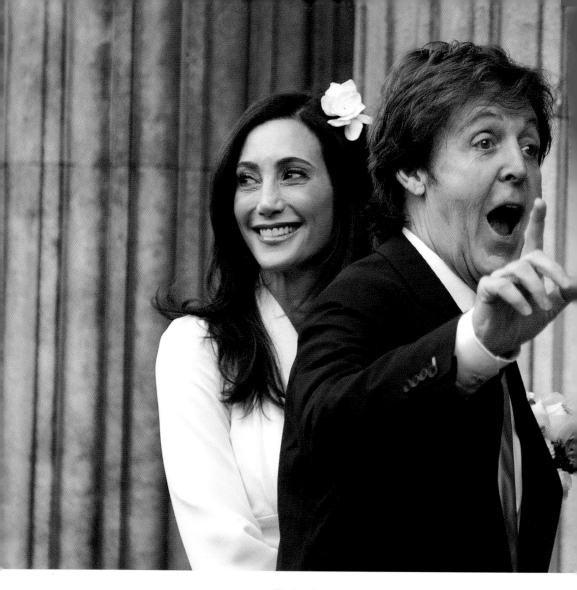

If a thing's worth doing once...
At the start of his third marriage, Paul McCartney and new bride Nancy Shevell leave Old Marylebone Town Hall after their wedding ceremony.
9th October, 2011

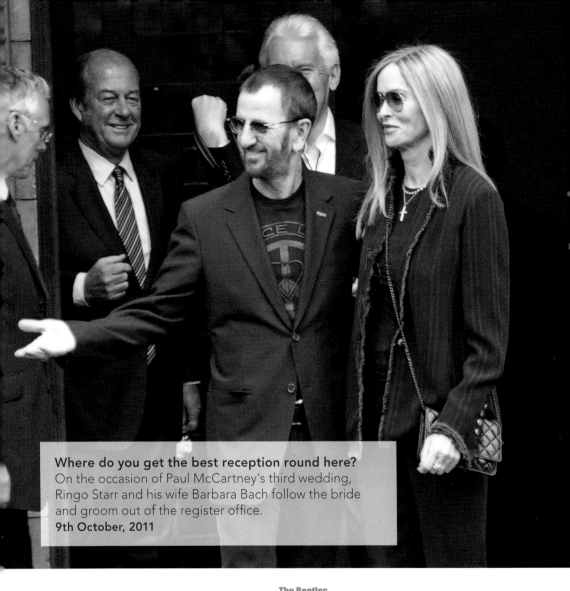

Where do you get the best reception round here?
On the occasion of Paul McCartney's third wedding, Ringo Starr and his wife Barbara Bach follow the bride and groom out of the register office.
9th October, 2011

Present mirth
Ringo Starr and Barbara Bach on their way into Paul McCartney's house in Cavendish Avenue, St John's Wood, London. The party went on so late that the neighbours complained about the noise.
9th October, 2011

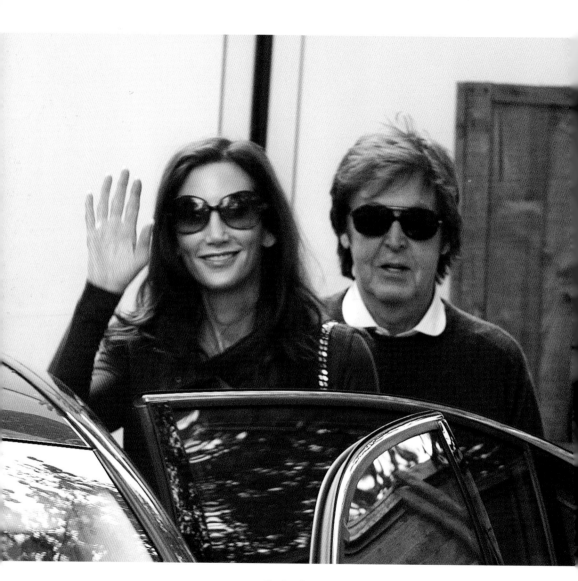

Off to the WI
Sir Paul and Lady
McCartney leave home
the following morning for
a brief honeymoon on
the Caribbean island of
Mustique.
10th October, 2011

Getting papped
Ringo minds his own
business in West London,
but everyone's got a
camera these days.
10th January, 2012

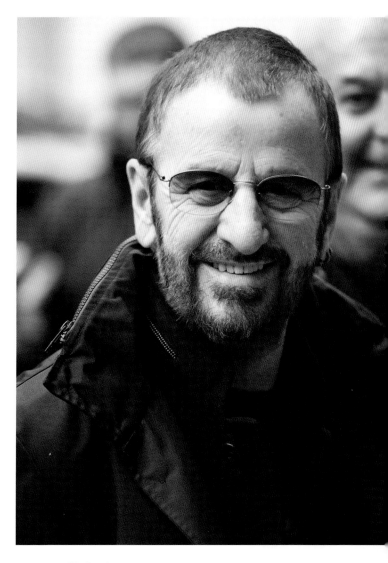

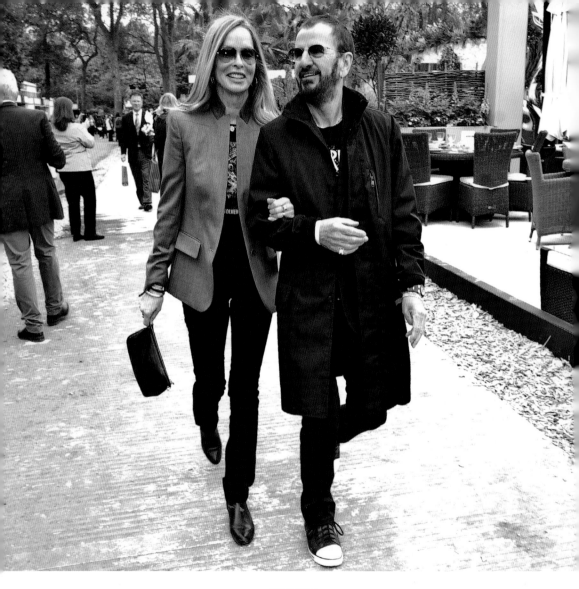

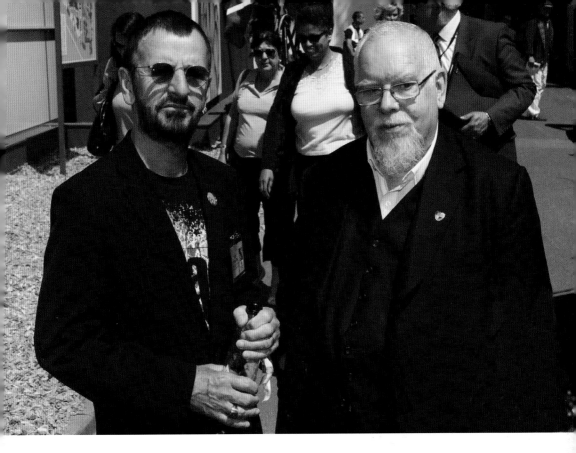

Starr flowers
Right: Ringo Starr and Barbara Bach attend the press and VIP preview day for the annual Chelsea Flower Show at the Royal Hospital Chelsea.
21st May, 2012

Lonely Hearts' reunion
At the Chelsea Flower show, Ringo ran into Peter Blake, the artist who designed the *Sergeant Pepper* album sleeve.
21st May, 2012

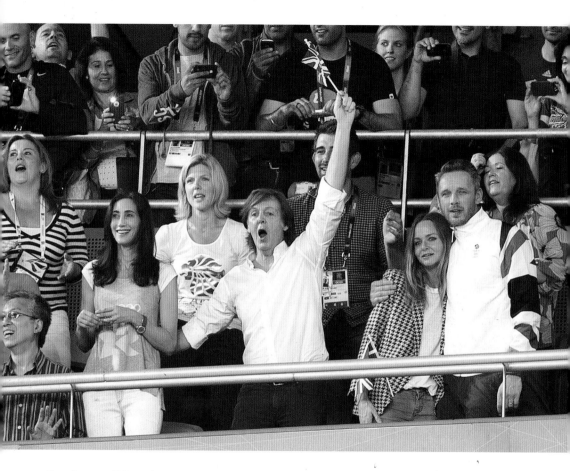

Getting well into it

Sir Paul McCartney waves the flag for Great Britain during a cycling event at the veldorome during the 2012 London Olympics. On his right is wife, Nancy; on his left daughter Stella and her husband Alasdhair Willis.

August 2012

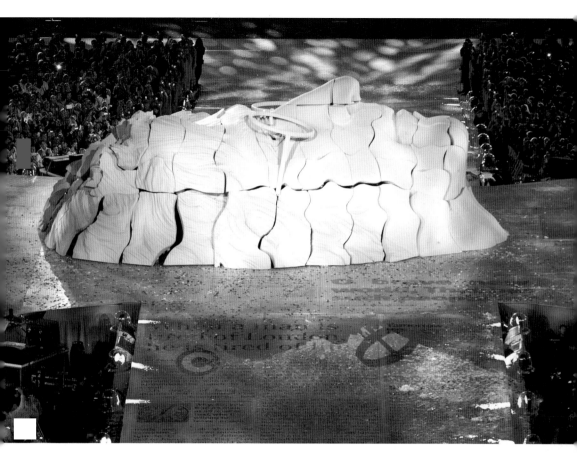

'You may say I'm a dreamer...'

The Closing Ceremony of the 2012 London Olympics featured a sculpture in the shape of the late John Lennon that was formed onstage, along with video footage of the star singing *Imagine*: a poignant tribute to the Beatle who was cut off in his prime.

12th August, 2012

The publishers gratefully acknowledge Mirrorpix, from whose extensive archives
the photographs in this book have been selected.

AMMONITE
PRESS